Dress Like a Woman

Editors: Sarah Massey, Ashley Albert, and Emma Jacobs
Designer: Najeebah Al-Ghadban
Production Managers: Alex Cameron and Anet Sirna-Bruder

Library of Congress Control Number: 2017949398

ISBN: 978-1-4197-2992-8
eISBN: 978-1-68335-298-3

Cover © 2018 Abrams
Front cover: Photograph by Bernard Hoffman/The LIFE Picture
Collection/Getty Images
Back cover: Bettmann/Getty Images
Front endpapers: Ann Rosener/Library of Congress, Prints &
Photographs Division, FSA-OWI Collection (LC-DIG-fsa-8b08373)
Back endpapers: Ann Rosener/Library of Congress, Prints &
Photographs Division, FSA-OWI Collection (LC-DIG-fsa-8b08371)

Printed and bound in China
10 9 8 7 6 5 4 3 2 1

Abrams Image books are available at special discounts when
purchased in quantity for premiums and promotions as well
as fundraising or educational use. Special editions can also
be created to specification. For details, contact specialsales@
abramsbooks.com or the address below.

ABRAMS The Art of Books
195 Broadway, New York, NY 10007
abramsbooks.com

DRESS LIKE A WOMAN

Working Women and What They Wore

foreword by ROXANE GAY

introduction by VANESSA FRIEDMAN

ABRAMS IMAGE, NEW YORK

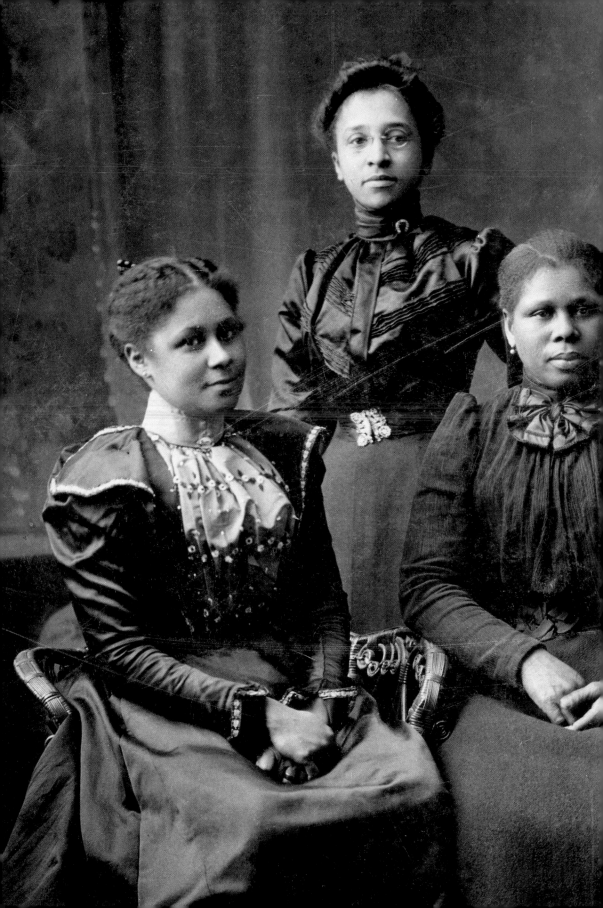

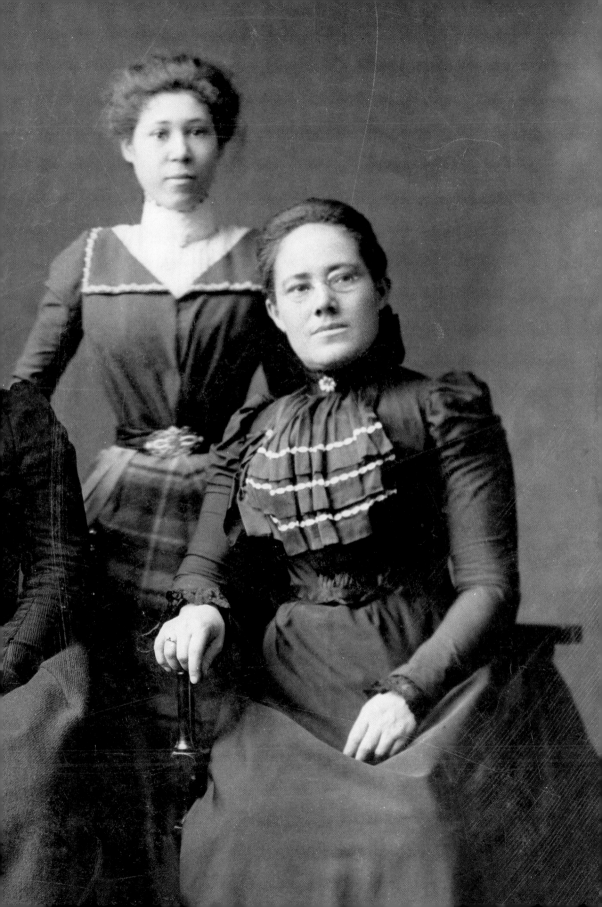

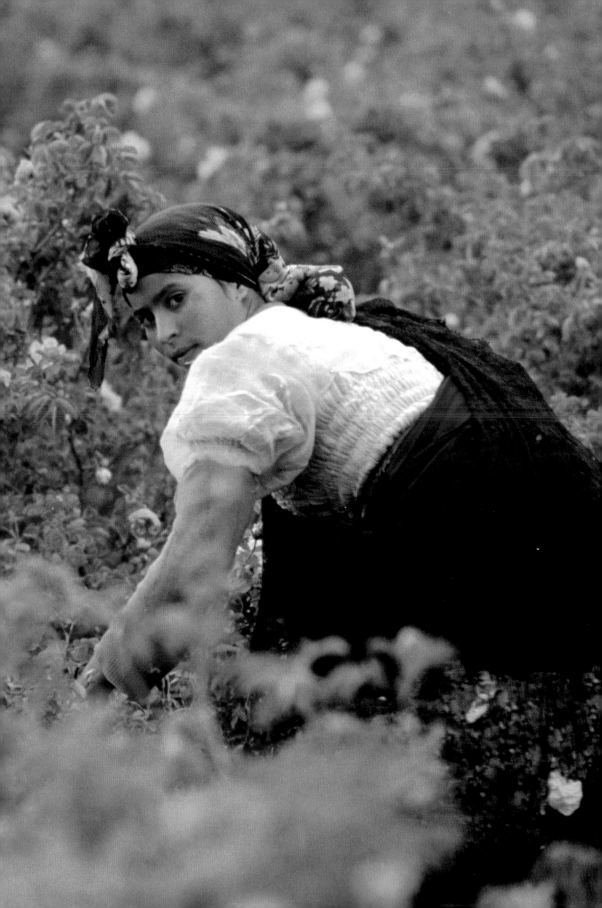

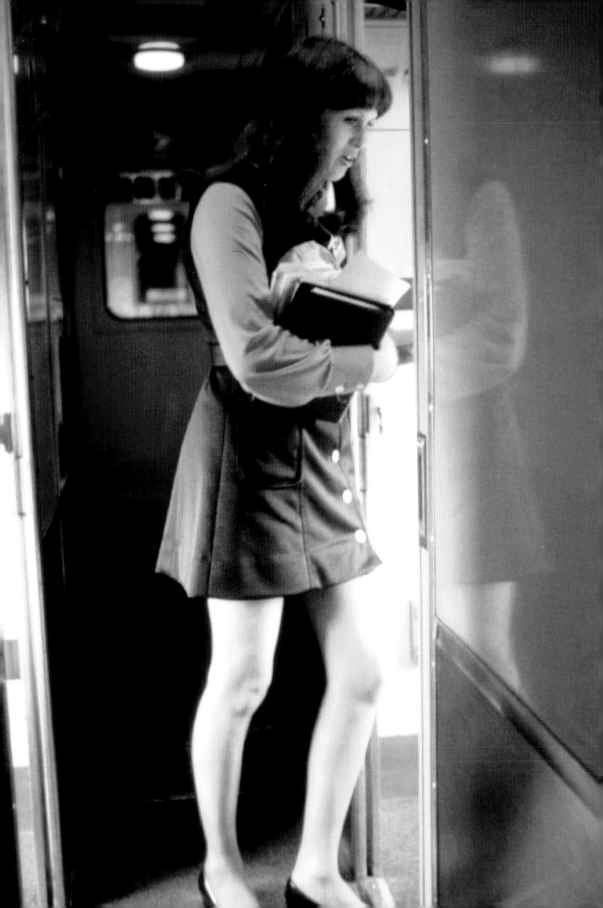

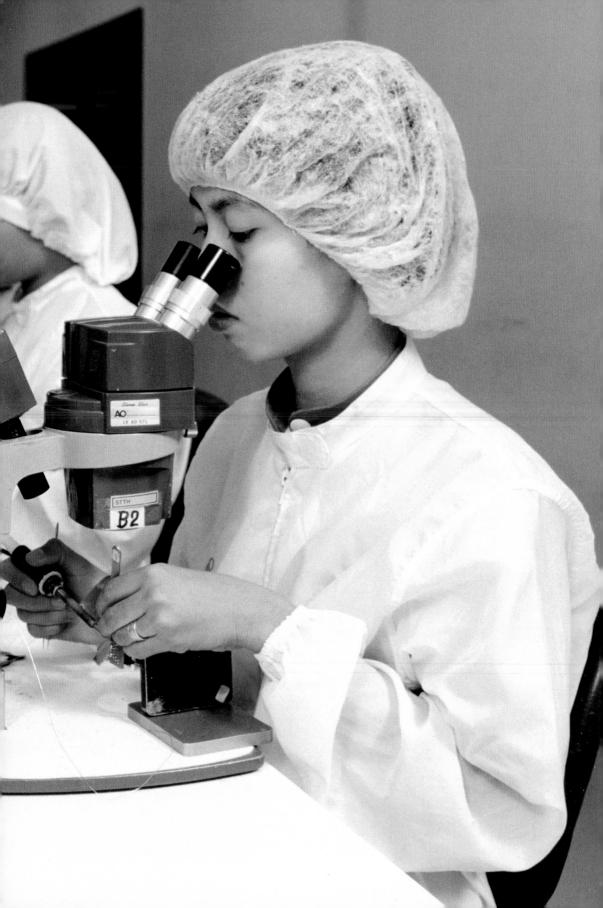

FOREWORD

Roxane Gay

Regulating how women dress, both in and out of the workplace, is nothing new. In ancient Greece, an appointed group of magistrates, *gynaikonomoi*, or "controllers of women," ensured that women dressed "appropriately" and managed how much they spent on their apparel, lest women dared to be extravagant in clothing themselves. The strict—and mandatory—codes were designed to remind women of their place in Greek society.

In the ensuing millennia, not much has changed. Throughout history, men have controlled women's bodies and their clothing by way of both social strictures and laws. This control has extended from how women appear in public to what women wear in school. It wasn't until the passage of Title IX in 1972 that schools were no longer allowed to require girls and women to wear dresses.

Employers have long imposed dress codes on women in the workplace, demanding that women wear, for instance, high heels, stockings, makeup, and dresses or skirts of an appropriate but feminine and alluring length. Employers have also mandated how women should wear their hair. Women of color, and black women in particular, have faced discrimination in the workplace when they choose to wear their hair in natural styles or braids. Employers have also tried to constrain what women wear by discriminating against faith-based practices, barring, for example, Muslim women from wearing the hijab.

In the early twentieth century, women began entering the workforce en masse. But only women who worked in factories, on farms, or in other forms of manual labor had the flexibility to wear clothing like pants, which were traditionally considered men's apparel. Women who worked in offices had to wear the skirts, heels, and jewelry expected of their sex. This division would continue until the 1970s, when the influence of the sexual revolution made its mark.

opposite A scientist in a biotech laboratory. Thailand, c. 1987. previous overleaf (from left) A Berber girl gathers rose petals during the Rose Harvest in Dadès Valley. Kelaat M'Gouna, Morocco, 1989; A passenger service representative on an Amtrak train. Chicago, Illinois, 1974. pages 4–5 Women's League officers pose for a portrait. African American women's clubs focused on social and political reform issues in their communities. Newport, Rhode Island, c. 1900.

Though women still had to conform to social mores, they now had the freedom to consider personal comfort and style in what they wore in the workplace.

Throughout the 1980s and early 1990s, women often wore pantsuits, with broad shoulder pads prominently figured, like their male counterparts. In *Fashion Talks: Undressing the Power of Style*, author and professor Shira Tarrant notes that "with the dress for success and the yuppie era with Reagan in office, women were starting to get MBAs. They were going to crack the glass ceiling, and in order to do so, they wore the big shoulder pads and the shirts that have an homage to men's ties." Sometimes called power suits, these pantsuits allowed women to feel like they would be taken more seriously, like they could compete with their male counterparts by looking the part. Though this style soon fell out of fashion, a more contemporary version was embraced again by Democratic nominee Hillary Clinton in the 2016 presidential election, and the outfit became a rallying symbol for women eager to see a woman president in their lifetime.

Feminism has made incredible gains, and today, what women wear in the workplace is as varied as the work women do. Nonetheless, there is still so much work to be done. The patriarchal standards for women's appearances remain deeply embedded in our culture. In 2010, the Swiss bank UBS came under fire after word leaked of their forty-four-page dress code, replete with guidelines on applying makeup, keeping toenails trim to avoid tearing stockings, avoiding overly tight shoes that might cause women to have "strained" smiles, avoiding fitted clothing that overly accentuates the female form, and wearing flesh-toned underwear so that a woman's underclothes remain a matter of discretion rather than spectacle.

Only in 2012 were women in the Royal Canadian Mounted Police allowed to wear pants on full dress occasions. In 2017, the United States congressional dress code still banned women— both congressional staffers and visitors, such as journalists—from wearing sleeveless tops or open-toed shoes. A journalist was even turned away from a room outside the House Chamber because her outfit, which bared her arms, was deemed "inappropriate." That same year, President Donald J. Trump, according to a source, declared that female staffers in the White House should "dress like women."

While most employers also have dress codes for men, requiring them to wear suits and ties, keep their hair and beards trimmed, and so on—those codes symbolize a notion of professionalism rather than cultural expectations of masculinity. As in so many things, the rules are different for women. To dress like a woman is to dress in very prescribed ways that enhance a rigid brand of femininity and cater to the male gaze. To dress like a woman suggests that women are merely decorative elements in the workplace. To dress like a woman is to ignore that women are individuals who have independent and diverse notions of how they wish to present themselves to the world.

I've never been good at dressing like a woman. I stopped wearing dresses when I was twelve years old. I'm 6'3", so if I were to wear high heels, I would tower over people more than I already do. I only wear makeup if I really have to because, for whatever reason, I never quite learned how to do it myself. And when I was nineteen, I started getting tattoos up and down my arms—hardly the mark of traditional femininity. Throughout my early twenties, I held a series of odd jobs, and what I wore to work ranged from pajamas (when I worked from home) to jeans and black T-shirts (when I worked as a bartender). Toward the end of my twenties, I entered the traditional workplace and wore long-sleeved shirts to hide my arms, and dress slacks that I hoped conveyed my competence and professionalism. And always, I felt out of place because I was not dressing—and did not want to dress—like a woman in the expected sense. When I started writing professionally, I treated whatever I happened to be wearing—often, a casual T-shirt and more pajama pants or jeans—as my work clothes.

In graduate school, I assumed that when I became a professor, I was going to have to wear suits to work, that I was going to have to look the part of someone with a PhD, someone qualified to lead a classroom. I quickly realized that there was no standard look to this part. I had colleagues who taught in dirty T-shirts and paint-splattered jeans. They were, as you might expect, men who knew their authority would not be questioned regardless of what they were wearing. My female colleagues, mostly younger and petite, always wore things like dressy blouses and blazers because they knew their authority *would* be questioned by virtue of their gender, stature, and clothing choices. As a tall woman of an imposing size in her early forties, I generally teach in jeans and long-sleeved dress shirts, sometimes overpriced T-shirts. I wear clothes that allow me to feel comfortable and confident. That is how I choose to dress like a woman.

No matter what I have worn to work, I've always been aware that the freedom to mostly wear what I want has been influenced, in large part, by the women who worked before me— women who, throughout history, refused to allow their ambitions to be constrained by narrow ideas of what it means to dress like a woman.

In this collection, you will see how women have dressed for their work, both in and beyond the traditional workplace. You will see how that dress has evolved as the role of women in contemporary society has evolved. And you will see that sometimes, dressing like a woman means wearing a pantsuit; other times, it means wearing a wetsuit, or overalls, or a lab coat, or a police uniform. Dressing like a woman means wearing anything a woman deems appropriate and necessary for getting her job done.

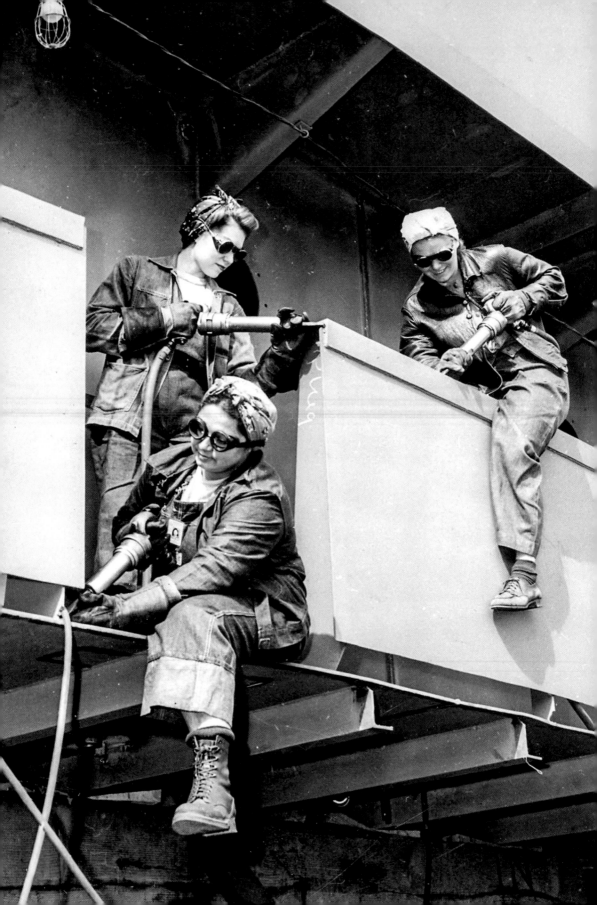

INTRODUCTION

Vanessa Friedman

When it was revealed, in early 2017, that newly installed president Donald J. Trump preferred the female members of his administration to "dress like women" in the office, the digital universe went predictably into meltdown mode. Twitter was overwhelmed by users posting photos of women dressed in the uniforms of their jobs: an astronaut, a soldier, a Supreme Court justice, a surgeon. A boxer, a tennis player, a fencer. A presidential candidate.

The point was, of course, that dressing like a woman means dressing however any woman wants to dress, and not just in the sheath dresses and heels modeled by his daughter, Ivanka, on the cover of her book *Women Who Work*. Though that counts, too.

Or at least that's how it seemed. But it was also clear that there was another, deeper truth underlying the response. Because this wasn't, after all, really a debate about what women wore—clothes on their own, enticing as they can be, cannot excite that kind of immediate passion. It was about what the clothes symbolized: the choices made, the dreams and aspirations implied, the contributions represented, the social progress (or not) made. It was about the fact that the question of female identity is illustrated in all its complexity by the question of what women wear to work.

Fashion has done its best to help navigate the changing tides of appropriate office dress, to define the look of power in all its myriad incarnations, from the factory floor to the C-Suite. But its role is largely as a mirror, reflecting back both the advances and the shifts to the side of its customers. In their choices the narrative lies.

This is why street style has become such a fascinating, booming genre: It creates a visual record of exactly those choices, authentically observed in real time on the daily commute. And it is why so many museum retrospectives devoted to the work of a woman often include

opposite **Chippers at the Marinship Corporation. Sausalito, California, 1942.**

sections on their wardrobes: not because the curators are trying to reduce their subject to the superficials of what she wore, but because those choices reveal a point of view on identity that is as accessible as, and perhaps even more recognizable than, any mission statement.

It's why Georgia O'Keeffe chose austerity and the telling detail as hallmarks of her clothes as well as her work, focusing on white and black, graphic contrast, subtly subverting expectations around gender. It's why dressing like a woman is so personal, even when it is professional.

It has always been this way.

Since the early twentieth century, as women migrated into the workforce in increasing numbers on waves of war and gender equality, penetrating every industry from aeronautics to Hollywood, the changing look of their employment has reflected and shaped the changing look of their gender: a constant duet of definition and redefinition. After all, what we wear telegraphs to the world around us who we are, and much of who we are is wrapped up in what we do.

This is true of men, too, of course, but because their options are so limited, and the judgment on their appearance so much less historically fraught, there is less room for creativity; less risk, but also less opportunity for change—in opinions and assumptions.

Clothing is uniform and armor, and in the workplace it represents the compromise between those two concepts as determined by the individual and as determined by the institution.

It can be as subtle as Supreme Court Justice Ruth Bader Ginsberg adding a lace jabot to her black judicial robes to signify her femininity and make the uniform of the bench her own, as unavoidable as the secretaries in *Mad Men* with their twinsets and their pearls (the mutating meaning of pearls could practically be a discourse unto itself, traced from the women of 1960s NASA through British Prime Minister Theresa May).

It can begin with necessity—women entering factories to take on the jobs that the men who had been shipped off to war could no longer do, and finding themselves in overalls and button-down shirts, trousers, and turbans—and evolve into an epiphany: an understanding of the freedom that comes with the ability to stride, the power that comes from practicality, and the way it can make all of life, not just the assembly line, easier. It can jump from there to the style of the silver screen (the menswear intellectual liberation and flirtation embodied by Marlene Dietrich) and then, in a few decades, to the store rails.

It can signify membership in a tribe, literally—see the robes of a Bedouin woman truck driver—or metaphorically. Think of the members of the female rock band The Runaways, not

to mention their fans, in their punky black. Think of the tight jeans of a lumberjack, the green scrubs of Doctors Without Borders worn with or without a colorful undershirt as a flag of off-duty sensibility.

It can take the form of a power shoulder, meant for breaking through preconceptions and gender prejudice. Or the assertive sapphire blue of a Bangladeshi garment worker's sari, refusing to be dismissed or blend into the background, insisting the individual be seen on the way to perhaps being heard.

But what the photos on the following pages demonstrate is that this essential interconnection is not limited to one kind of job, or one historical epoch, or one region of the globe; it is both universal and ubiquitous.

As a result, the evolving narrative of women in the world (as opposed to, say, women in the home) can be told in many ways through the photos of women at work—those we know, because they have been pioneers in their fields or have achieved extraordinary things, and those who remain unknown but whose influence has nevertheless radiated out to shape the attitudes and ideas of those around them. That narrative is commemorated in these records.

Who were we? Who are we? Where are we going? What does it mean to "dress like a woman"?

Both nothing and everything. Take a look.

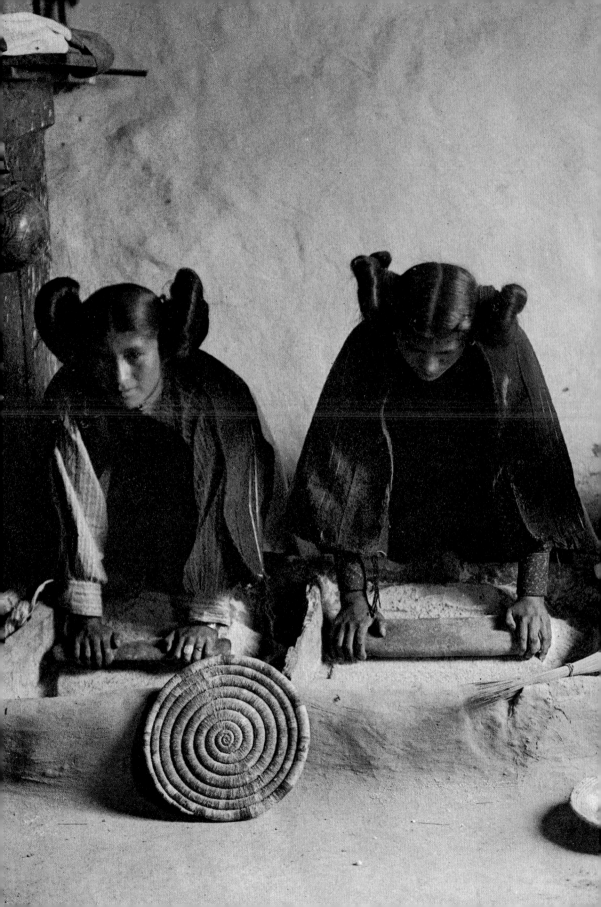

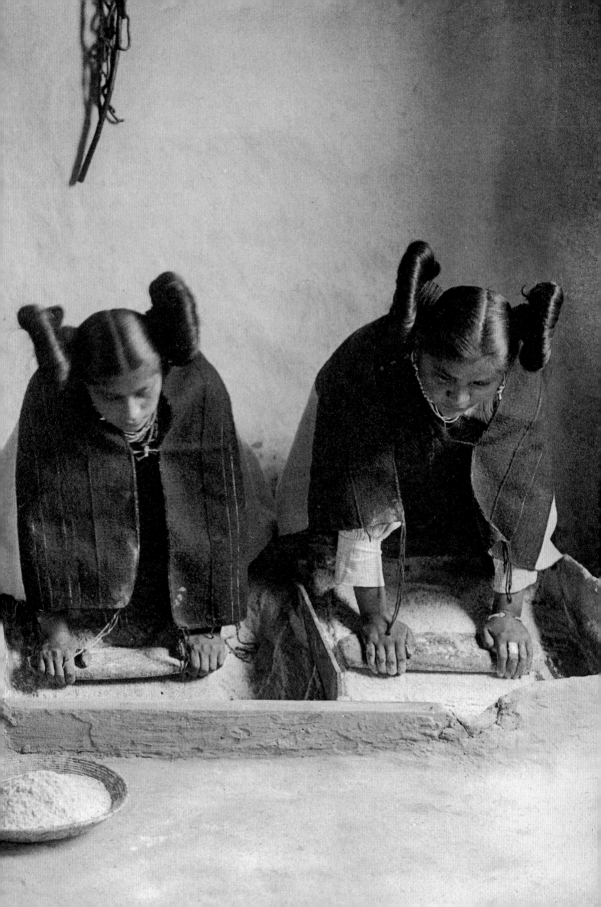

opposite Elder Lucy Smith, the founder of All Nations Pentecostal Church, the first Chicago church built by a female pastor, listens to the choir. Chicago, Illinois, c. 1941. previous overleaf Four young Hopi women grind grain. Arizona, c. 1906.

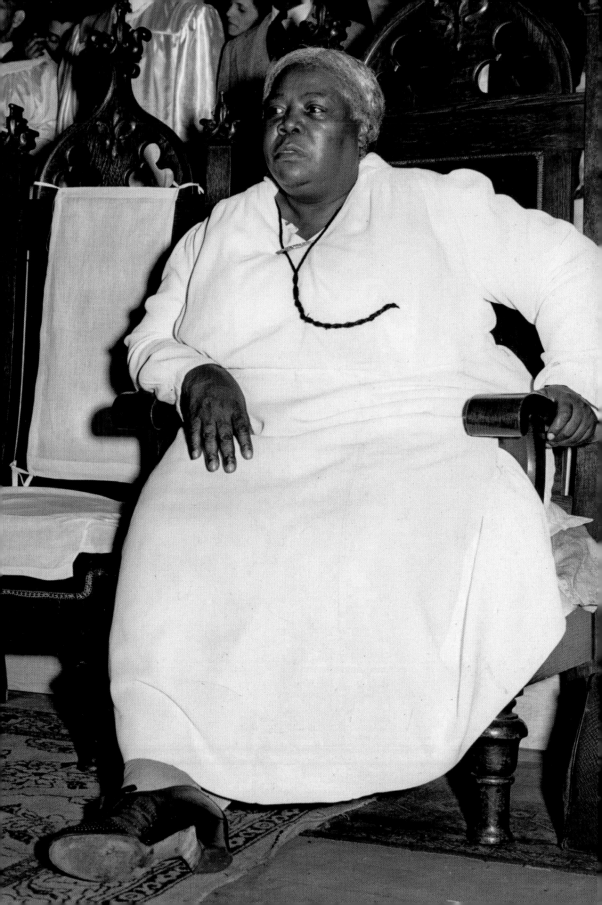

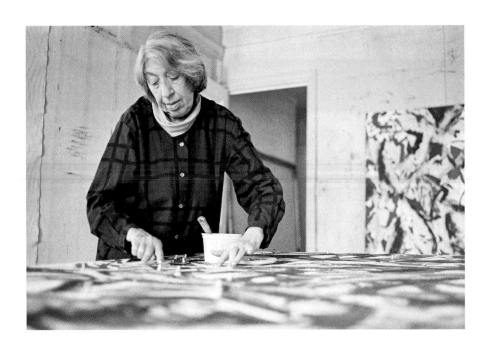

above Abstract expressionist painter Lee Krasner in her studio. New York City, New York, 1981.

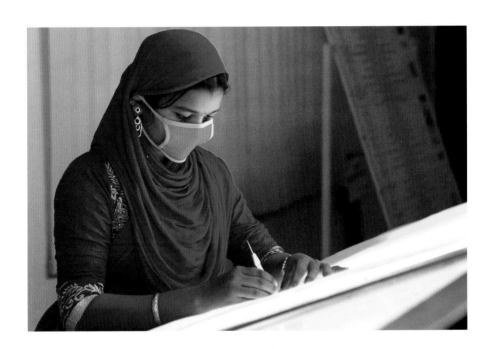

above A worker at a ready-made garment factory. Gazipur, Bangladesh, 2016.

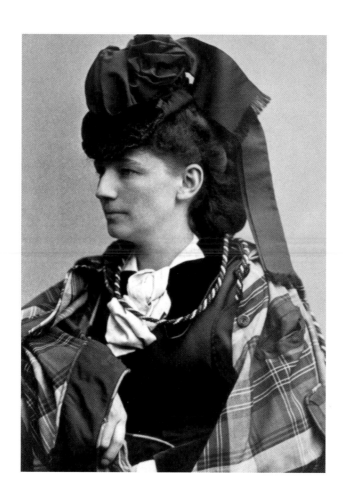

above Victoria Woodhull, America's first female presidential candidate. United States, c. 1870s.
opposite Christine Loh during her time in office as a Legislative Councillor. Hong Kong, China, 1993.
overleaf (from left) Guides at EXPO '70, the first world's fair held in Asia. Osaka, Japan, 1970; Education activist Malala Yousafzai onstage after being awarded the Nobel Peace Prize. Birmingham, England, 2014.

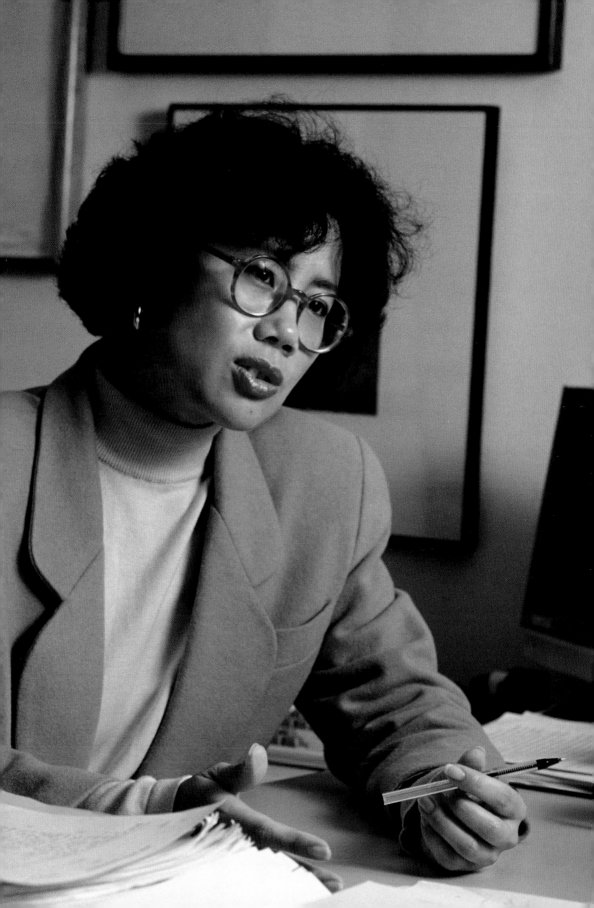

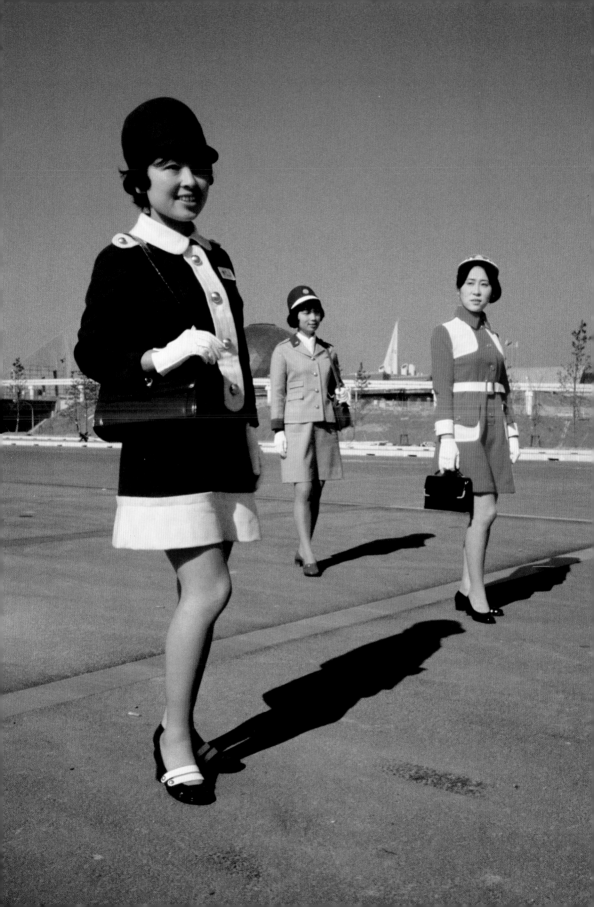

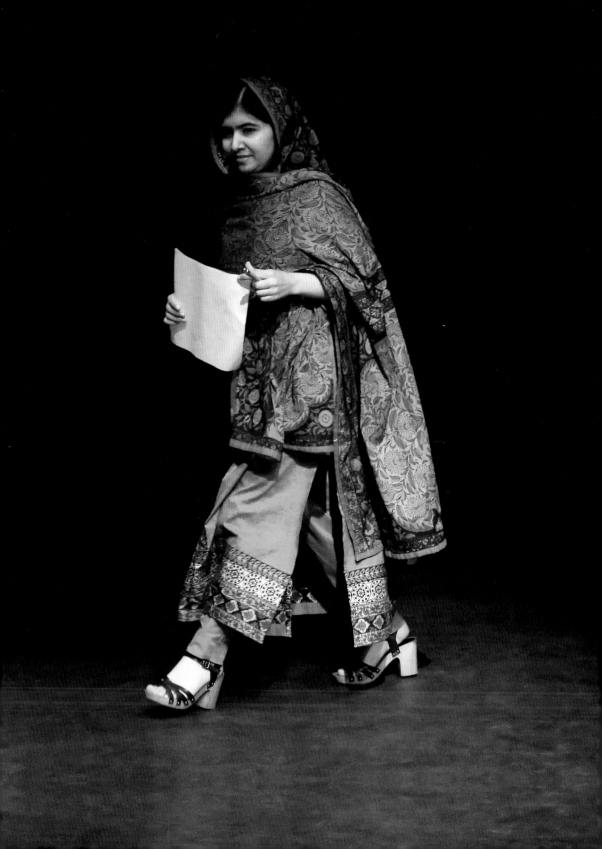

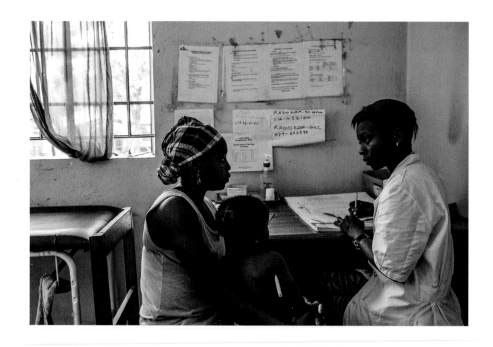

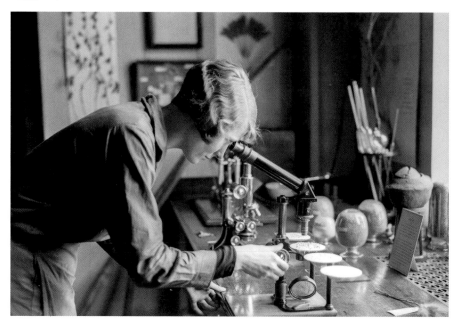

top A doctor provides free health services to a woman and her child at the Gondama Referral Center. Bo District, Sierra Leone, 2014. bottom A woman conducts plant research in a laboratory. England, 1934. opposite An art conservator at the Louvre Museum assesses the condition of one of the collection's works and repairs some of its damaged areas. Paris, France, 1980.

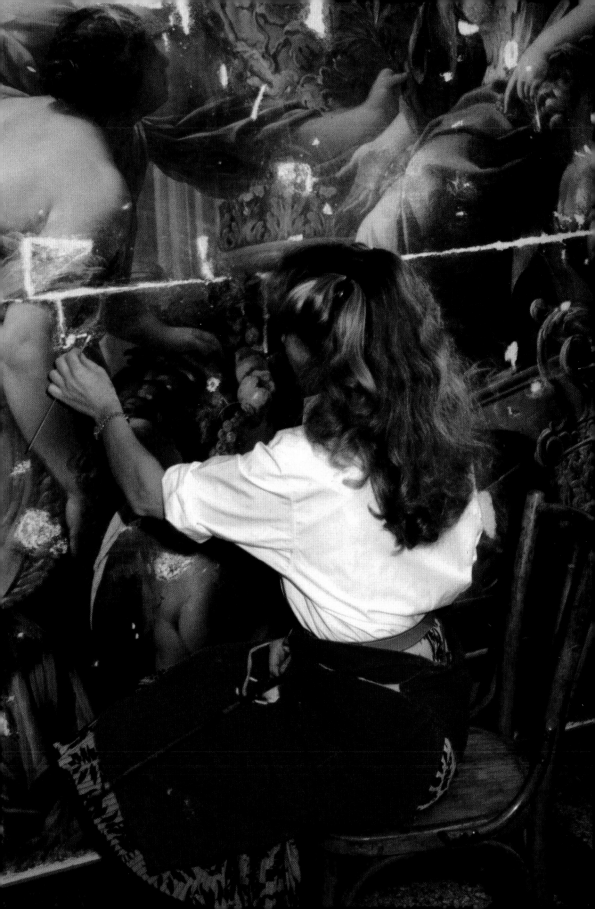

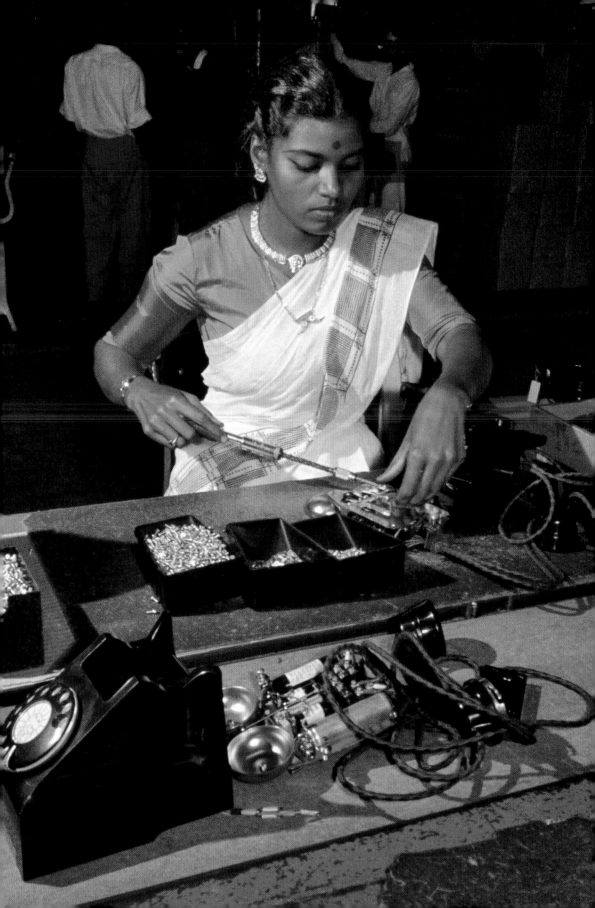

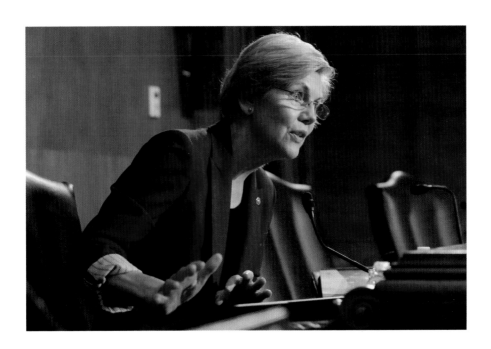

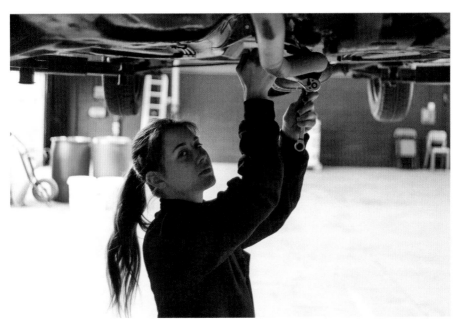

top Massachusetts senator Elizabeth Warren. Washington, D.C., 2014. bottom A mechanic fixes a car in an auto repair shop that caters exclusively to female customers. The shop provides prospective mechanics with hands-on classes and offers clients a massage or manicure while they wait for their cars. Saint-Ouen-l'Aumone, France, 2014. opposite A technician assembles a telephone. Bangalore, Karnataka State, India, 1962.

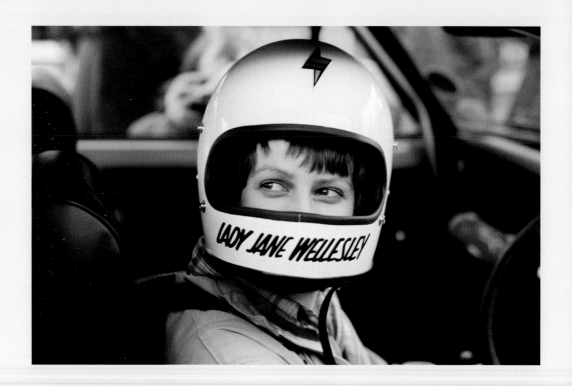

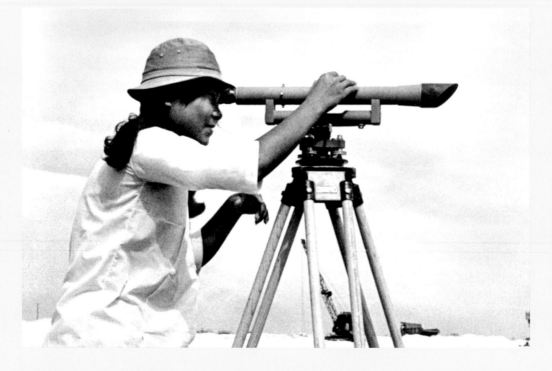

top British socialite and racing driver Lady Jane Wellesley in her racecar. England, c. 1975. bottom An engineer from a Vietnamese civilian construction crew surveys a construction site for new roads through a theodolite. Da Nang, Vietnam, 1969.

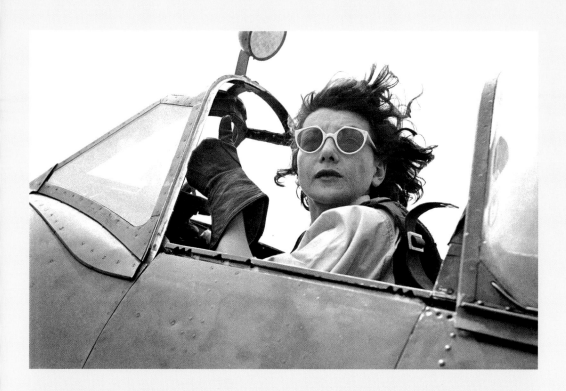

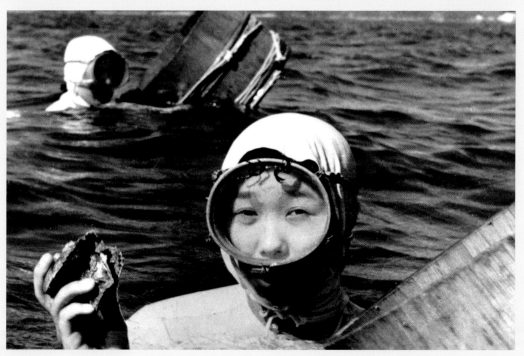

top A ferry pilot for the Air Transport Auxiliary sits in the cockpit of a Supermarine Spitfire fighter. Castle Bromwich, England, 1944. bottom Young pearl divers collect oysters. Japan, 1959.

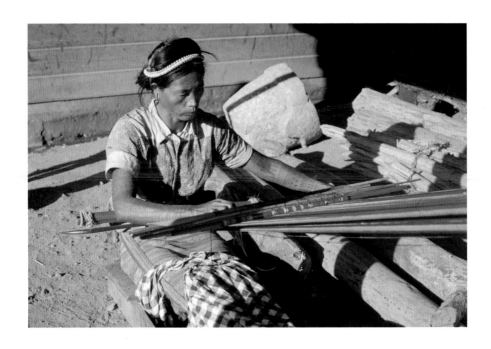

above A peasant woman weaves with colorful yarn in front of a workshop. Bontoc, Philippines, 1950.
opposite A motor transport driver from the Women's Royal Navy Service repairs her car engine.
England, 1943.

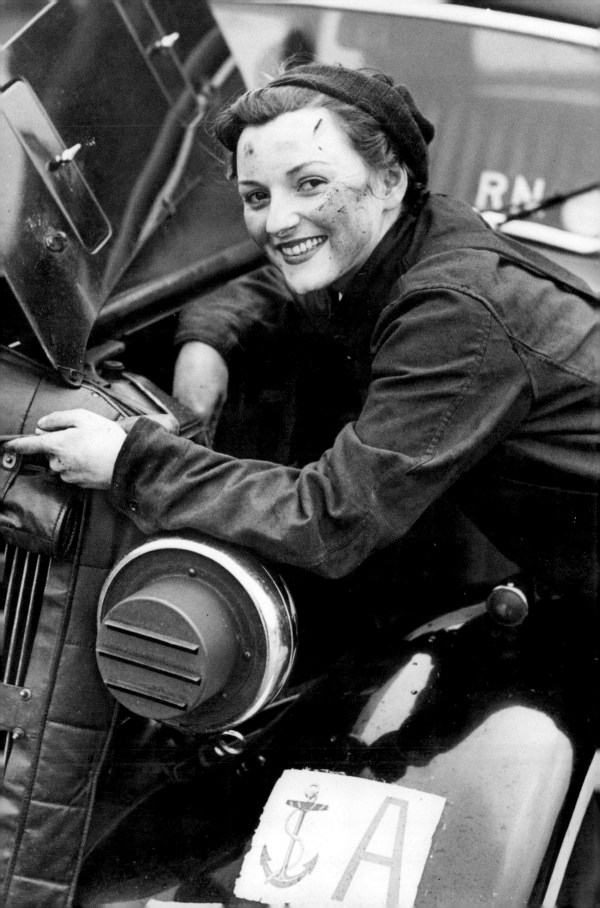

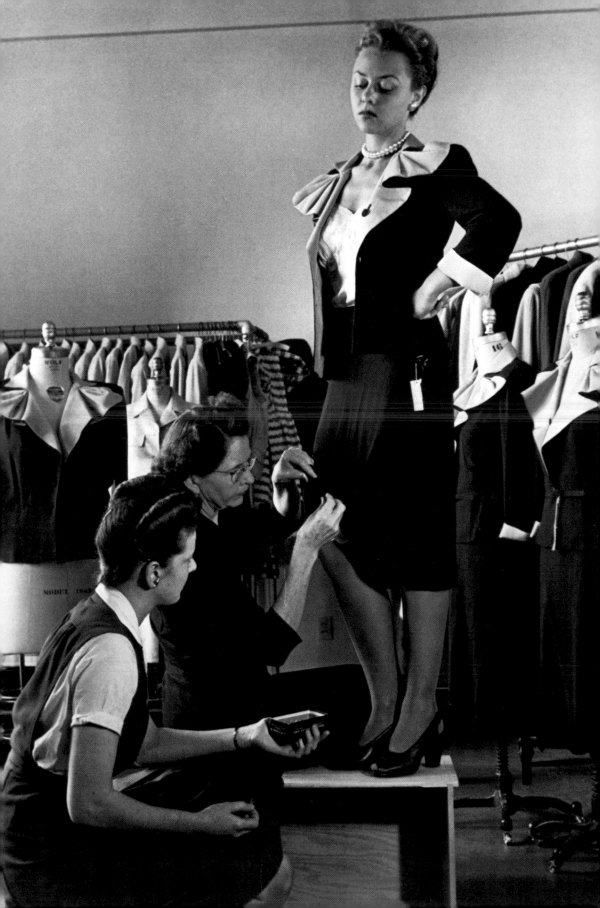

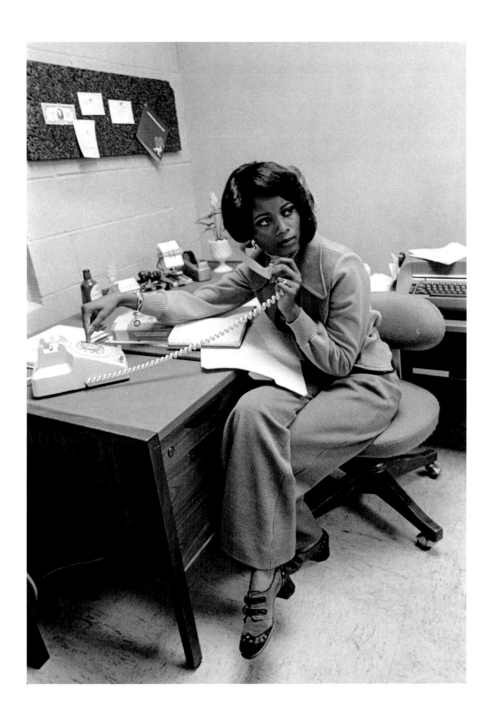

above An officeworker takes a phone call. United States, c. 1975. opposite A Neiman Marcus saleswoman alters a customer's hemline. Dallas, Texas, 1960.

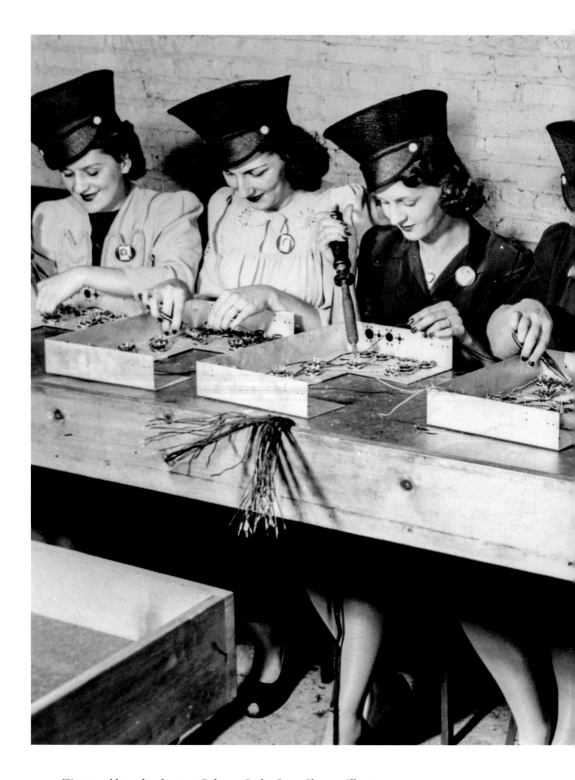

above Women solder radio chassis at Belmont Radio Corp. Chicago, Illinois, 1922.
overleaf Women and a child carry clay water jugs on their heads. Near Anuradhapura, Sri Lanka, 1965.

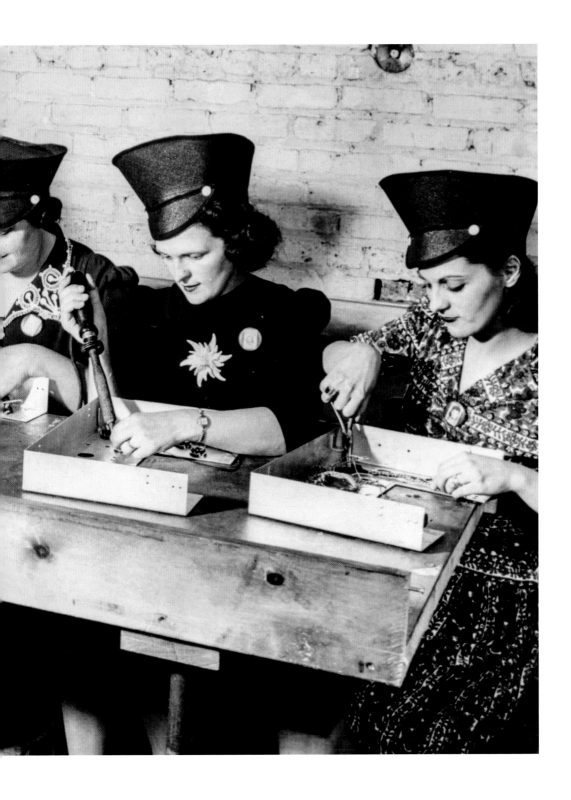

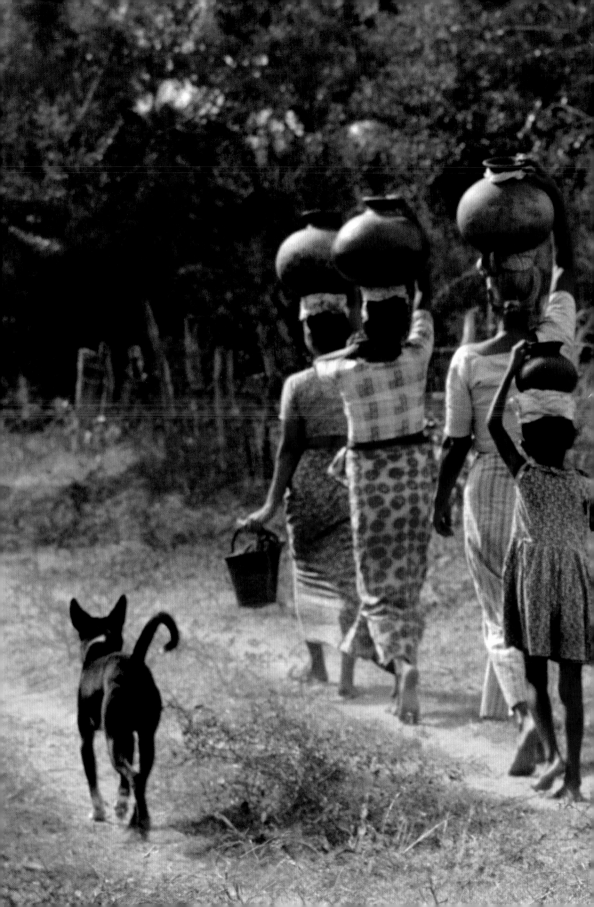

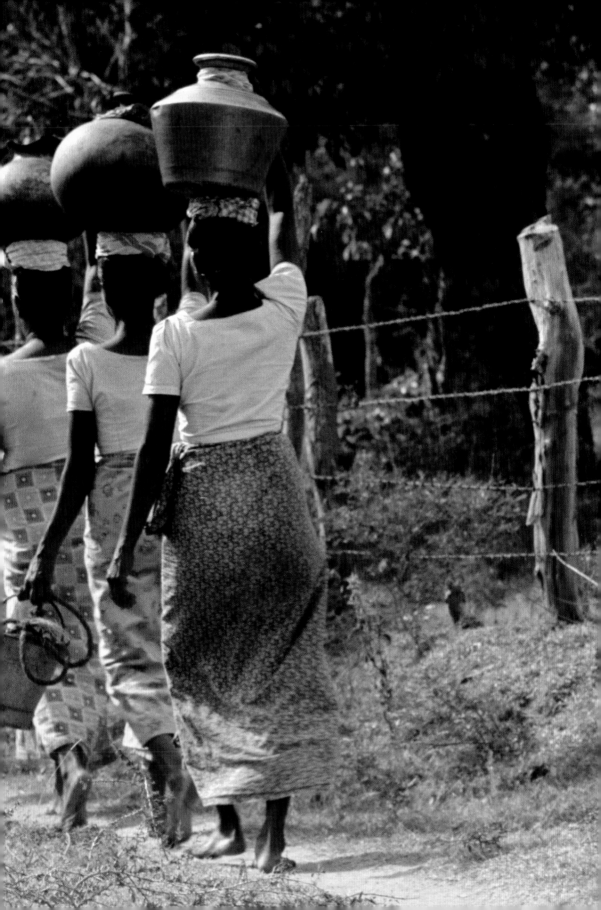

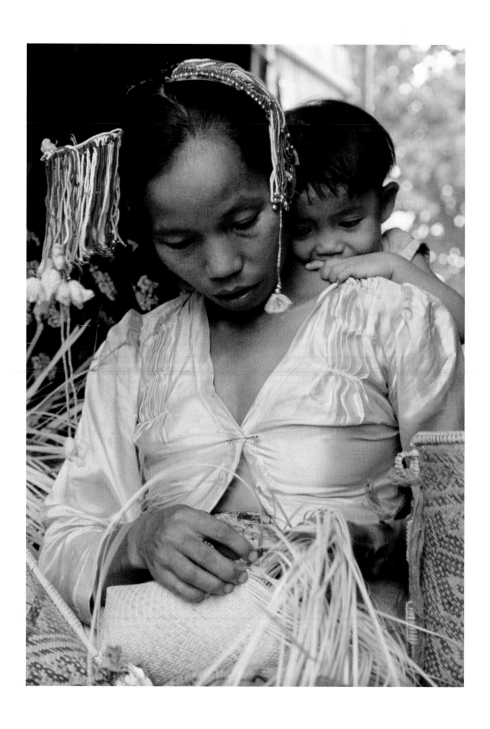

above A child looks over his mother's shoulder as she weaves a basket. Keningau, Malaysia, 1962.

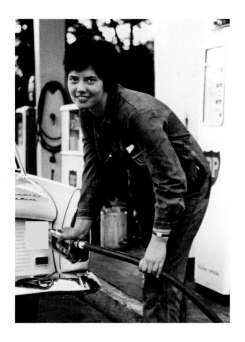

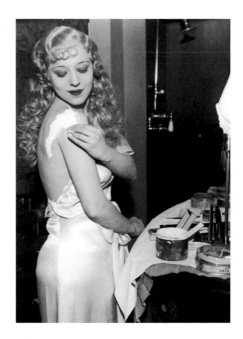

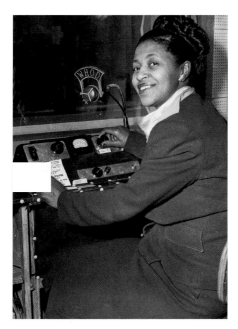

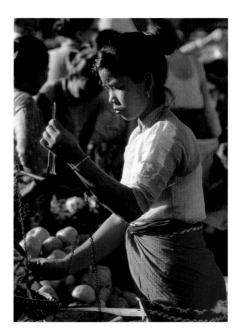

clockwise (from top left) A BP petrol station employee refuels a car. Germany, 1961; American burlesque dancer Sally Rand applies grease paint to her shoulder in preparation for her famous ostrich-feather fan dance. United States, c. 1935; A produce vendor weighs a pan of arrowroot. Rangoon, Burma, 1961; WHOD disc jockey Mary Dee poses at the station. Pittsburgh, Pennsylvania, 1951.

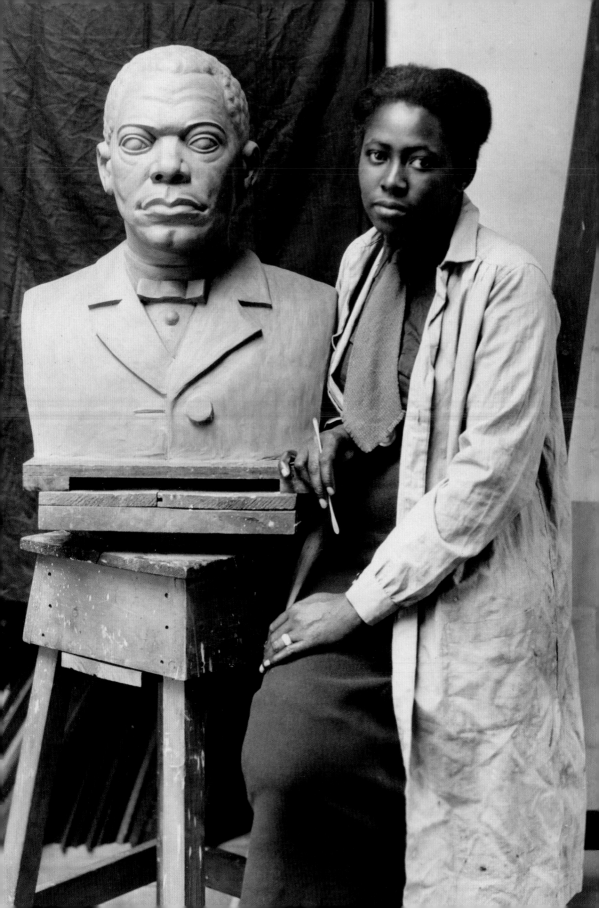

opposite Selma Burke, a sculptor and member of the Harlem Renaissance movement, with her bust of Booker T. Washington. New York City, New York, c. 1935.

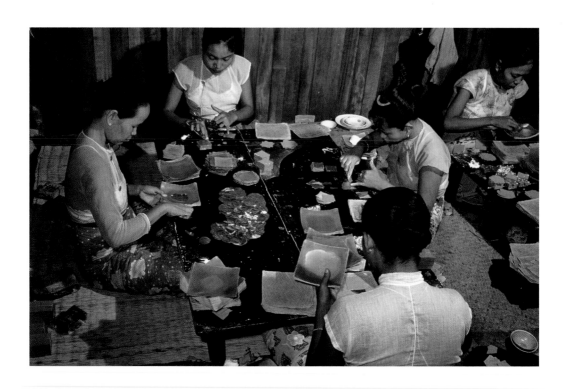

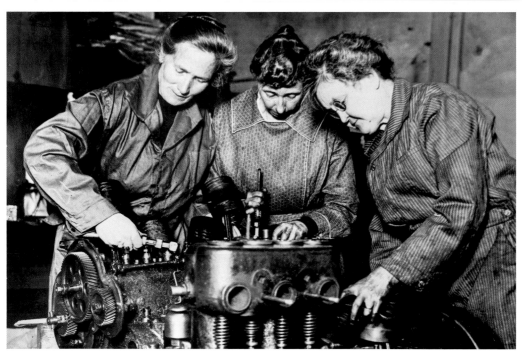

top Women place thin gold metal foil into protective folders. Mandalay, Burma, 1959.
bottom Auto mechanics repair an engine. Los Angeles, California, c. 1915–1920.

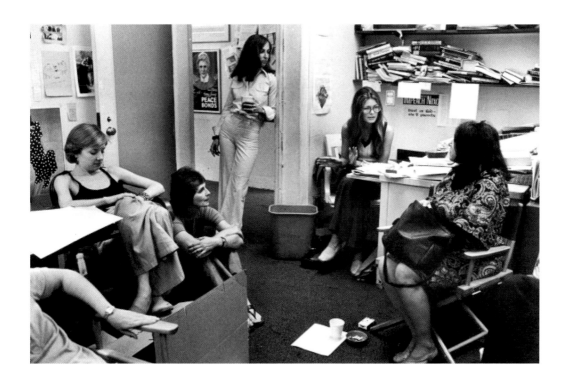

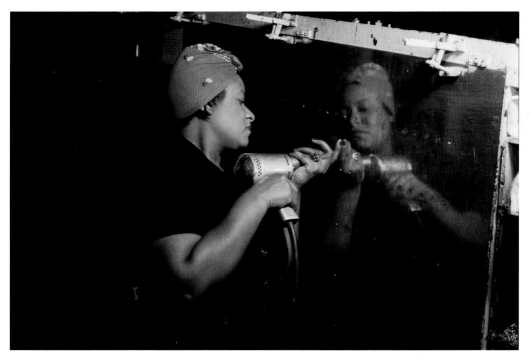

top Gloria Steinem (second from right) and her staff at a meeting in the *Ms.* magazine offices. New York City, New York, 1975. bottom A woman operates a hand drill in the construction of a *Vengeance* dive bomber at the Vultee Aircraft plant. Nashville, Tennessee, 1943.

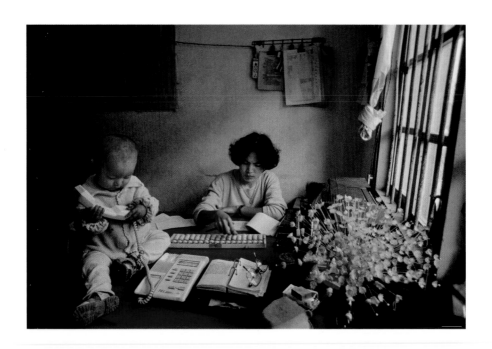

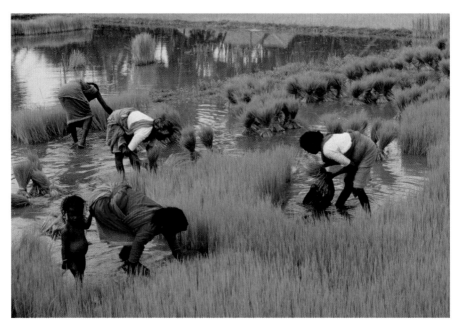

top A woman uses an abacus as she keeps books in her family's grain shop. Yunnan Province, China, 2007.
bottom Women gather rice seedlings for transplanting. Near Tiruchchirappalli, Tamil Nadu State, India, 1962.
opposite A Bedouin woman drives her tribe's water truck. Riyadh, Saudi Arabia, 1986.

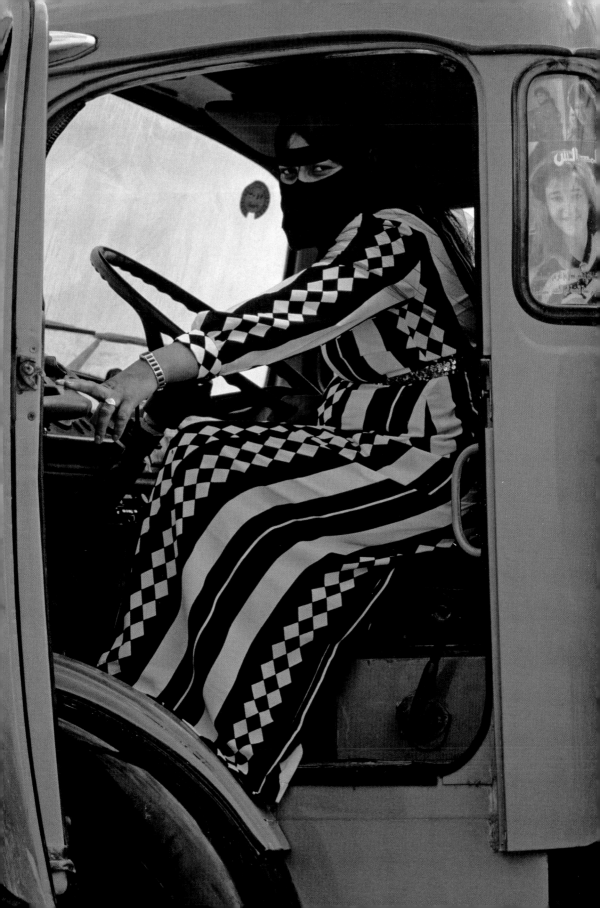

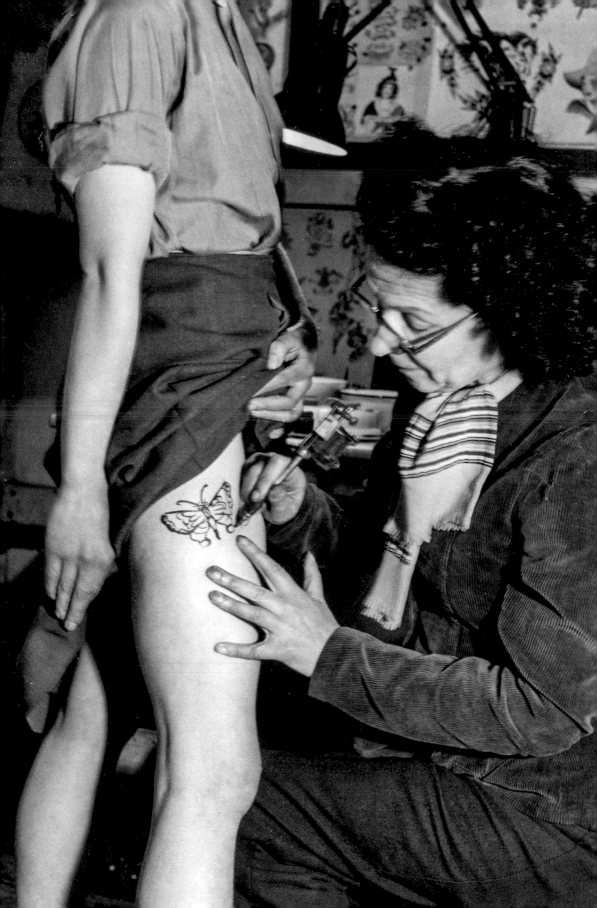

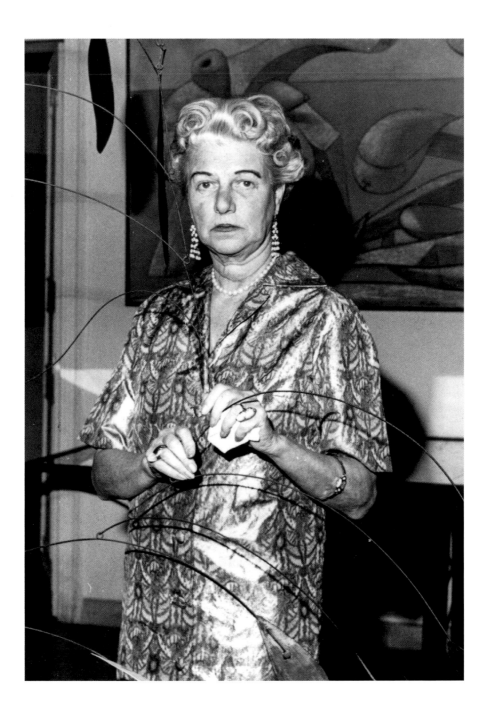

above American art collector Peggy Guggenheim. Venice, Italy, 1964. opposite Jessie Knight, the first female tattoo artist in Britain, tattoos a butterfly onto a female customer. Aldershot, England, c. 1940s.

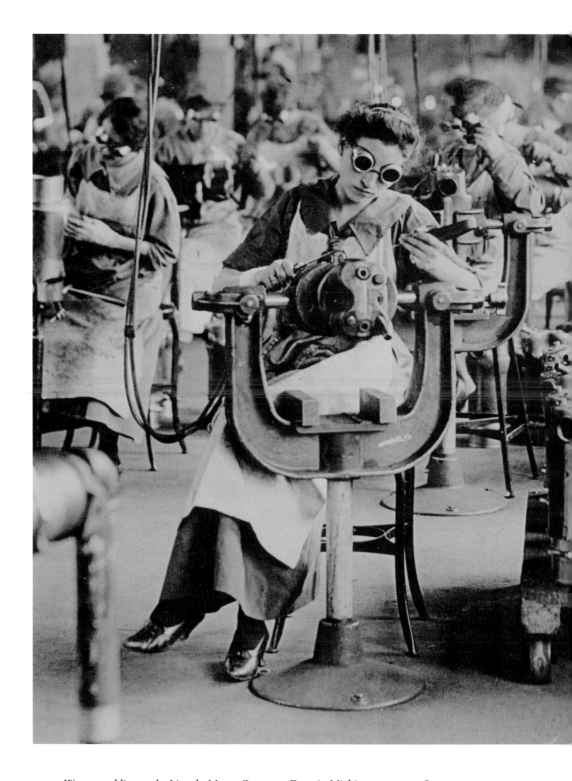

above Women welding at the Lincoln Motor Company. Detroit, Michigan, c. 1914–1918.

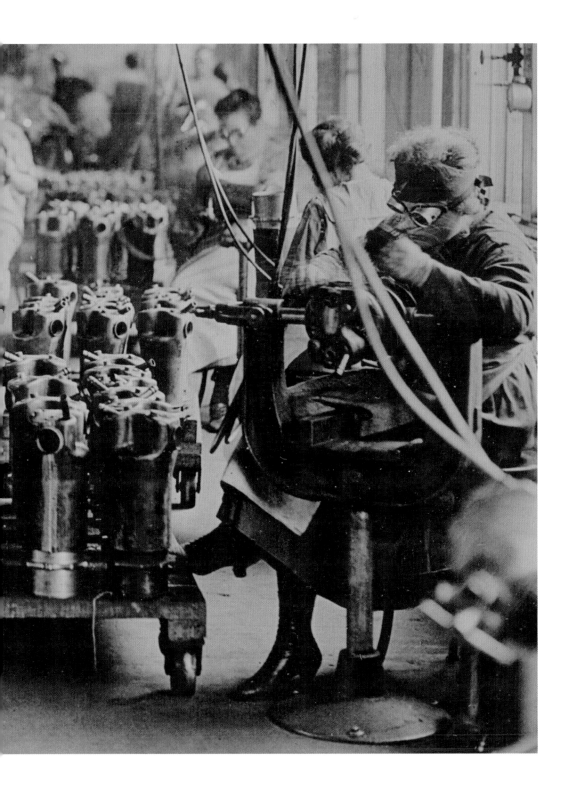

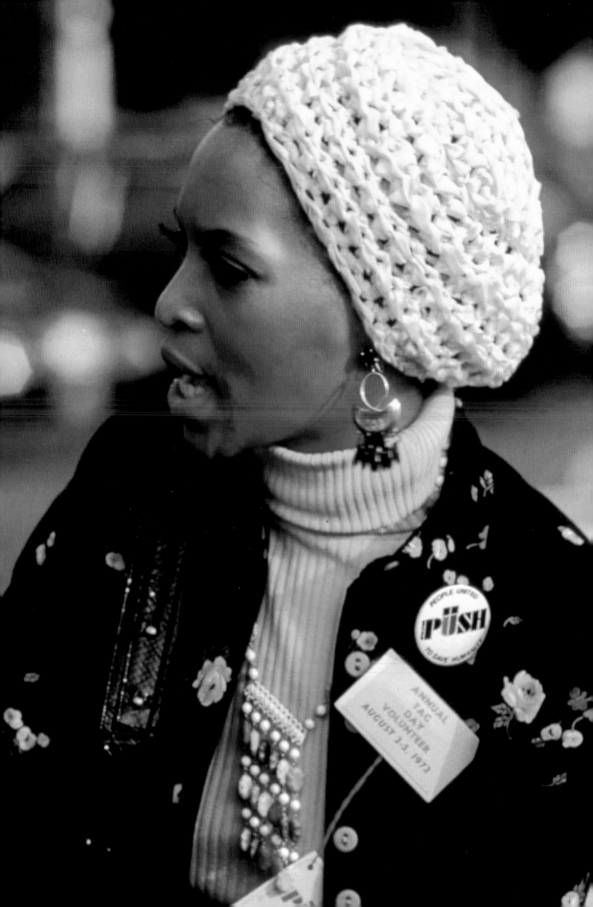

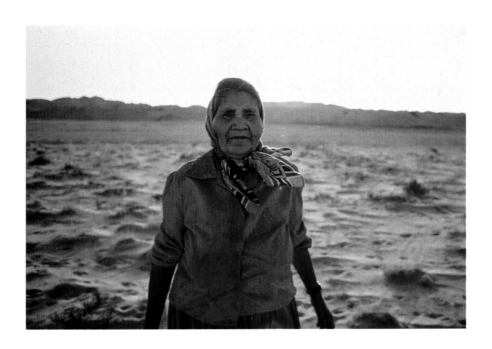

above A Navajo sheepherder. San Juan County, New Mexico, 1972. opposite A volunteer at the Operation PUSH (People United to Save Humanity) Black Expo, an annual black businesses and cultural trade exposition. Chicago, Illinois, 1973.

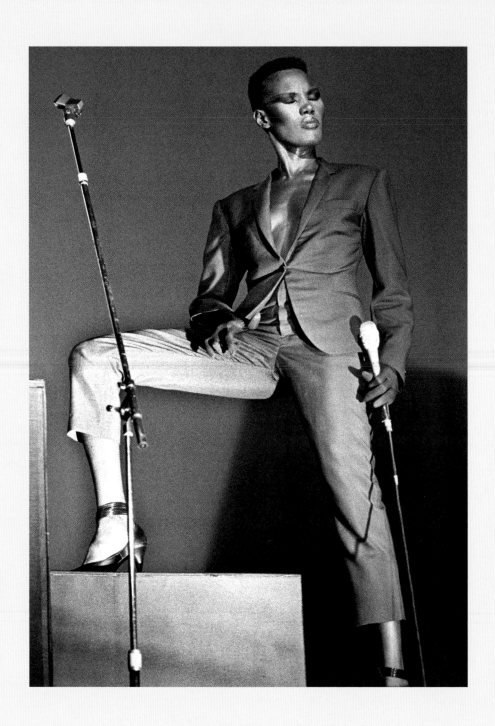

above Actress and musician Grace Jones poses onstage. Amsterdam, Netherlands, 1981.

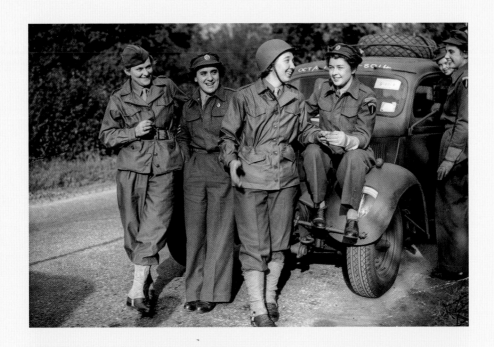

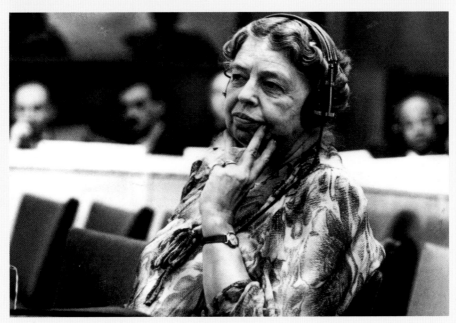

top Two members of the American Women's Auxiliary Army Corps with members of the British Auxiliary Territorial Service. These women were among the first to drive their own vehicles through France. Paris, France, 1944. bottom Former First Lady and United Nations representative Eleanor Roosevelt attends a conference at the temporary United Nations headquarters. Lake Success, New York, 1946.

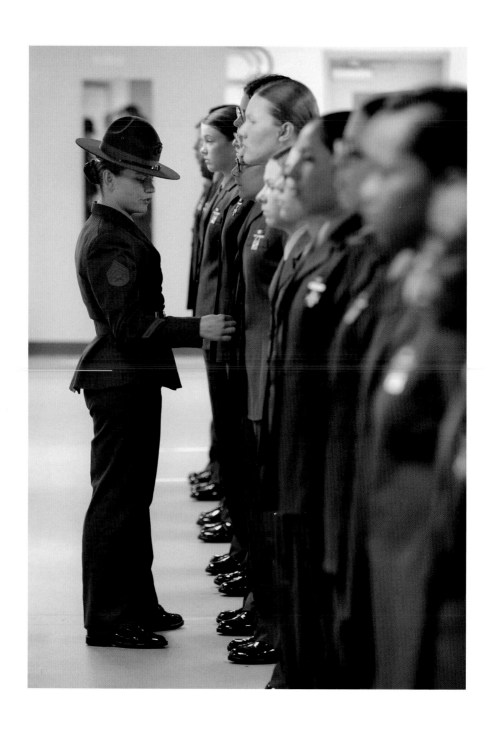

above A U.S. Marine drill instructor inspects her female recruits during Marine Corps boot camp. Parris Island, South Carolina, 2004.

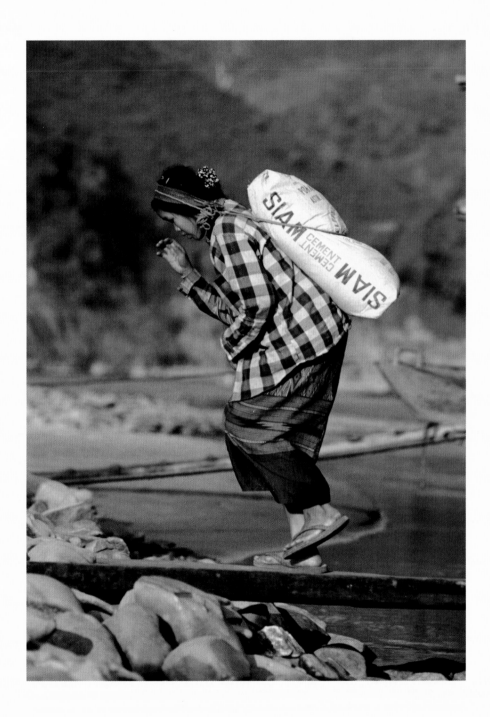

above A woman totes a 110-pound sack of cement home to her small village, where it will be used to help build a new school. Sainyabuli Province, Laos, 1999. overleaf Olympic sprinter Wilma Rudolph runs across the finish line and wins the first of three gold medals—the first American woman to achieve this feat—in the 100-meter dash at the 1960 Summer Olympics. Rome, Italy, 1960.

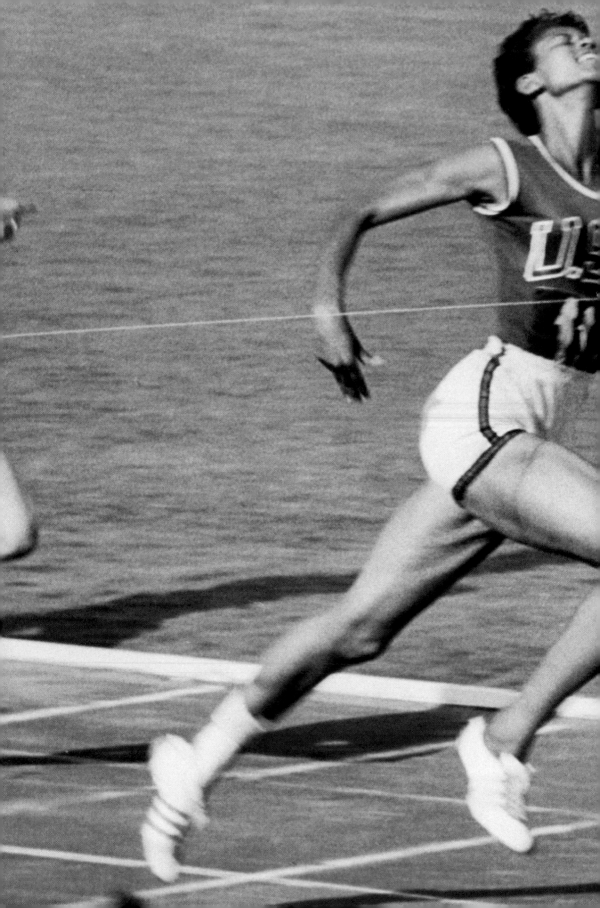

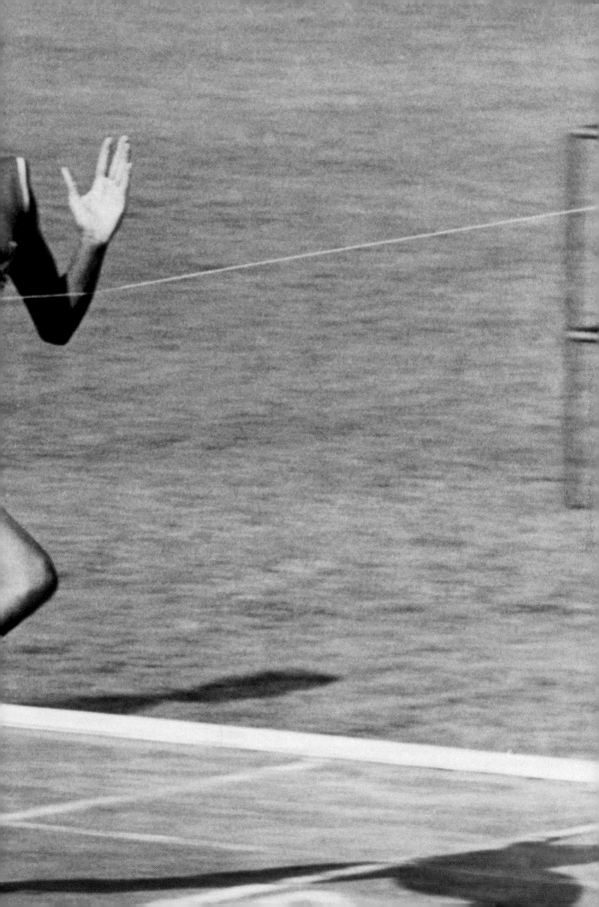

opposite A woman digs fields on a mountainside. Mexico, c. 1955.

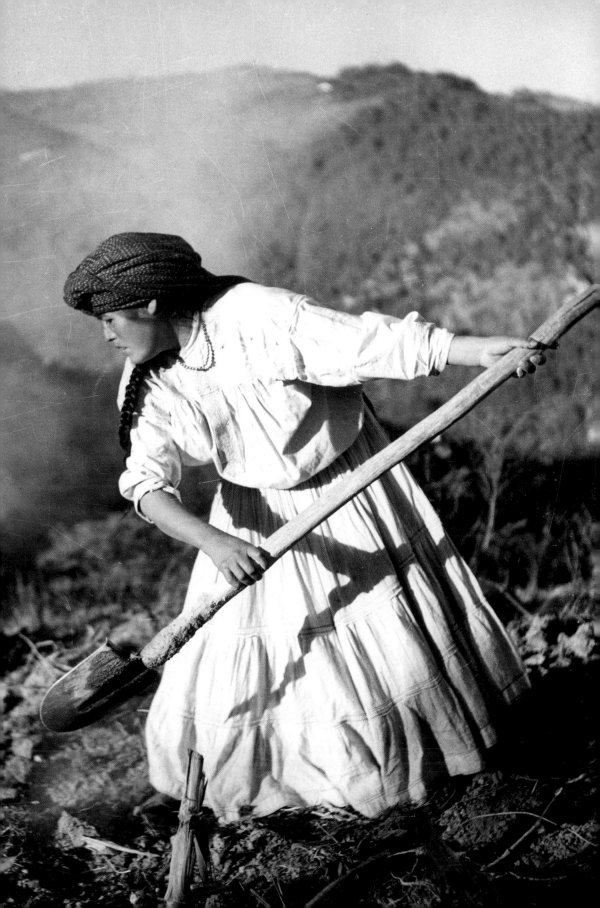

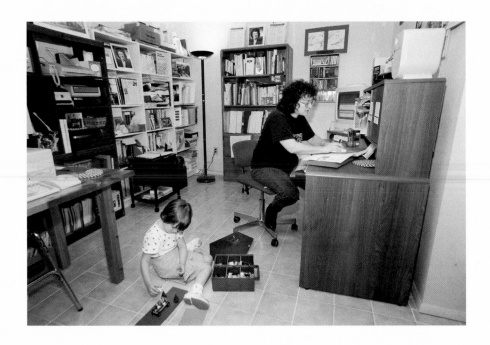

above A mother works in her home office while her daughter plays with toys. Lorton, Virginia, 1997.

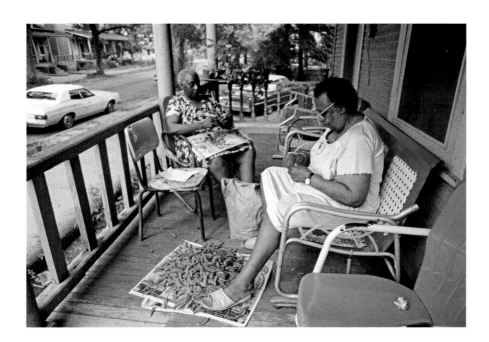

above Two family members shell peas on their porch. Savannah, Georgia, 1983.

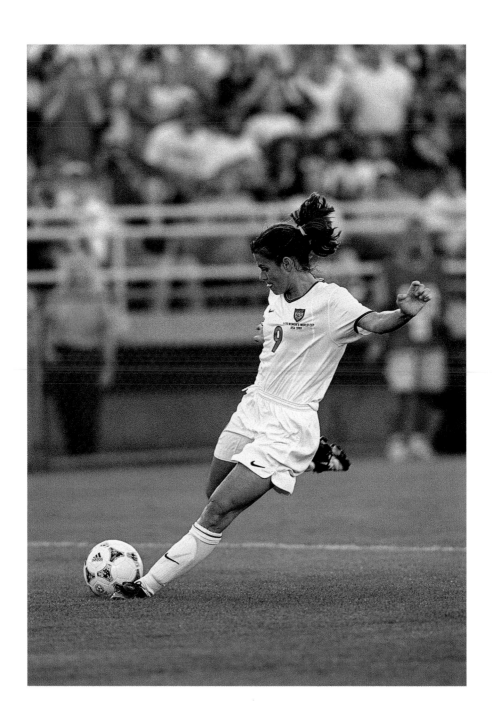

above Professional soccer player and Olympic gold medalist Mia Hamm. Chicago, Illinois, 1999.
opposite A Max Factor beautician paints seams on a woman's legs to create the illusion of stockings.
Stockings shortages were common during World War II, and the scarcity of clothing materials and beauty
products meant women had to resort to tricks like this one. United Kingdom, 1940.

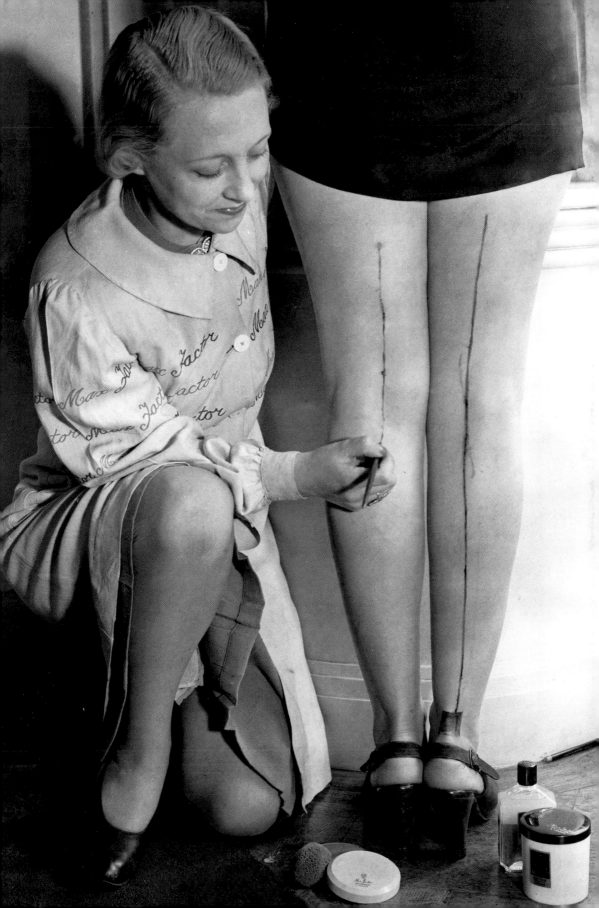

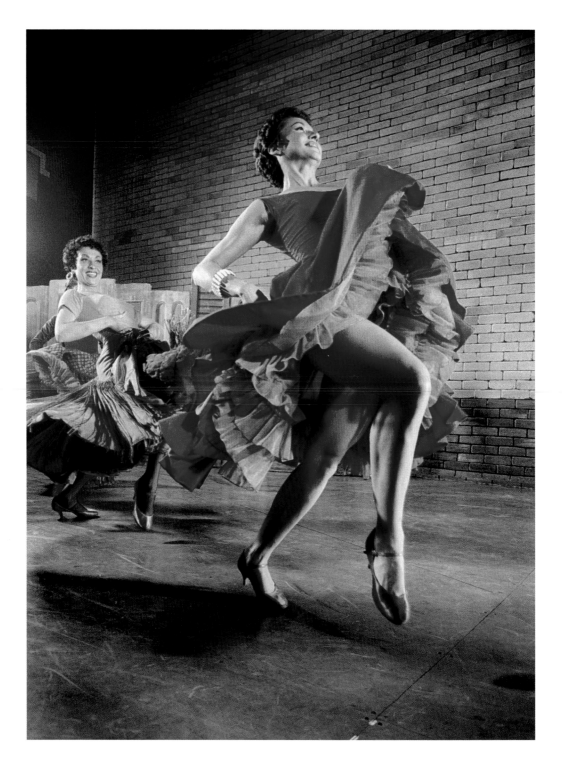

above Actresses Chita Rivera (right) and Liane Plane (left) dance in a scene from the original Broadway production of *West Side Story*. New York City, New York, 1957.

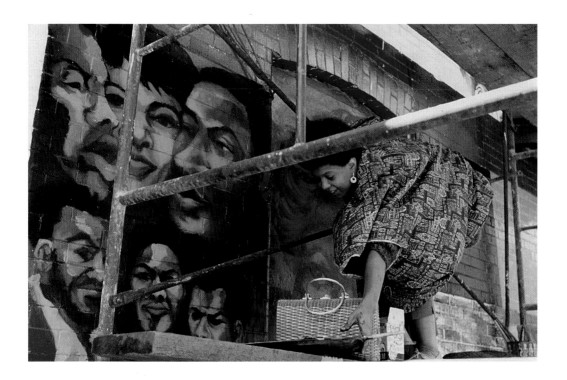

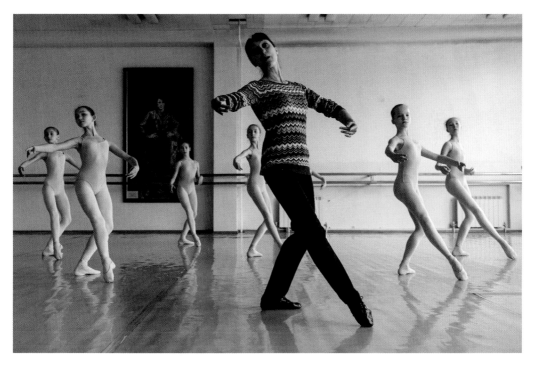

top Artist Barbara Jones-Hogu paints *The Wall of Respect*, a mural in Chicago's South Side celebrating black artists in the theater world. Chicago, Illinois, 1967. bottom Students follow their instructor in a classical ballet class. Novosibirsk, Russia, 2017.

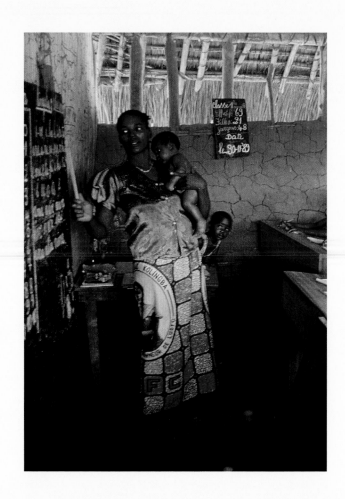

above A schoolteacher leads her class. Busu-Efuta, Democratic Republic of Congo, c. 1989.

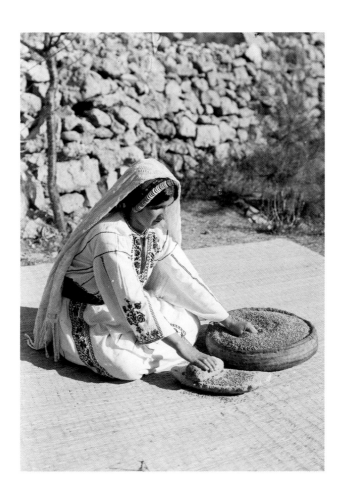

above A woman hand-mills grain. Jerusalem, c. 1898–1946.

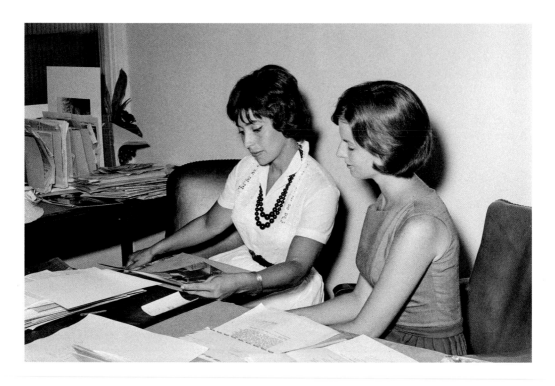

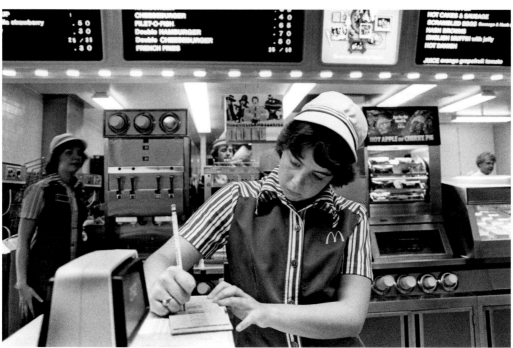

top First Lady Jacqueline Kennedy's press secretary Pamela Turnure (right) with a foreign correspondent in the White House. Washington, D.C., 1961. bottom An employee at the counter of a McDonald's restaurant. Southfield, Michigan, 1978.

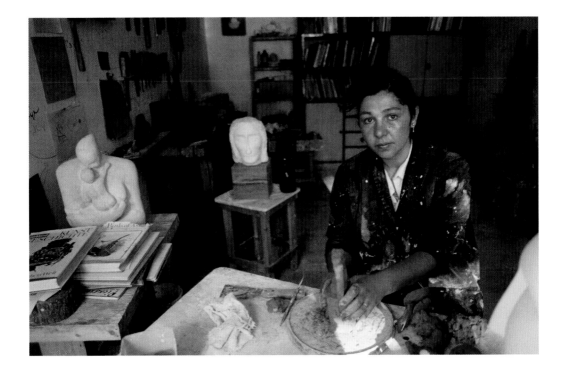

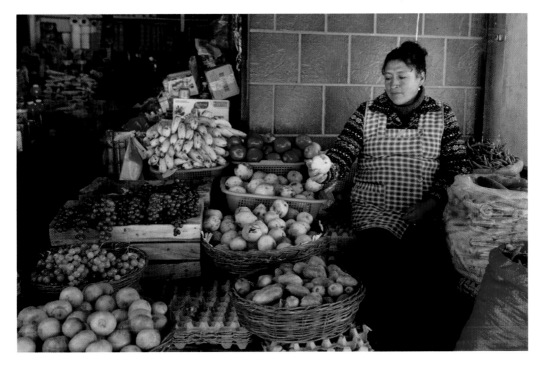

top Iranian sculptor Simin Ekrami in her studio. Tehran, Iran, 1990. bottom A woman sells fruit at the market. Sacaca, Bolivia, 2016.

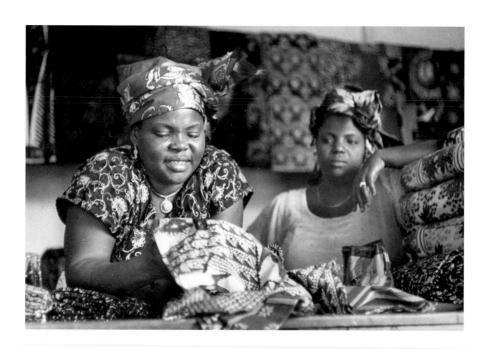

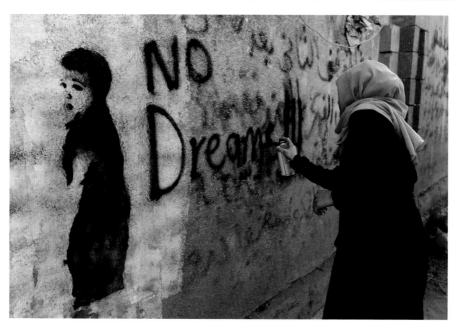

top Prominent merchant and philanthropist Mary Nzimiro shows a bolt of cloth to a customer while an employee looks on. Port Harcourt, Nigeria, 1953. bottom A woman completes a mural for the Yemeni capital's annual Open Day of Art. Sana'a, Yemen, 2017. opposite A factory employee seals tins of nonindustrial vegetable oil. Encrucijada, Cuba, 2010.

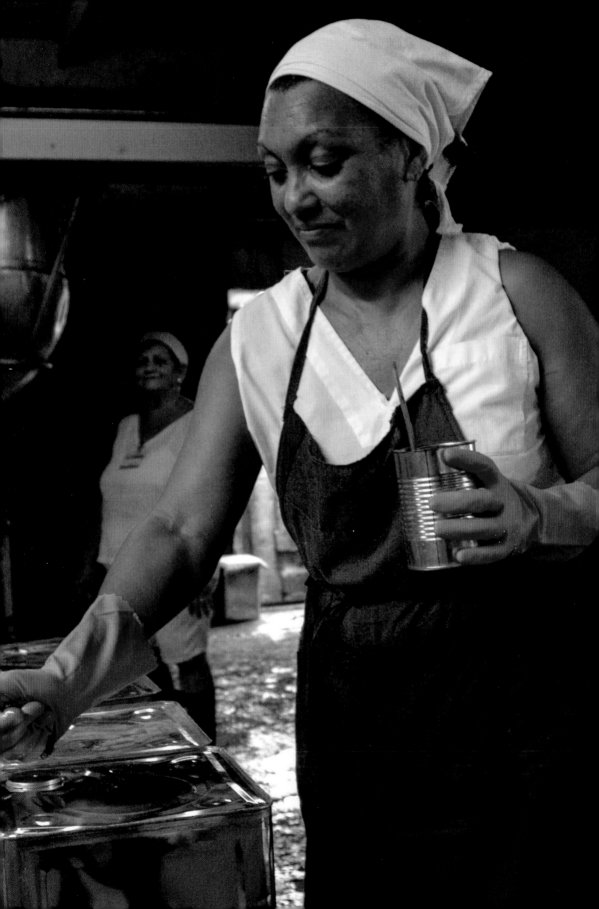

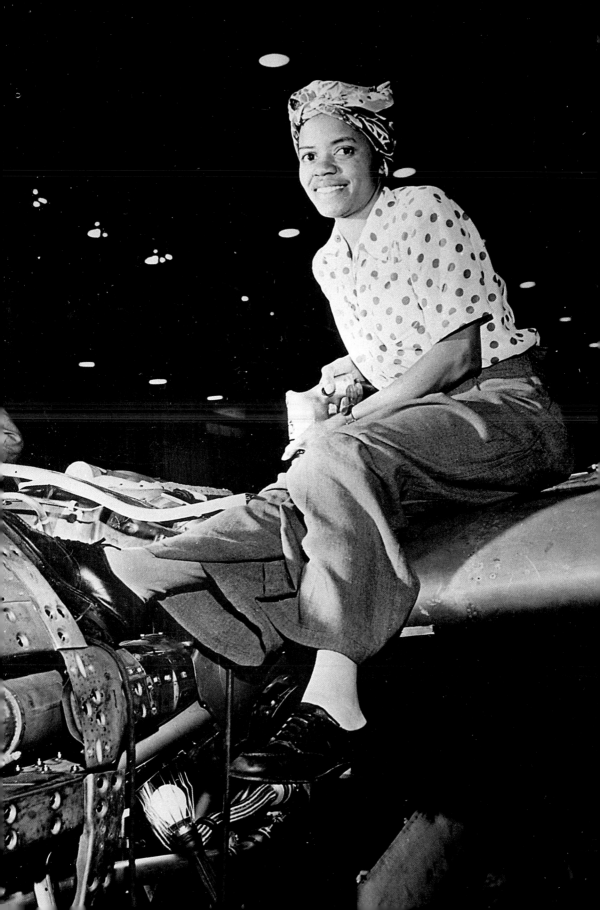

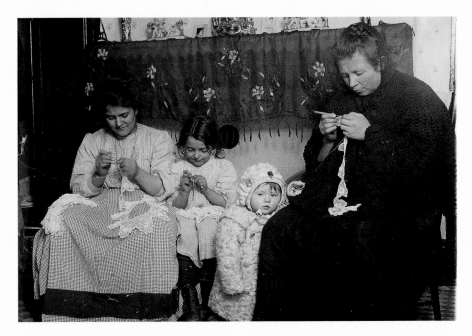

top Doctors Cornelia Meaders and Alice Lewis, ambulance surgeons at Reception Hospital. They were responsible for covering one of the busiest and poorest areas of the city. New York City, New York, c. 1915.
bottom A lace contractor teaches a young girl how to make lace. New York City, New York, 1911.
opposite A riveter at Lockheed Aircraft Corporation. Burbank, California, c. 1940–1945.

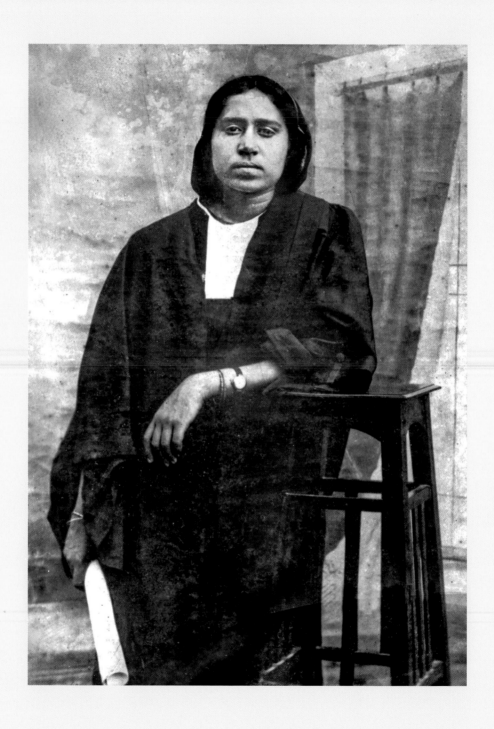

above Sita Devi Devidoss, the first Indian woman to qualify as a barrister. London, England, 1928.

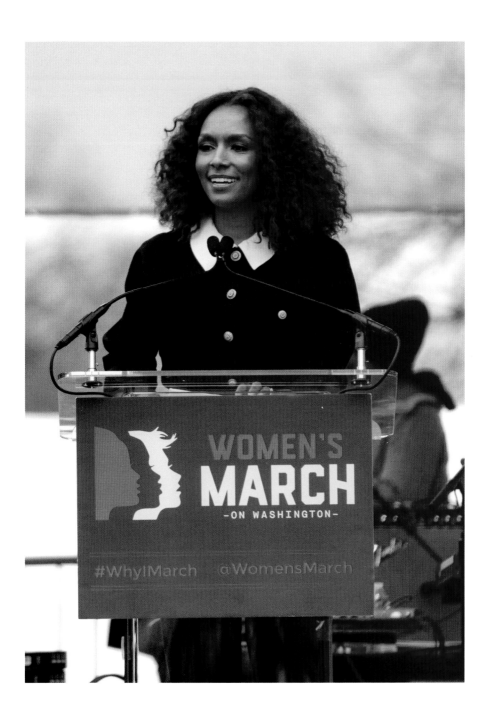

above Writer and transgender rights activist Janet Mock speaks onstage at the Women's March on Washington. Washington, D.C., 2017.

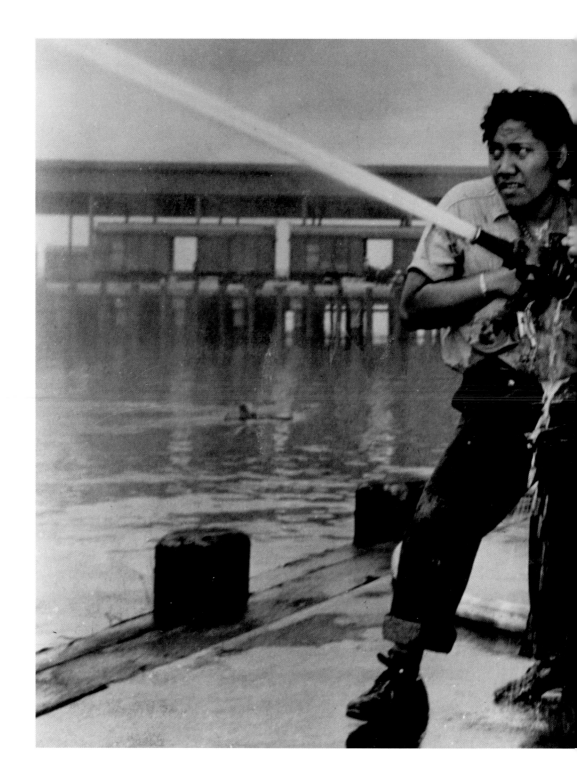

above Firefighters participate in a training exercise at the Pearl Harbor Naval Shipyard. Oahu, Hawaii, 1941.
overleaf Members of the Forestry Commission of the Women's Land Army (WLA) carry logs on their
shoulders ready to be stacked. The WLA was created to recruit women for the lumber and forestry industry in
World War II. These women were colloquially known as "land gals" and "lumber Jills." Suffolk, England, 1941.

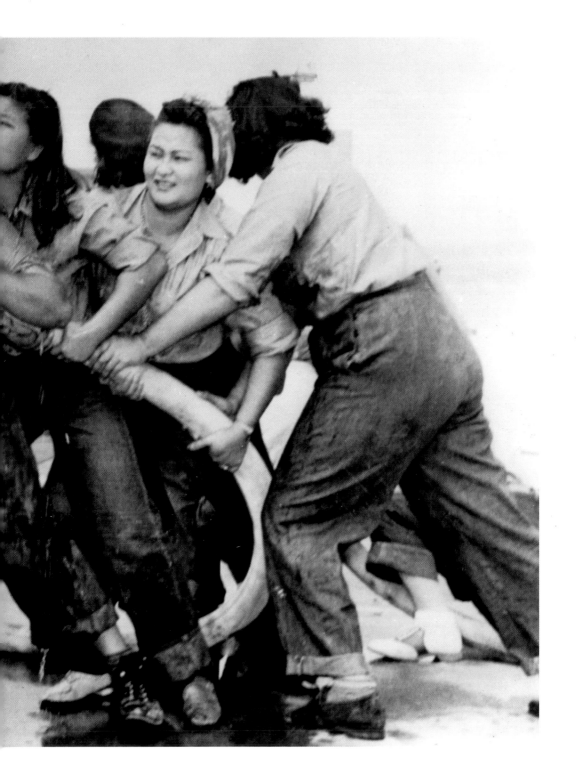

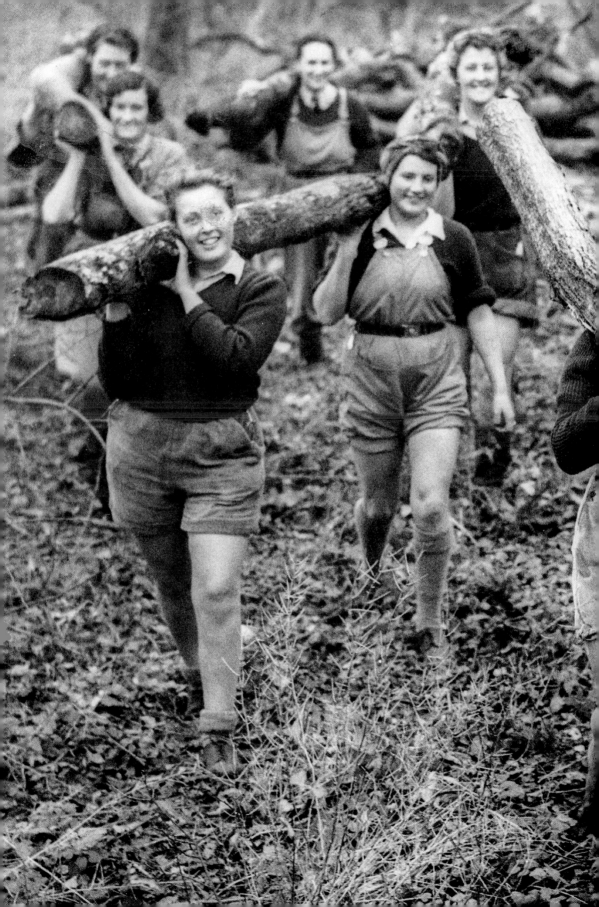

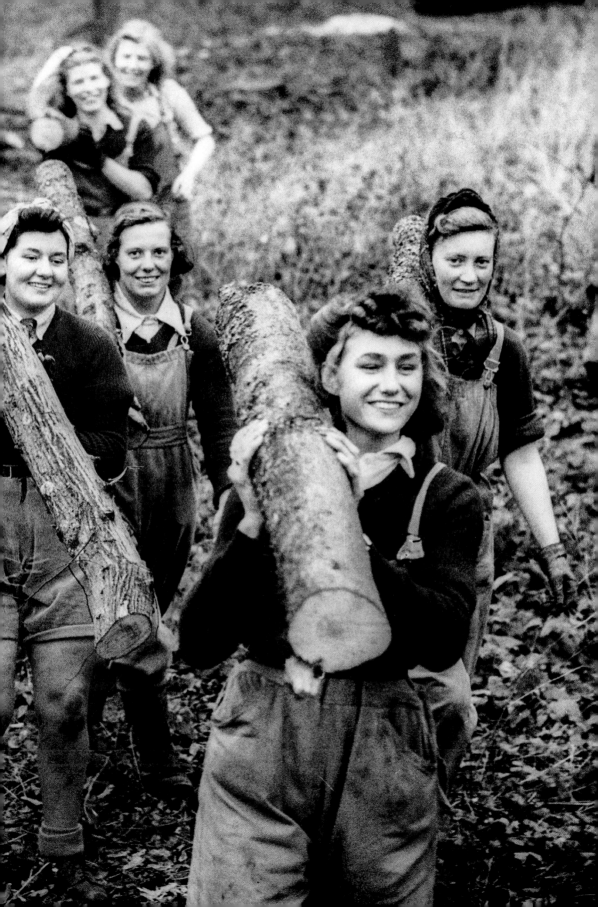

opposite A rural farmer with a crop of vegetables. United States, c. 1920–1954. overleaf (from left) Debbie Harry, the lead singer of Blondie, performs onstage. London, England, 1980; Dr. Mary Edwards Walker poses with her Medal of Honor. Walker was the only female assistant surgeon during the Civil War and remains the only woman to ever receive the medal. Walker was an early champion of wearing men's clothing. United States, 1865.

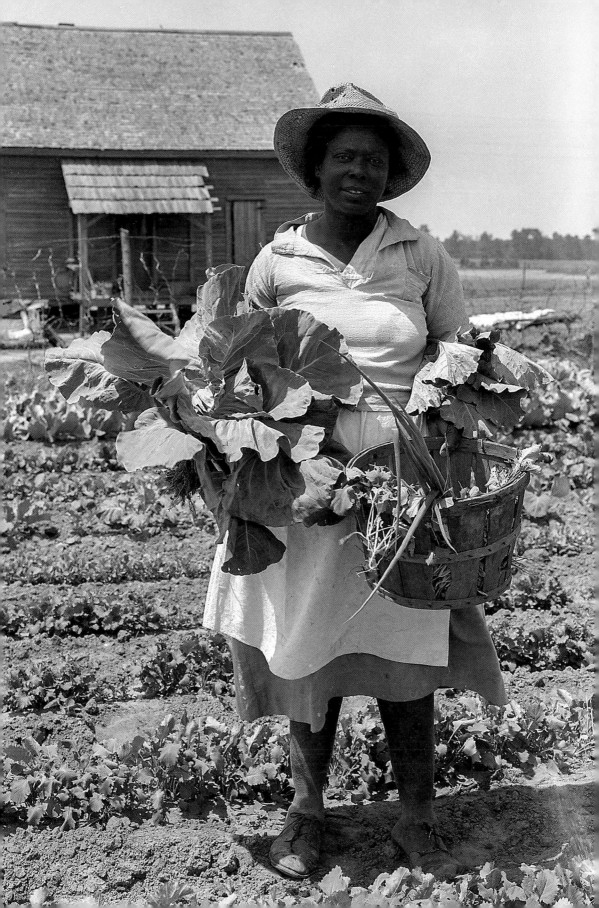

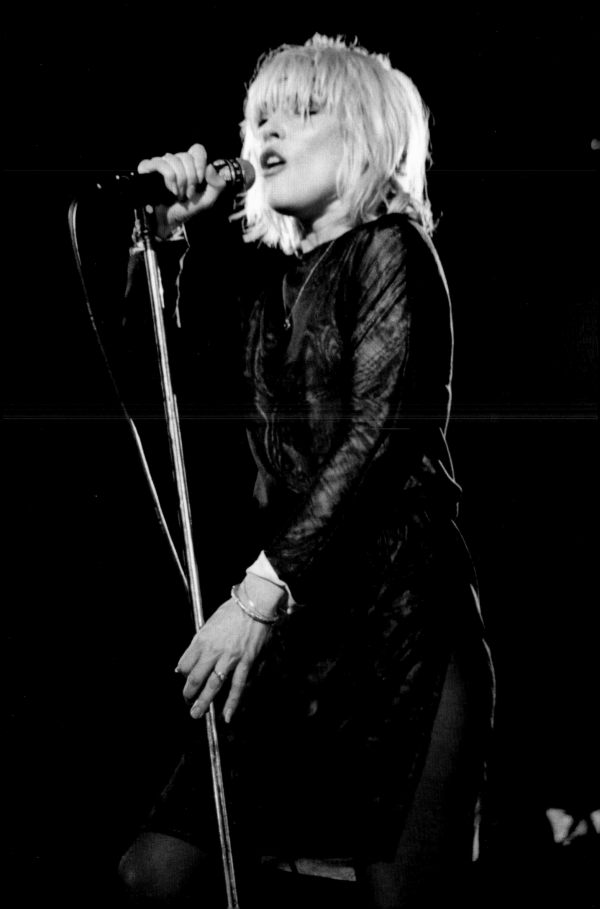

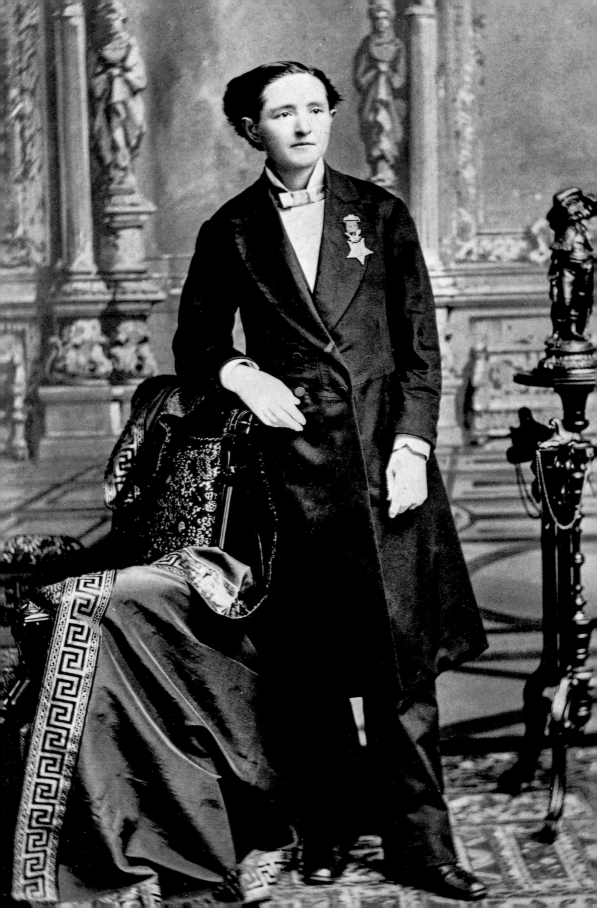

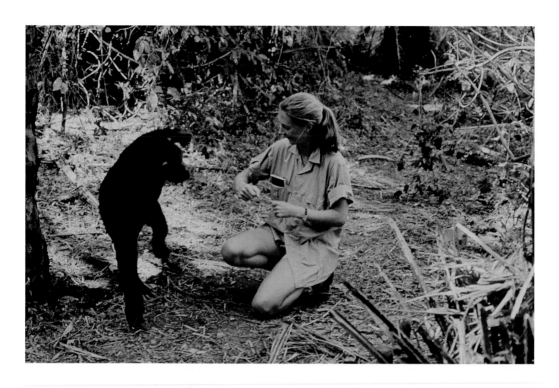

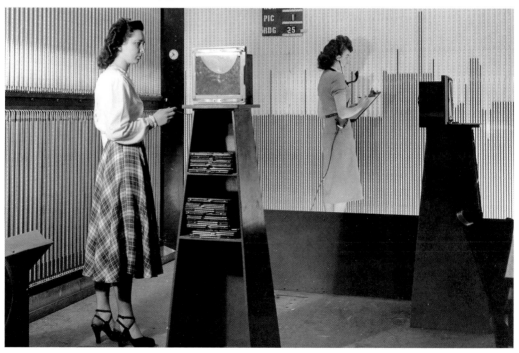

top Primatologist and anthropologist Jane Goodall. Gombe Stream National Park, Tanzania, 1965.
bottom Women set up manometer boards in the Supersonic Wind Tunnel at Lewis Field. Cleveland,
Ohio, 1949.

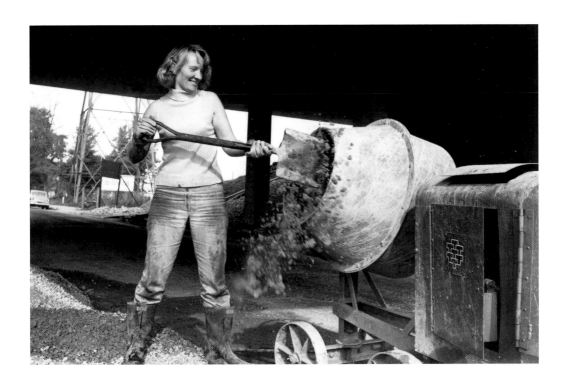

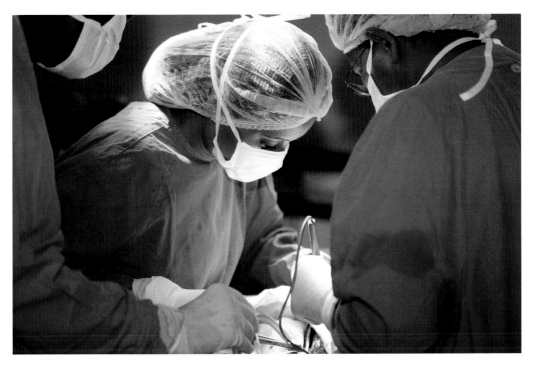

top A woman operates a cement mixer for motorway construction. Location unknown, 1971.
bottom A female surgeon operates on her patient. Location unknown, 2007.

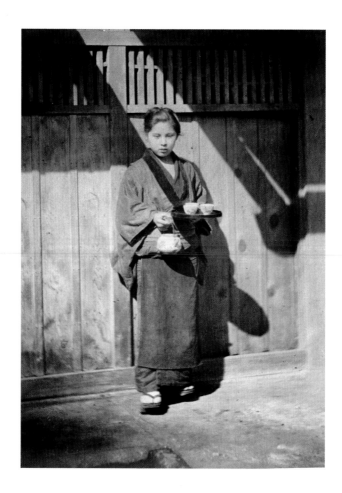

above Tearoom waitress. Japan, c. 1877. opposite American photographer and journalist Margaret Bourke-White stands in front of the Flying Fortress bomber. Bourke-White was America's first female war correspondent and the first woman allowed to work in combat zones in World War II. Algeria, 1943.

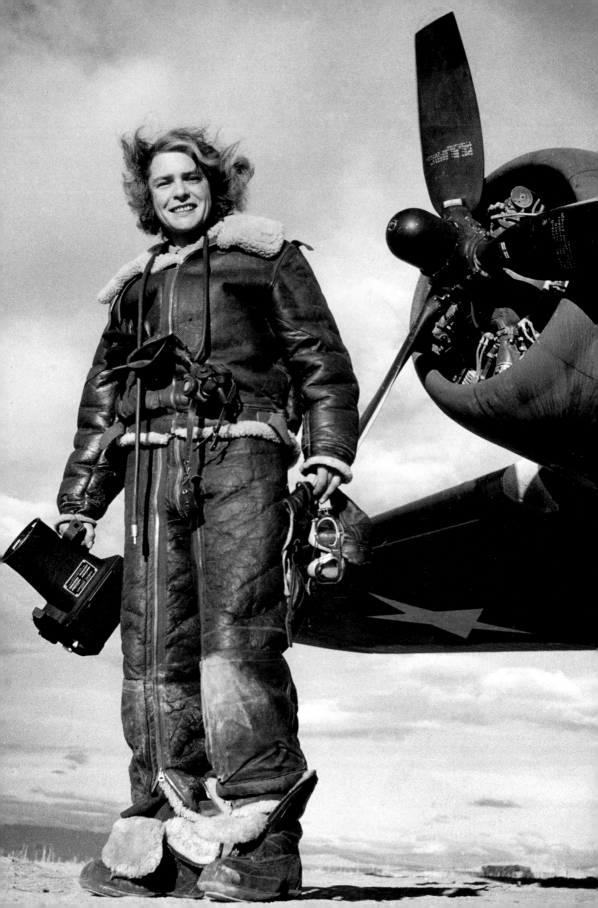

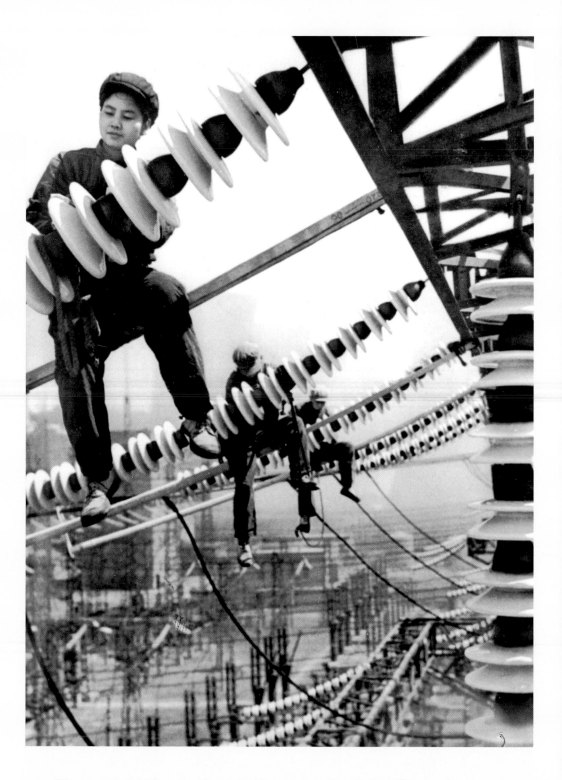

above Women maintain high-tension electrical cables at a power plant. Fushun, China, c. 1980.

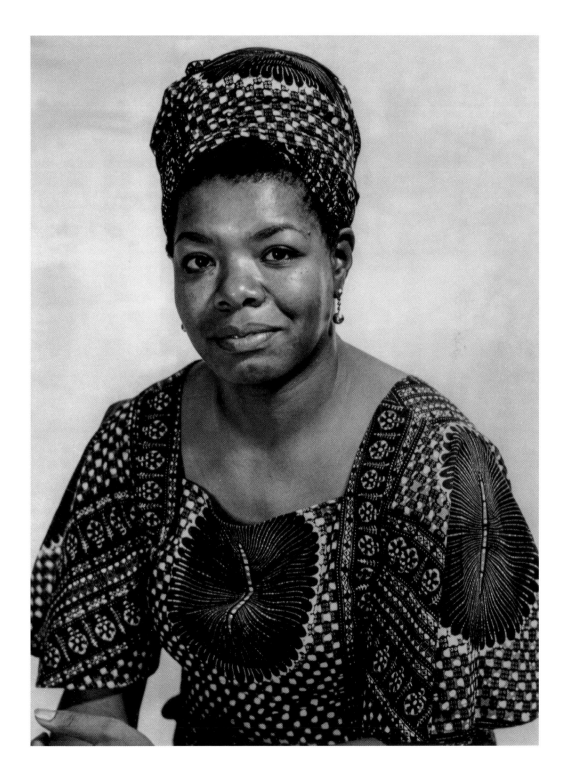

above A publicity still of American poet and novelist Maya Angelou for *Georgia, Georgia*. The film, written by Angelou, was the first with an original screenplay by an African American woman. Location unknown, 1972.

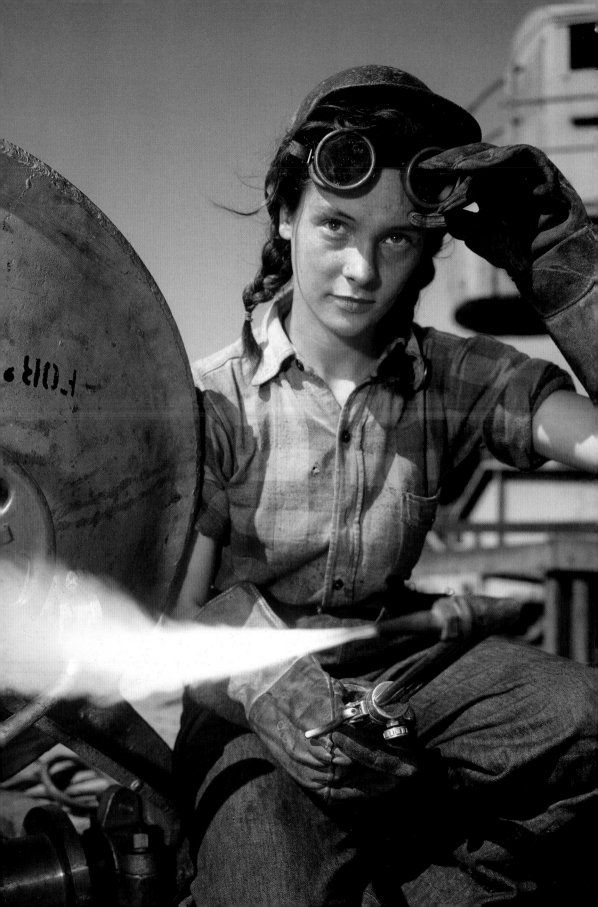

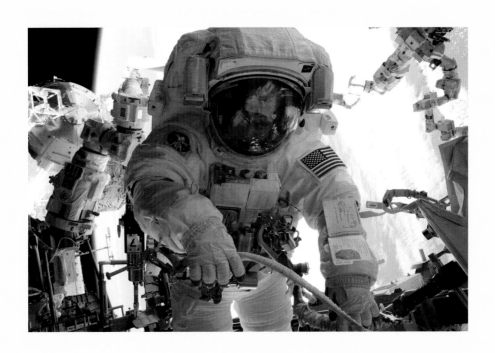

above Astronaut Peggy Whitson during a spacewalk. International Space Station, 2017.
opposite A welder at the Electric Boat Company, which produced submarines and torpedo boats during World War II. Groton, Connecticut, 1943.

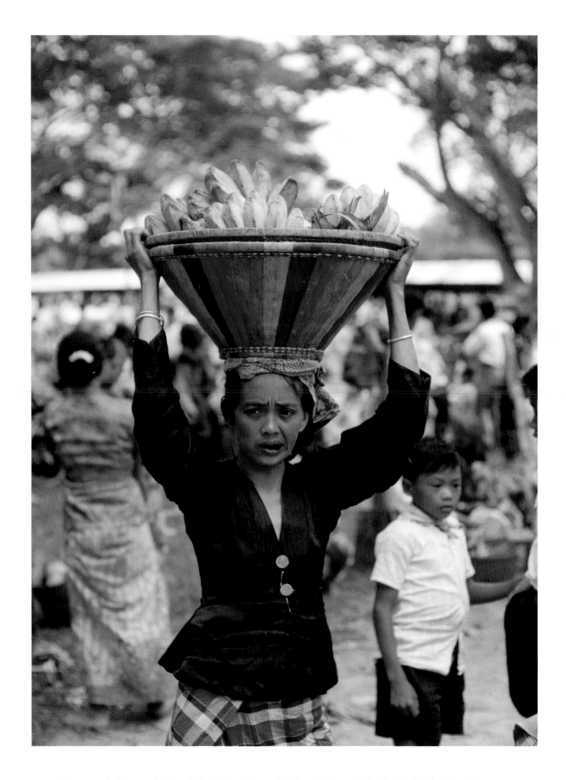

above A woman balances a basket full of plantains on her head. Borneo Island, East Malaysia, 1962.

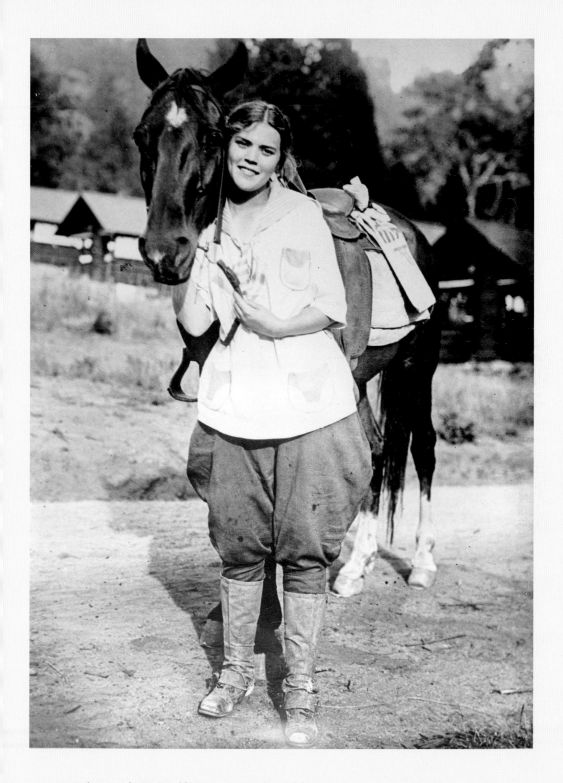

above A mail carrier during World War I. Los Angeles, California, c. 1915.

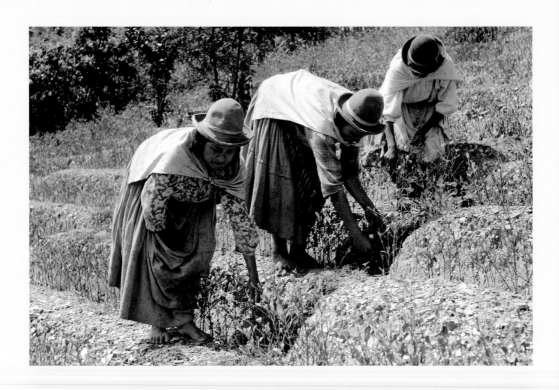

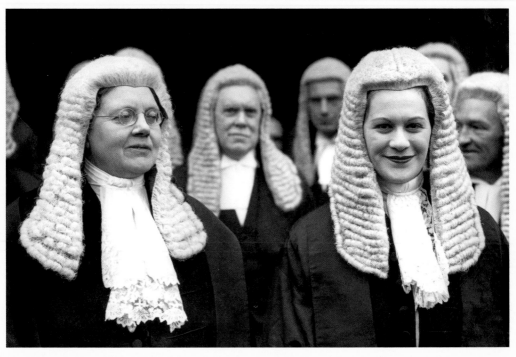

top Three women harvest coca leaves in the mountains. Near Chulumani, Bolivia, c. 1955.
bottom Helena Normanton (left) and Rose Heilbron (right), the first two women to be appointed King's Counsel. London, England, 1949.

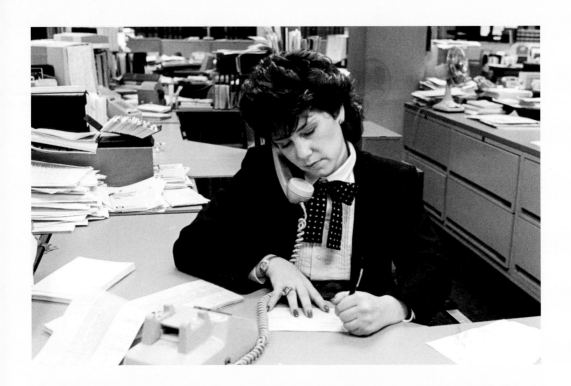

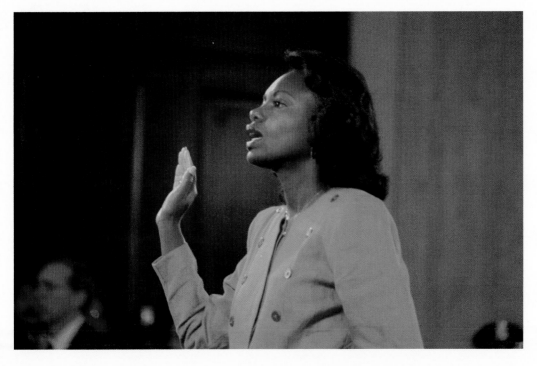

top A stockbroker at a merchant and investment banking firm. New York City, New York, 1984.
bottom Lawyer and professor Anita Hill is sworn in before testifying at the Senate Judiciary hearing on the Clarence Thomas Supreme Court nomination. Washington, D.C., 1991.

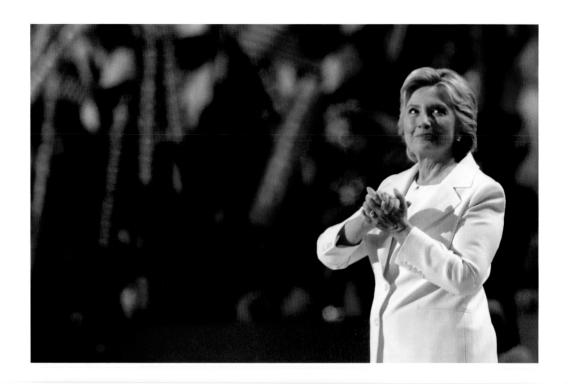

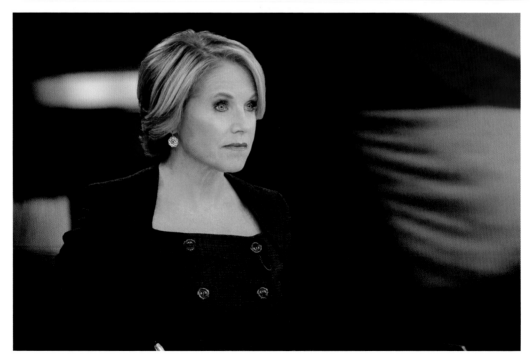

top Hillary Clinton at the Democratic National Convention, where she became the first female candidate to secure the party's nomination for president. Philadelphia, Pennsylvania, 2016. bottom Katie Couric, anchor and managing editor of *CBS Evening News* from 2006 to 2011. New York City, New York, 2010.

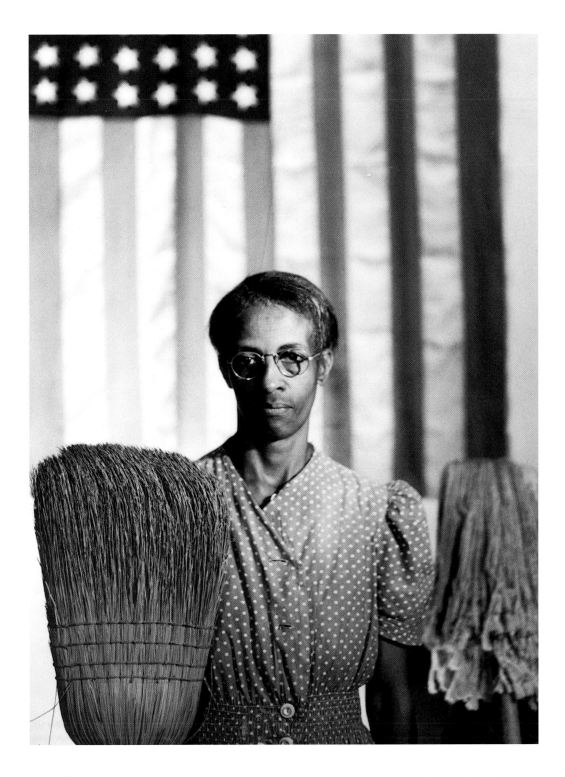

above Ella Watson, a government charwoman. In 1942, she shared with photographer Gordon Parks her experience of living in the segregated American capital, where she mopped the floors at the Farm Security Administration building to support her family. Inspired by Grant Wood's painting *American Gothic*, Parks carefully posed Watson in front of an American flag with her broom and mop. Washington, D.C., 1942.

above An aircraft mechanic checks electrical assemblies at the Vega Aircraft Corporation. Burbank, California, 1942.

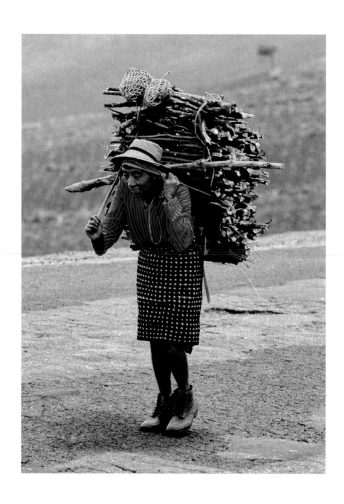

above A woman carries a load of firewood on her back. Guatemala, 1994.

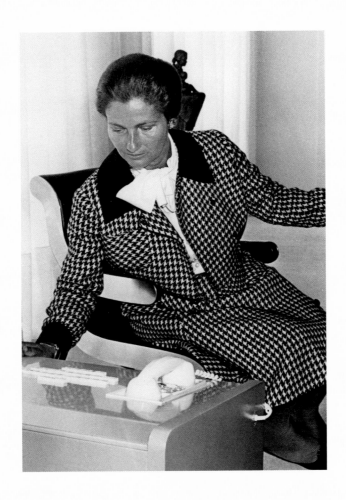

above French lawyer and politician Simone Veil, who served as France's Minister of Health from 1974 to 1979. Paris, France, 1974.

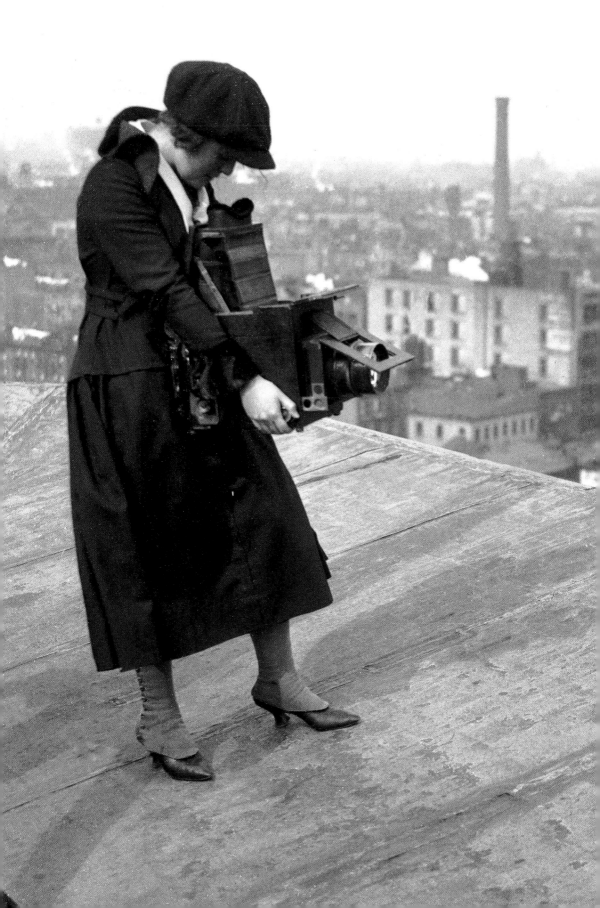

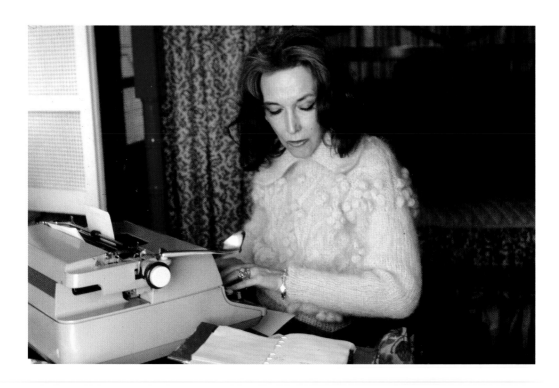

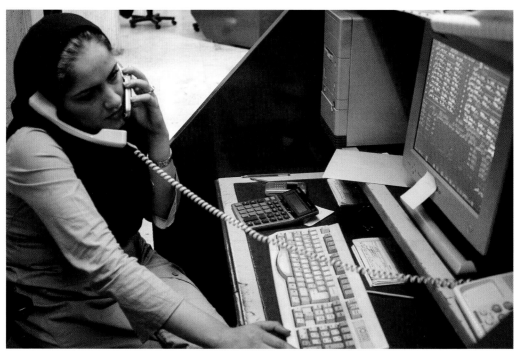

top Helen Gurley Brown, author of *Sex and the Single Girl* and editor in chief of *Cosmopolitan*, at her typewriter. New York City, New York, 1979. bottom A young stock trader multitasks while working at the city's stock exchange. Tehran, Iran, 2004.

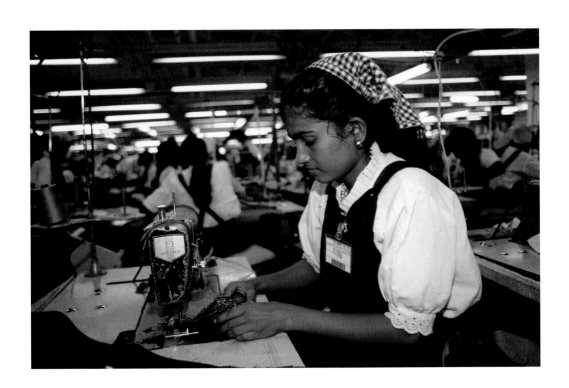

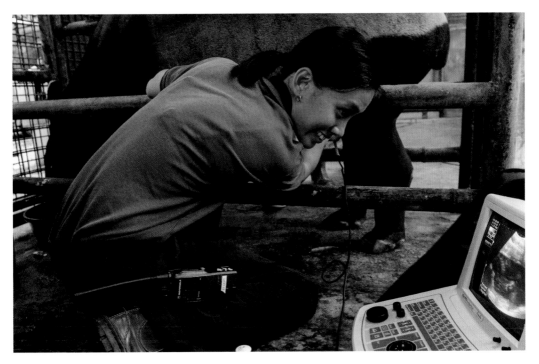

top A laborer sews materials in a textile factory. Colombo, Sri Lanka, c. 1998. bottom Doctor Serena Oh, assistant director of veterinary services at the Wildlife Reserves Singapore, gives an ultrasound to a pregnant Malayan tapir. Singapore, 2010.

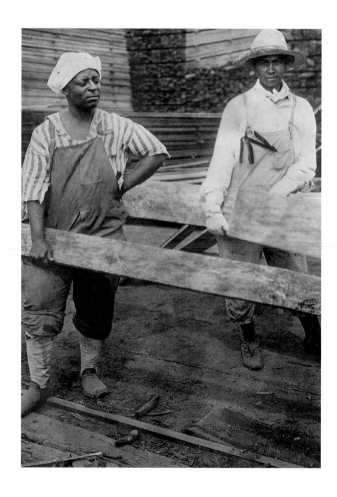

above Women at work in a lumberyard. United States, 1919. opposite A punch-press operator stamping out automotive parts pauses at her workstation. Oakville, Ontario, 1962.

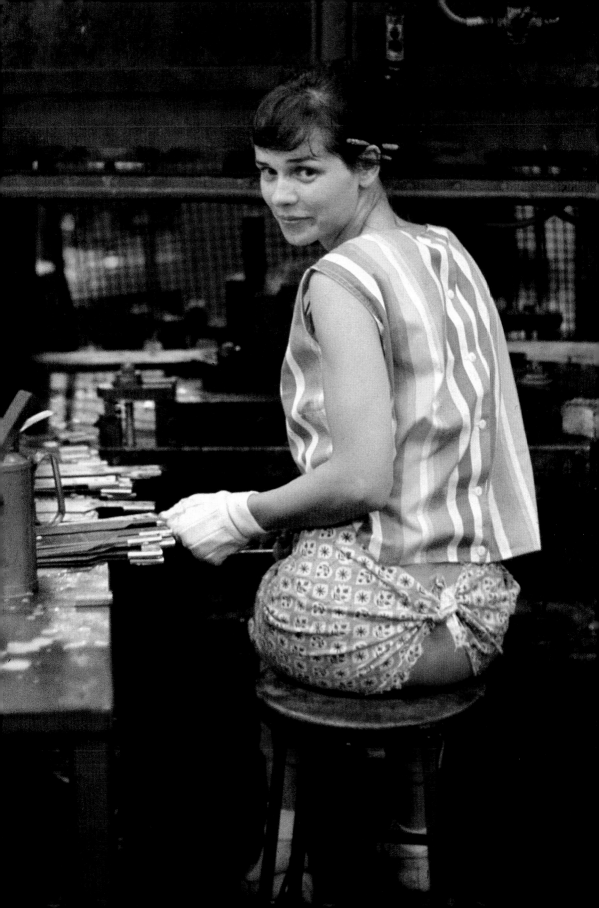

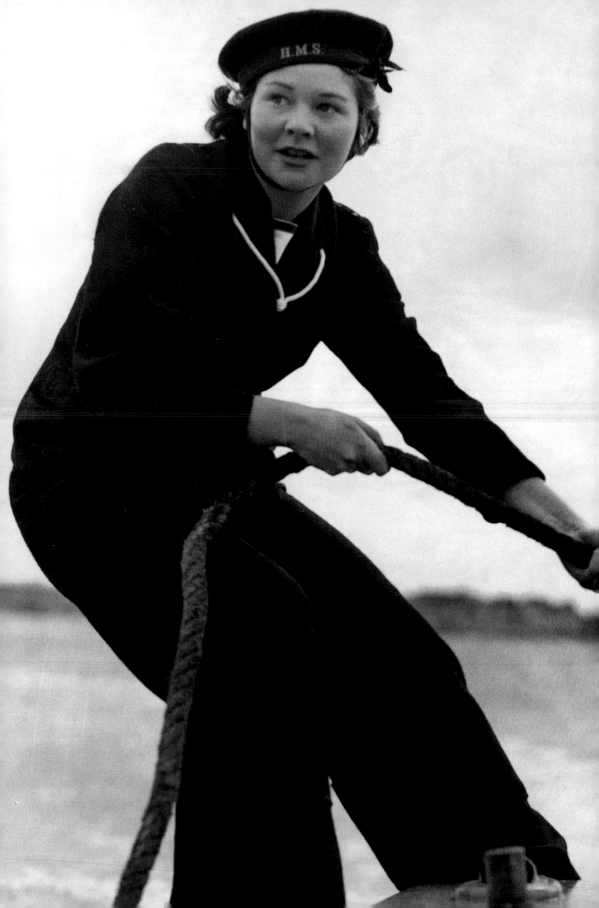

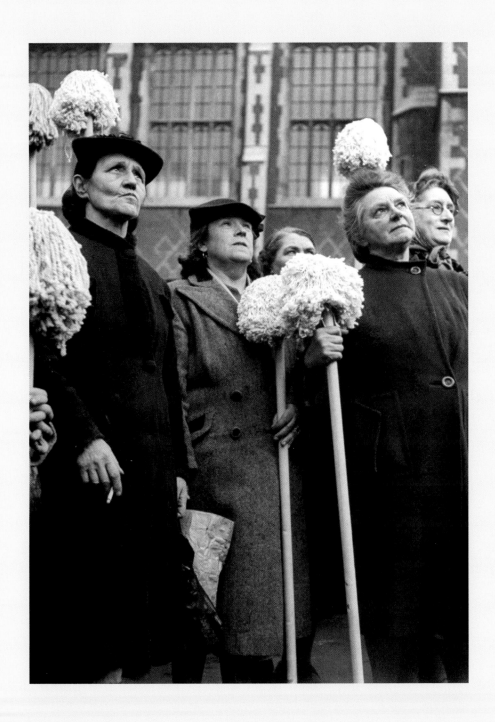

above Cleaning women on strike protest for a raise. London, England, 1939. opposite A member of the Women's Royal Naval Service secures the motorboat she's been using to deliver mail and goods to ships at anchor. United Kingdom, 1942.

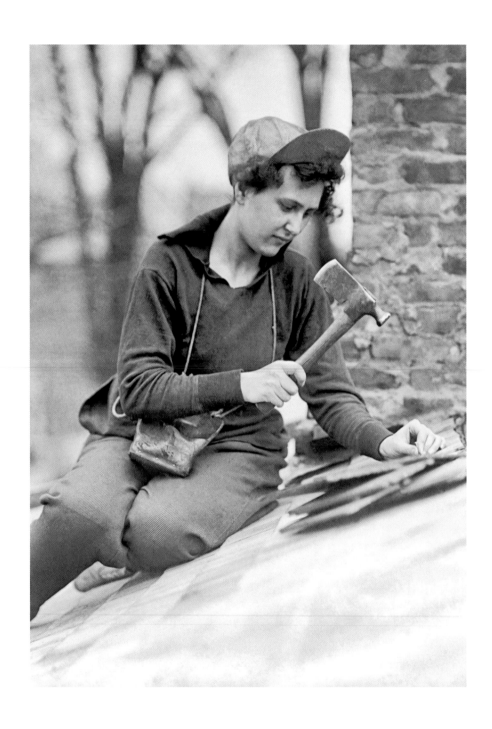

above A roofer hammers tiles into place. United States, c. 1940.

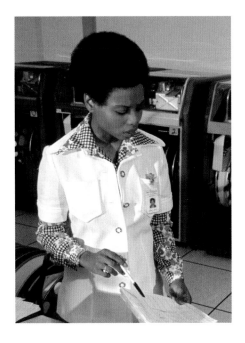

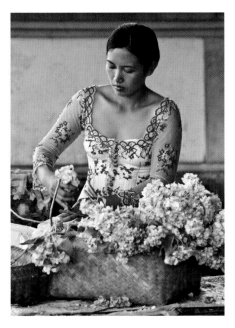

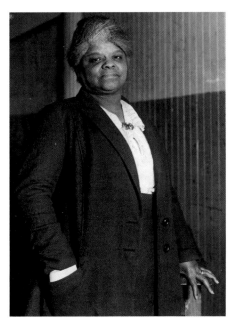

clockwise (from top left) War correspondent Kate Webb interviews a subject during the Vietnam War. Vietnam, c. 1967; A woman works in an office with an IBM 1130 computer. Pittsburgh, Pennsylvania, 1974; Ida B. Wells, a journalist, suffragist, and cofounder of the NAACP. United States, 1920; A woman prepares flowers for the Galungan festival. Ubud, Bali, Indonesia, 2010.

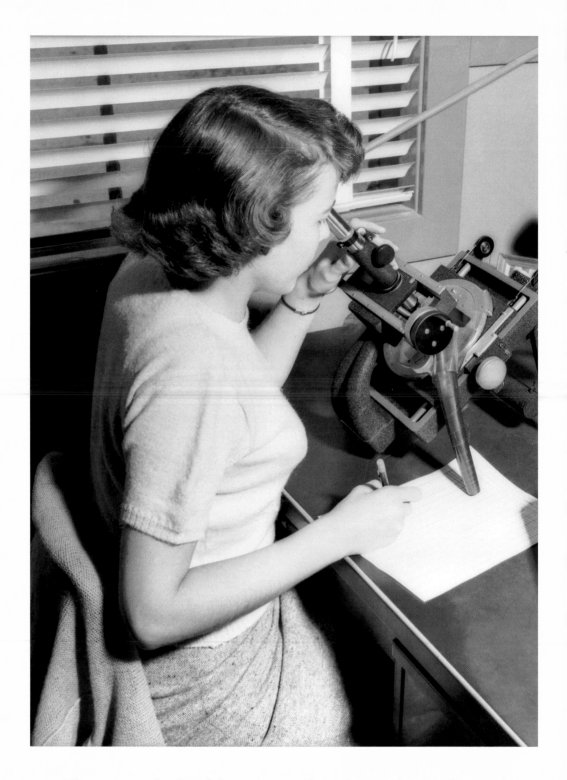

above A "human computer" works with the X-4 program at the Langley Research Center. The National Advisory Committee for Aeronautics hired women as computers to read data from test results and then calculate formulas and plot outcomes. Hampton, Virginia, 1952.

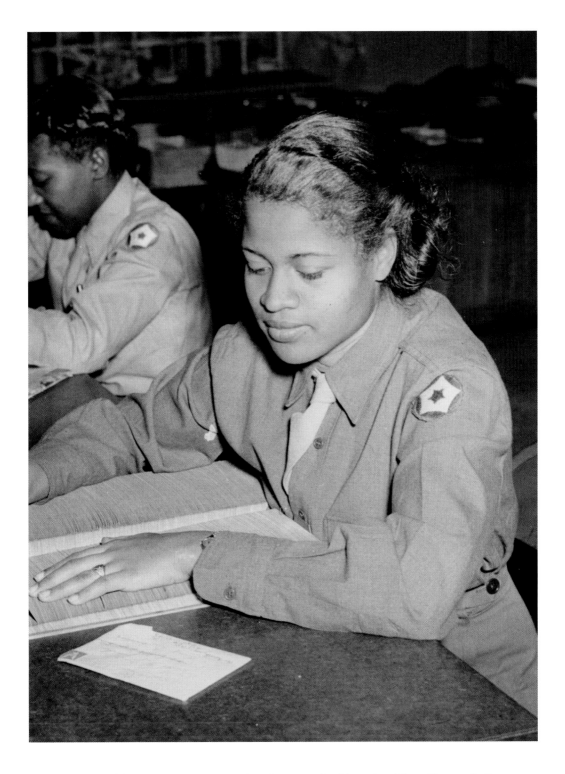

above Members of the Women's Army Corps identify incorrectly addressed mail for soldiers in the Post Locator Department at Camp Breckinridge. Morganfield, Kentucky, 1943.

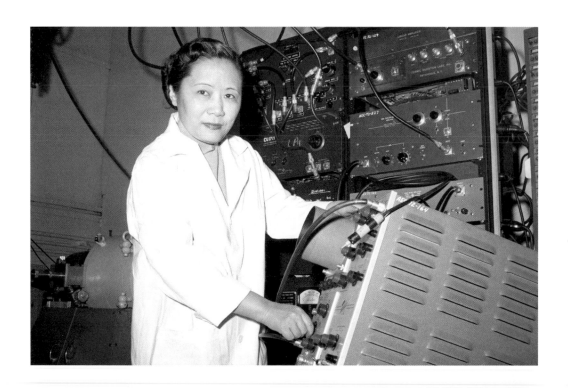

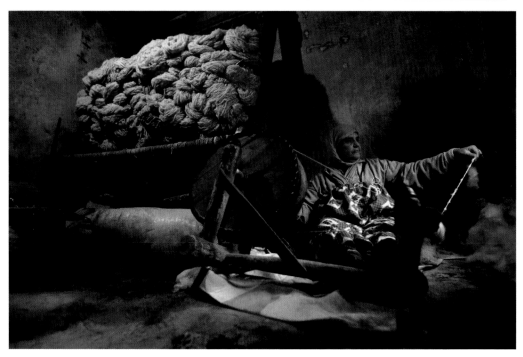

top Experimental physicist Dr. Chien-Shiung Wu in a laboratory at Columbia University. New York City, New York, 1958. bottom A Lebanese woman works in a small carpet-weaving workshop in Al Fakiha Village. Beqaa, Lebanon, 2016.

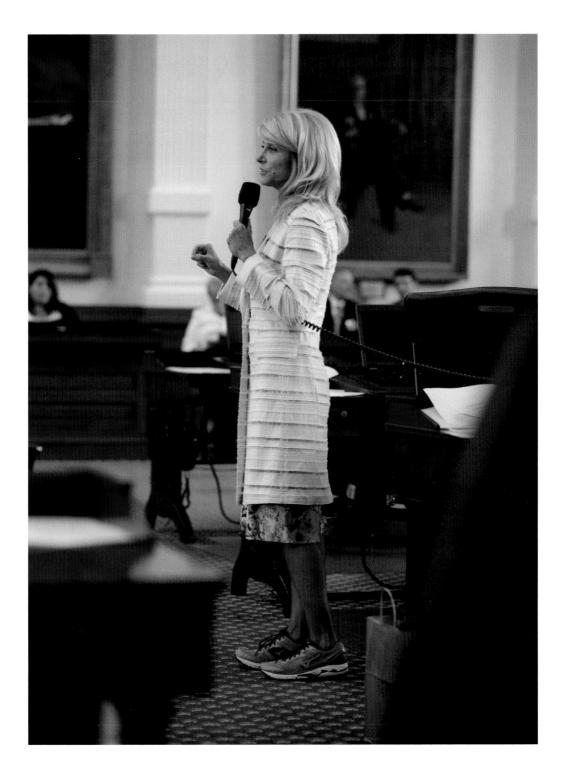

above Former Texas state senator Wendy Davis during her eleven-hour filibuster in which she advocated for reproductive rights. Austin, Texas, 2013. overleaf "Top women" at U.S. Steel's Gary Works factory. Wearing oxygen masks as a safety precaution, the women regularly cleaned around the tops of the twelve blast furnaces. Gary, Indiana, c. 1940–1945.

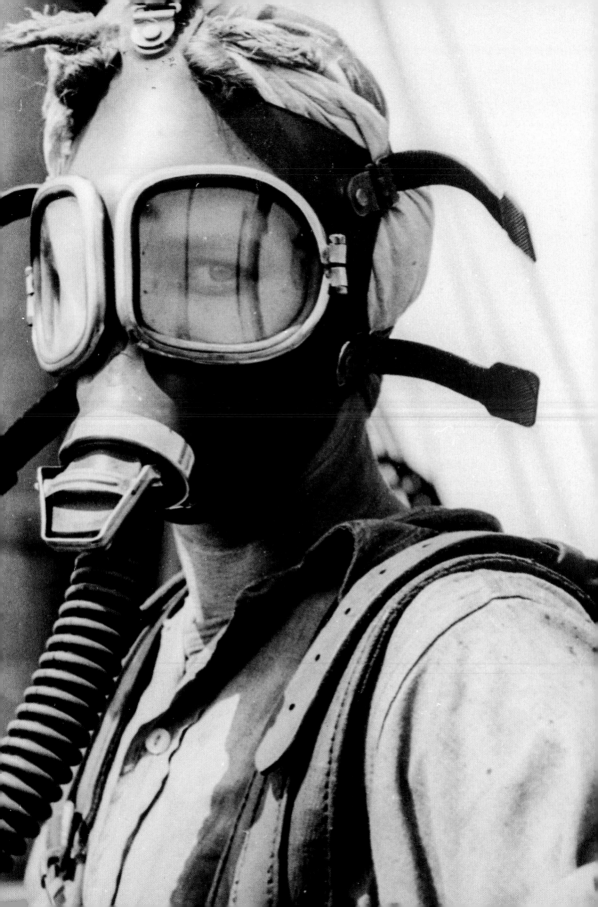

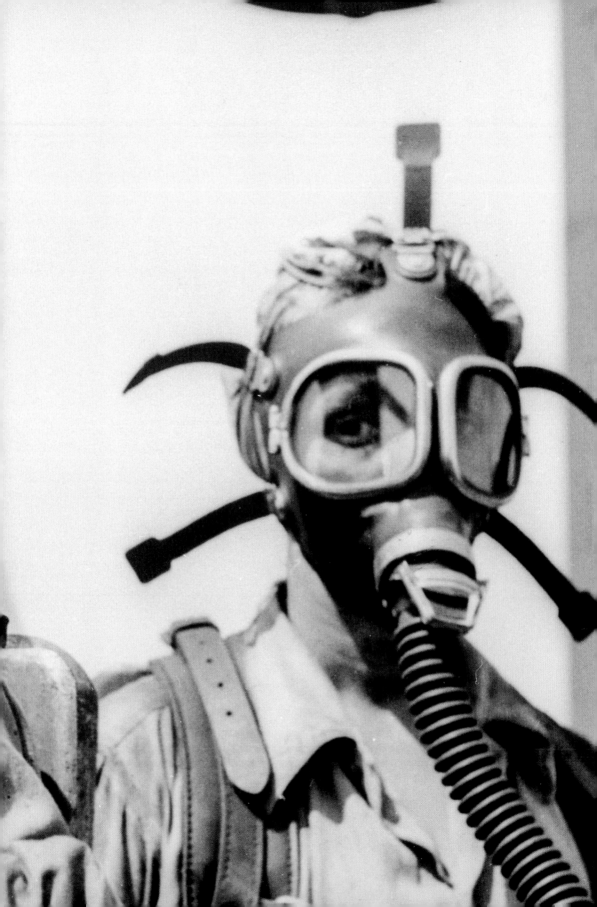

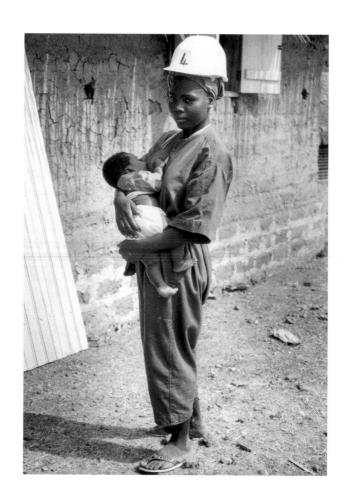

above A working woman breastfeeds her child at a refugee camp. Côte d'Ivoire, c. 1999.

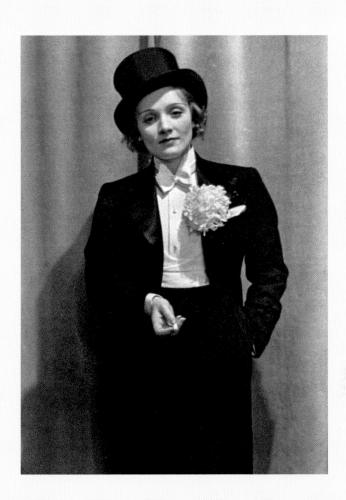

above German actress Marlene Dietrich wears a tuxedo, top hat, and corsage with a cigarette in hand at a ball for foreign press. Berlin, Germany, 1929. overleaf (from left) A group of women with the Glasgow Corporation clean the front steps of a civic building. Glasgow, Scotland, 1953; A woman makes adjustments to a data transfer unit at a Solartron factory. Farnborough, England, 1969.

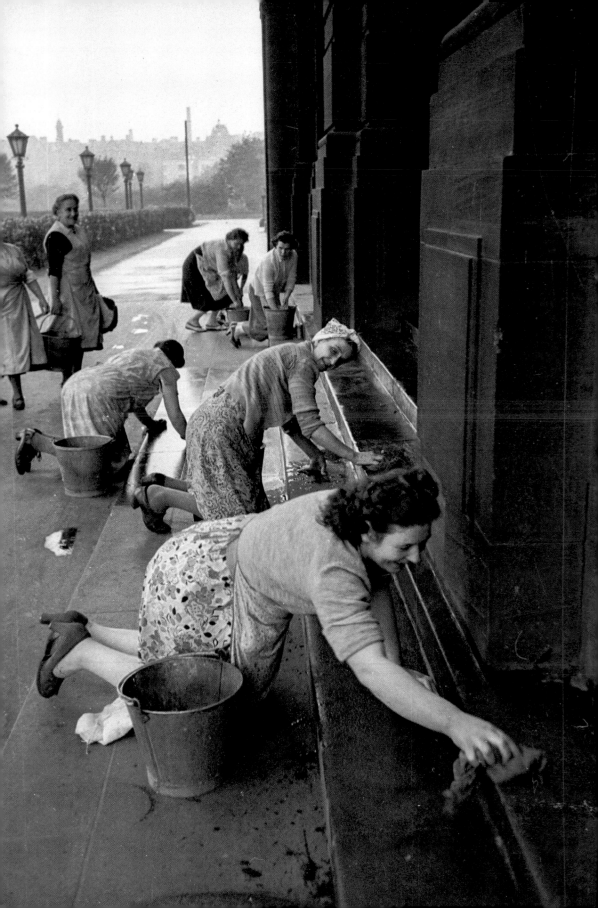

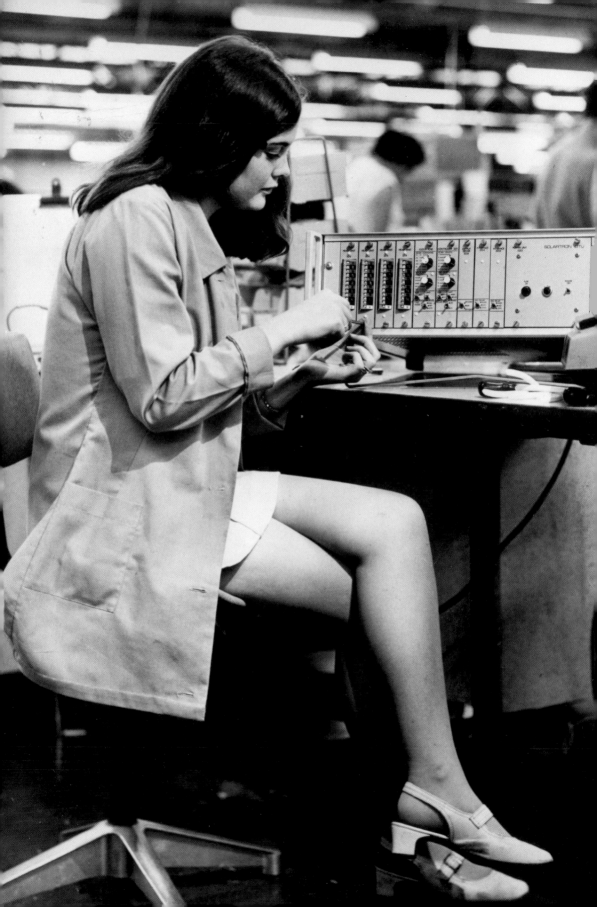

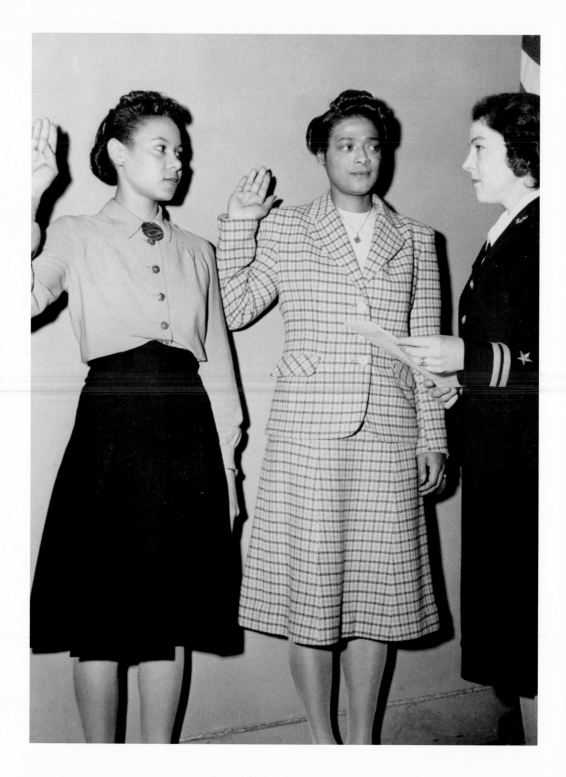

above Frances Willis (left) and Harriet Pickens (right), the U.S. Army's first African American WAVES officers, being sworn in as apprentice seamen. New York City, New York, 1944.

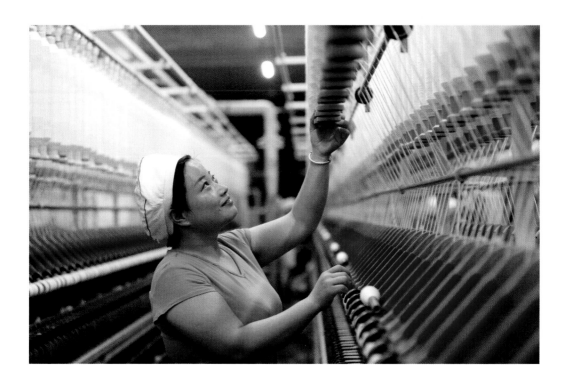

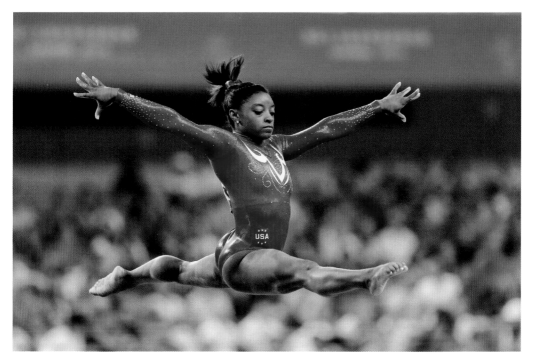

top A woman at work in a textile factory. Huaibei, Anhui, China, 2015. bottom Olympic gold medalist Simone Biles. Nanning, China, 2014.

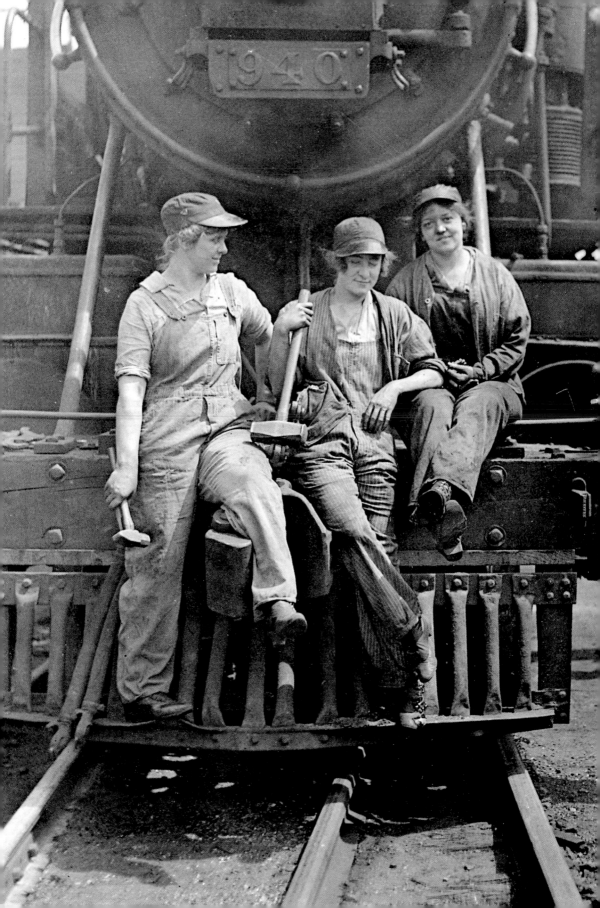

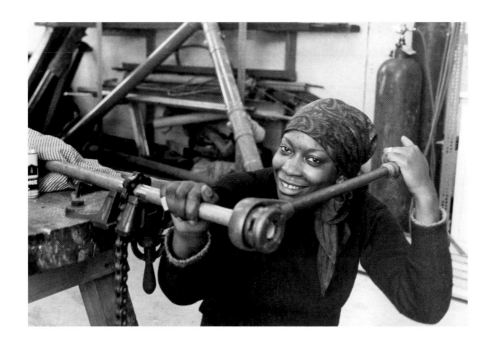

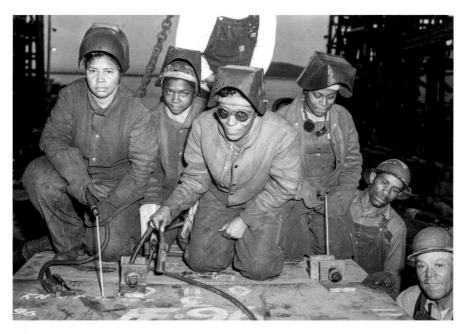

top The first female plumber appointed by the Camden Council poses with some of her tools. London, England, 1977. bottom Welders prepare to work on SS *George Washington Carver* during World War II. Richmond, California, 1943. opposite Laborers sit in front of an engine in a railroad yard at Bush Terminal. Brooklyn, New York, 1918.

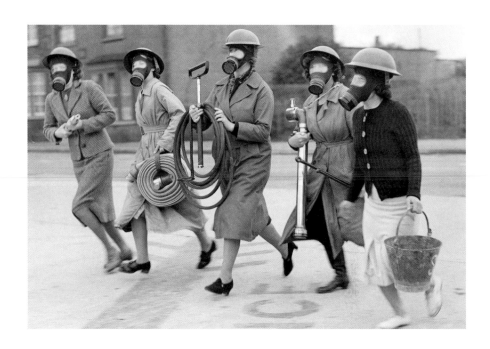

above Members of the women's auxiliary fire brigade run a training drill. Flamborough, England, 1939.

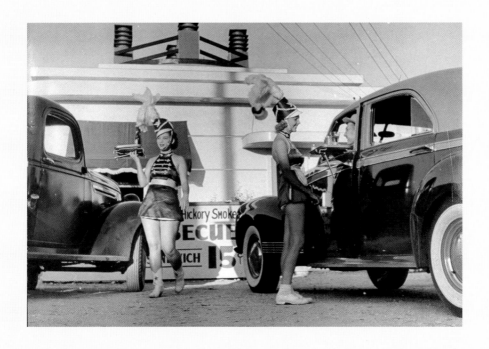

above Waitresses, or "car hop girls," at a drive-in restaurant. Corpus Christi, Texas, 1940. overleaf Workers install fixtures and assemblies to a tail fuselage section of a B-17 bomber plane at the Douglas Aircraft Company plant. Long Beach, California, c. 1942.

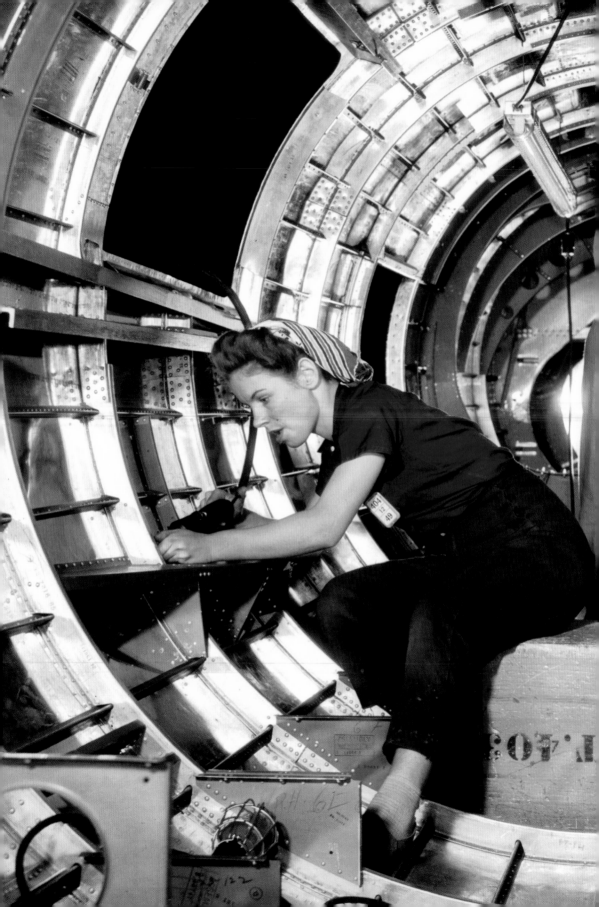

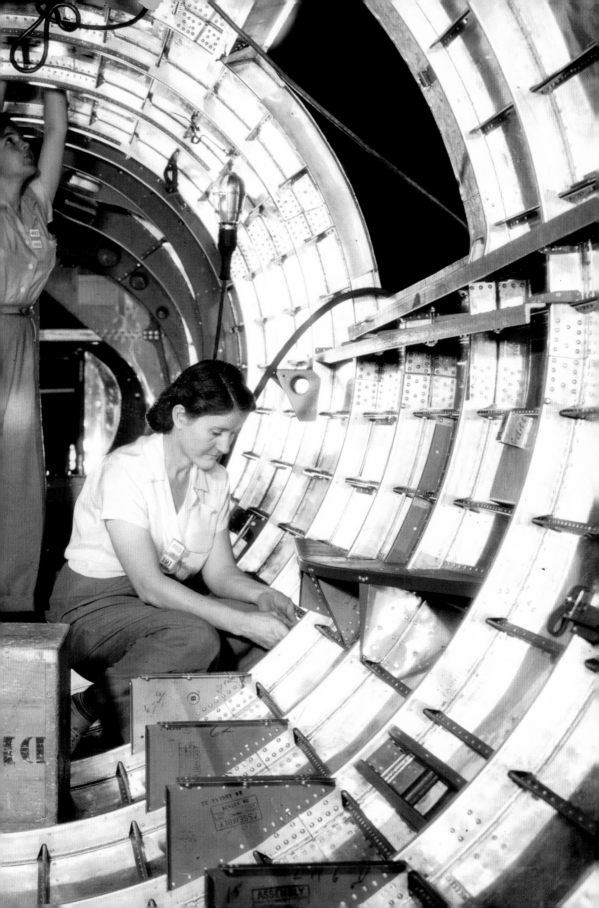

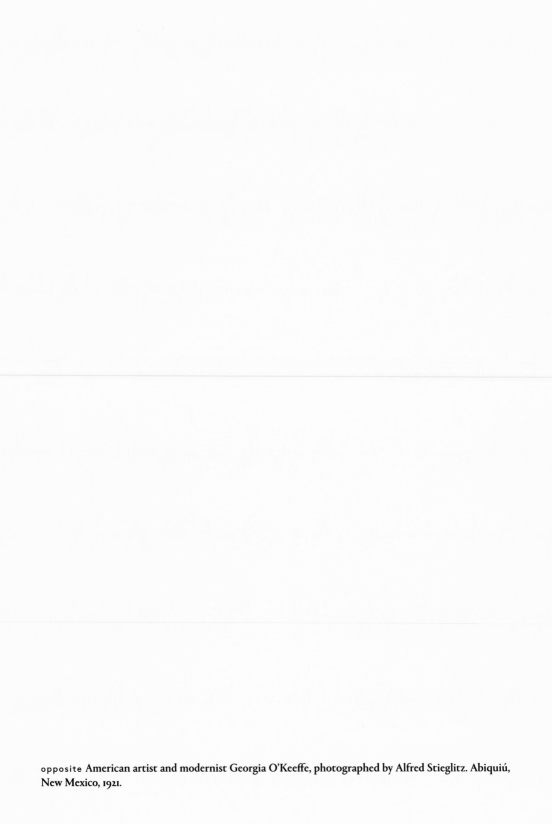

opposite American artist and modernist Georgia O'Keeffe, photographed by Alfred Stieglitz. Abiquiú, New Mexico, 1921.

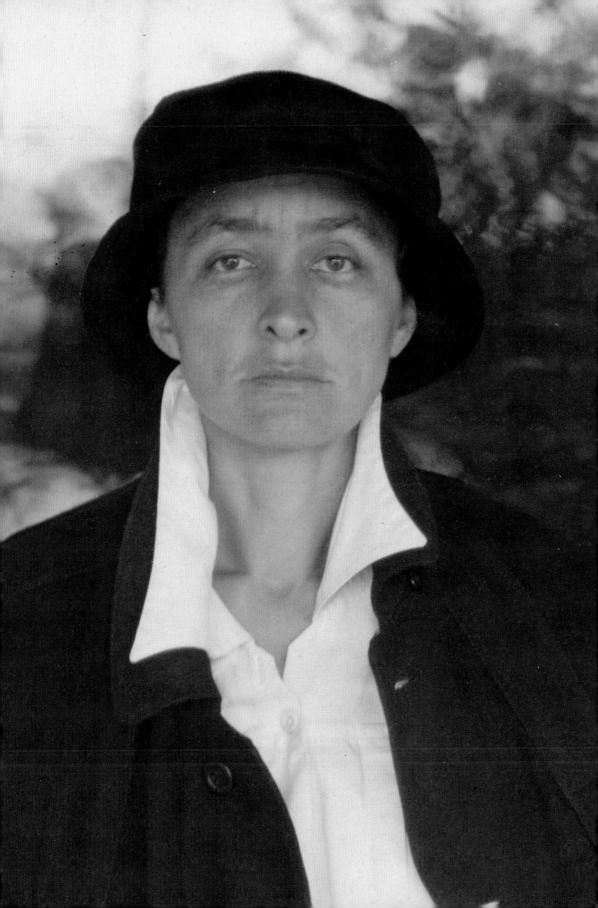

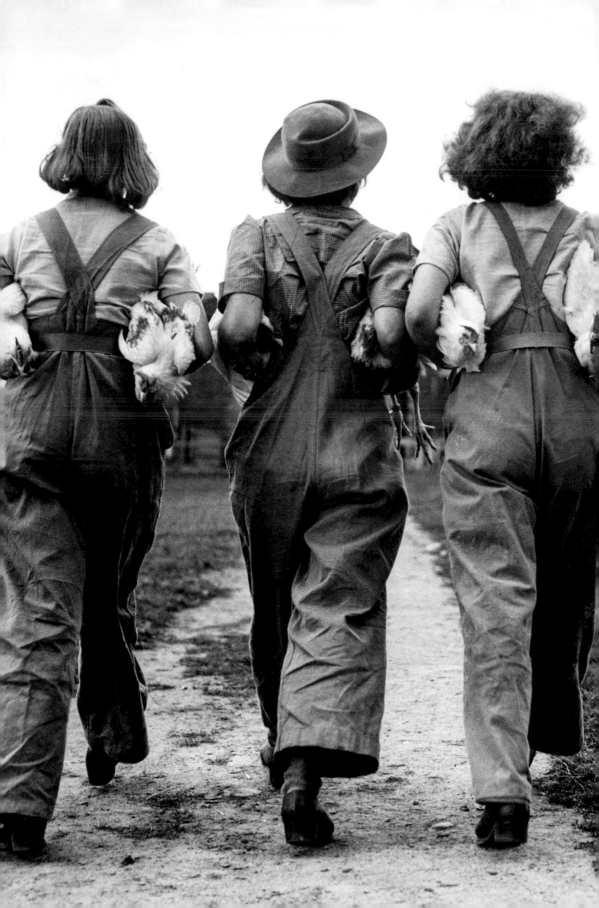

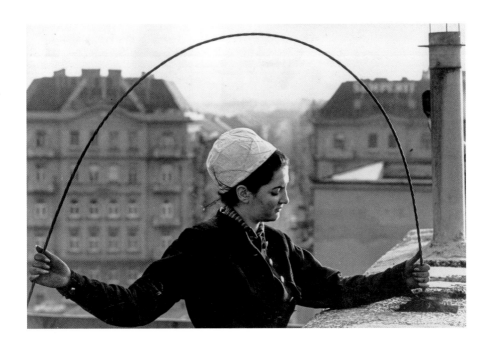

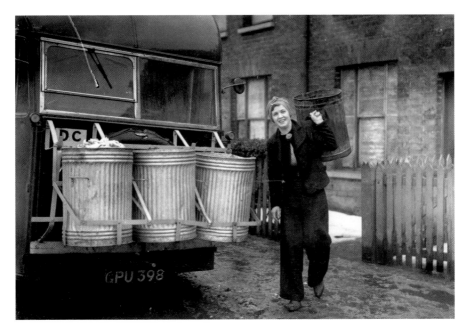

top A chimney sweep at work. Vienna, Austria, 1967. bottom One of the first female sanitation workers in the country carries garbage to her truck. Ilford, England, 1941. opposite Three members of the Women's Land Army. Moulton, Northamptonshire, England, 1940. overleaf Lara Logan, South African journalist and foreign affairs correspondent of *CBS News,* interviews U.S. soldiers at Camp Victory. Baghdad, Iraq, 2006.

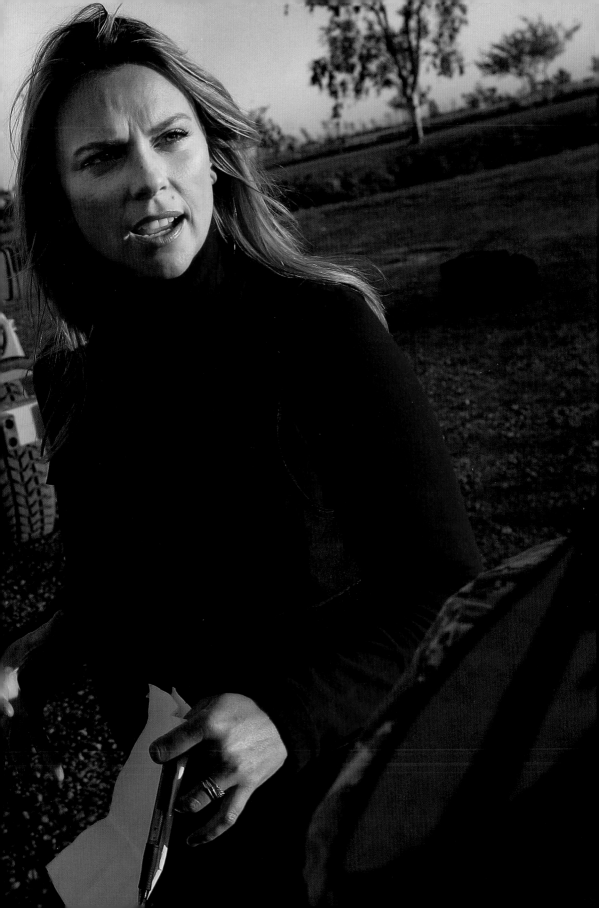

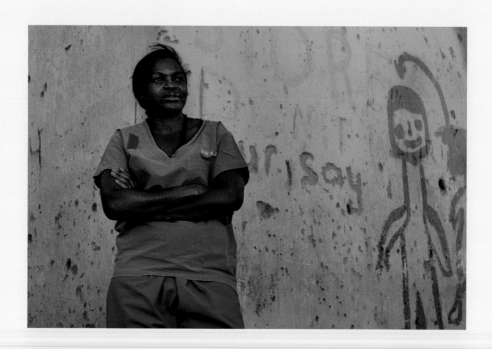

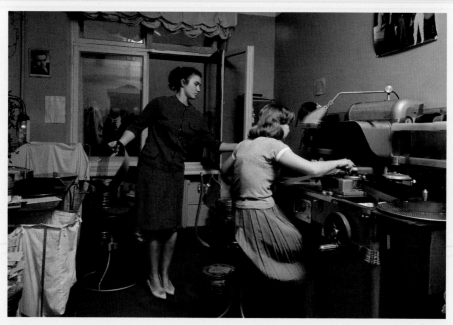

top Dr. Helena Ndume, Namibia's most celebrated opthalmologist and surgeon. Omaruru, Namibia, 2015. bottom Two Mosfilm production studio employees at an editing bay. Moscow, Russia, 1967. opposite Musician and folk icon Joni Mitchell. Isle of Wight, England, 1970.

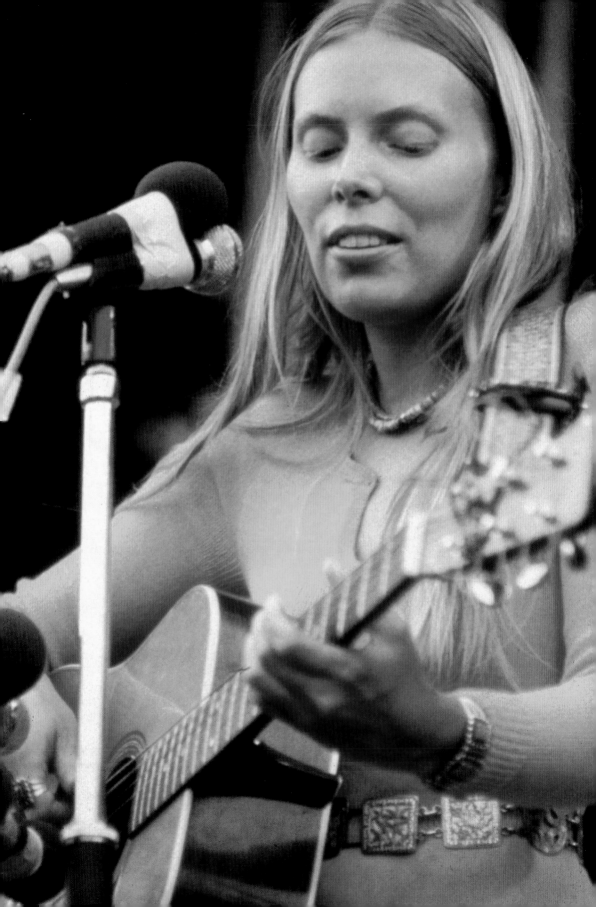

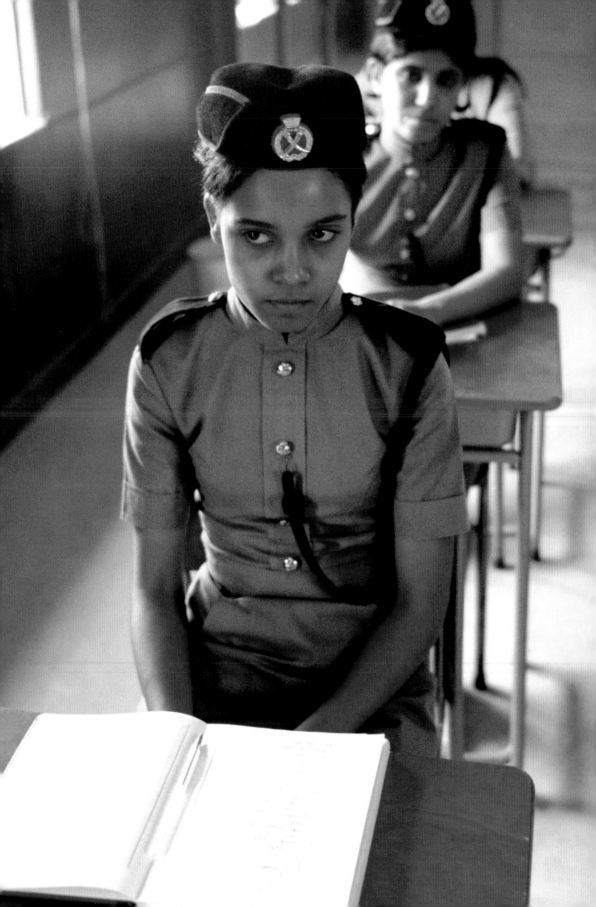

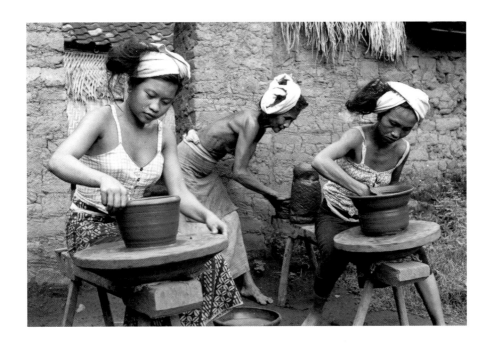

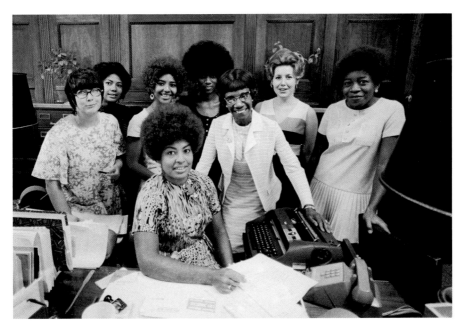

top Women throw pots by hand. Bali, Indonesia, c. 1954. bottom Congresswoman Shirley Chisholm (center right) with her staff in her office. In 1968 Chisholm was the first African American woman elected to the United States Congress, and in 1972 would be the first to run for president of the United States. Washington, D.C., 1970. opposite Members of Bahrain's female police corps, who only handle juvenile and women's cases. Bahrain, 1975.

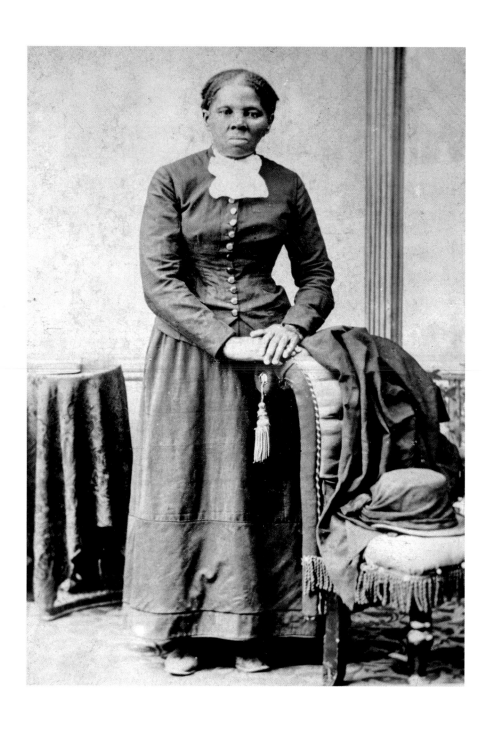

above Harriet Tubman, abolitionist and conductor on the Underground Railroad. United States, c. 1871–1876.

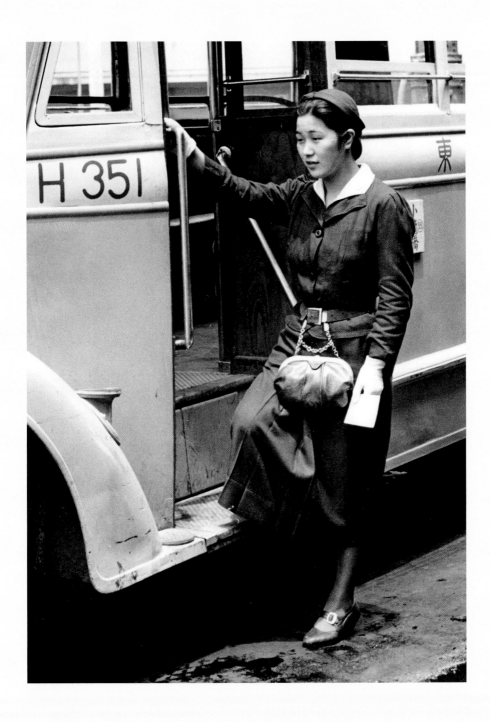

above A bus conductor climbs aboard her bus. Female bus conductors were among the first to wear Western clothes and hats as opposed to traditional dress like kimonos. Tokyo, Japan, c. 1955.

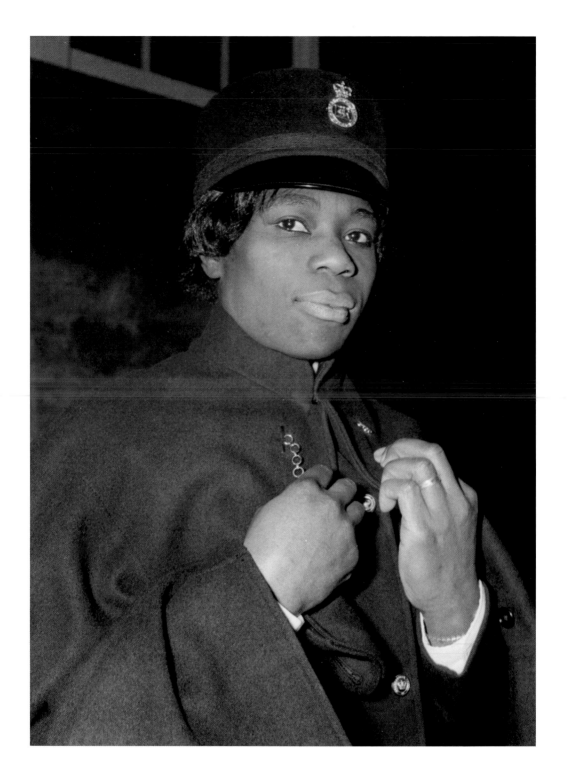

above Sislin Fay Allen, a Jamaican-born woman and the first black woman in London's Metropolitan Police Force, completes police training. She wears a cape, which was part of the new police uniform designed for female police officers by leading British fashion designer Norman Hartnell. London, England, 1968.

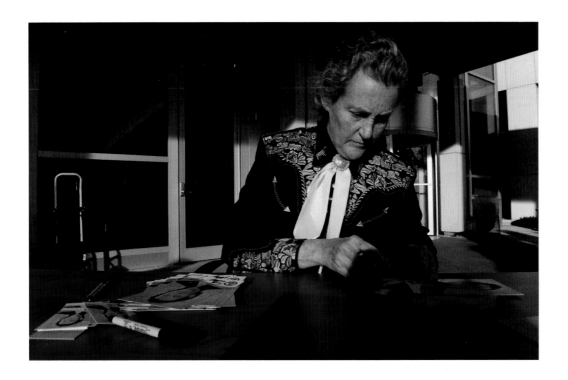

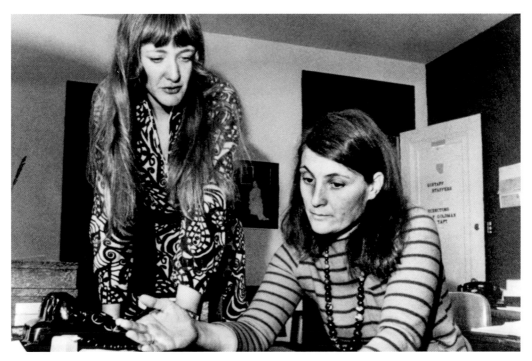

top Dr. Temple Grandin, autism activist and animal scientist, autographs her inventor's trading card outside of the U.S. Patent and Trademark Office. Denver, Colorado, 2016. bottom Founders of Distaff Staffers, an agency that secured part-time professional jobs for married women with families, review papers at their office. Washington, D.C., 1971.

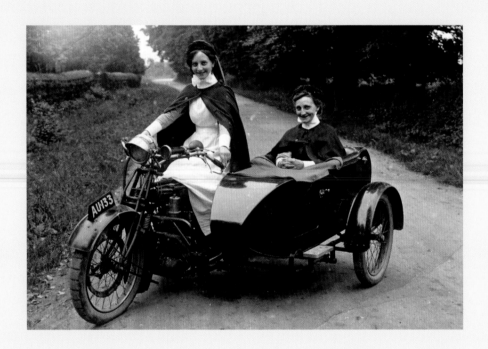

above Nurses ride in a motorcycle with a sidecar. England, c. 1915.

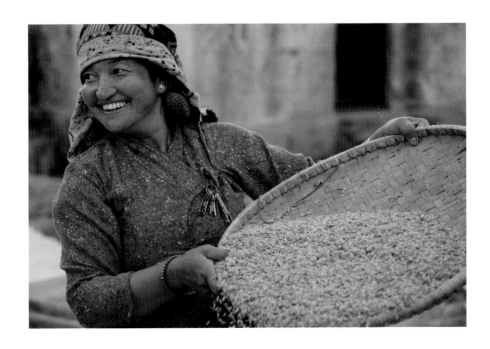

above A woman sifts grain on the street. Kathmandu, Nepal, 2013. overleaf New York City policewomen demonstrate the disadvantages of the traditional uniform while conducting police work. In 1979, the city no longer required women to wear skirts, black wool gloves, or cloth raincoats, or to carry a handbag. New York City, New York, 1979.

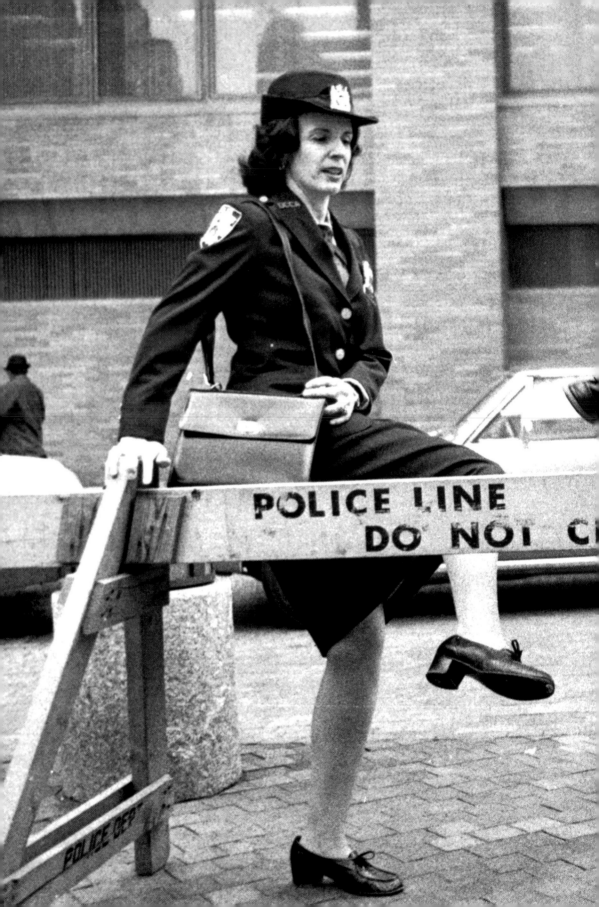

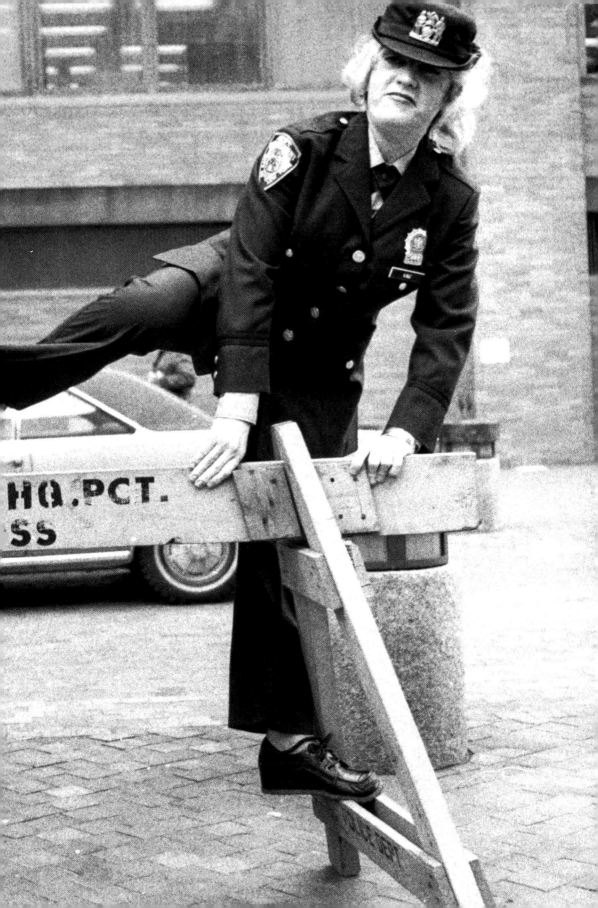

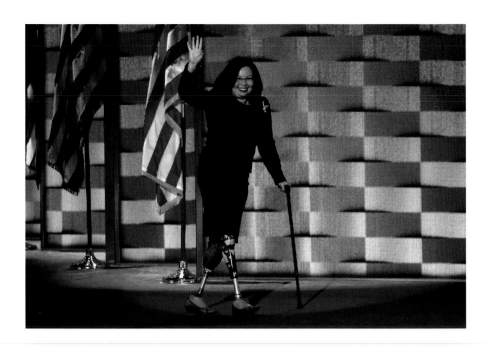

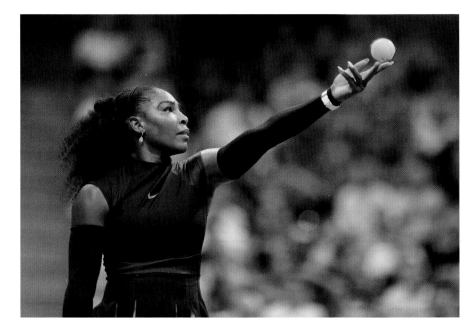

top Iraq War veteran and Illinois senator Tammy Duckworth—the first disabled woman elected to Congress—at the Democratic National Convention. Philadelphia, Pennsylvania, 2016. bottom American tennis player Serena Williams at the U.S. Open Tennis Tournament. Flushing, Queens, New York, 2016. opposite American war correspondent and photographer Peggy Diggins. United States, c. 1943.

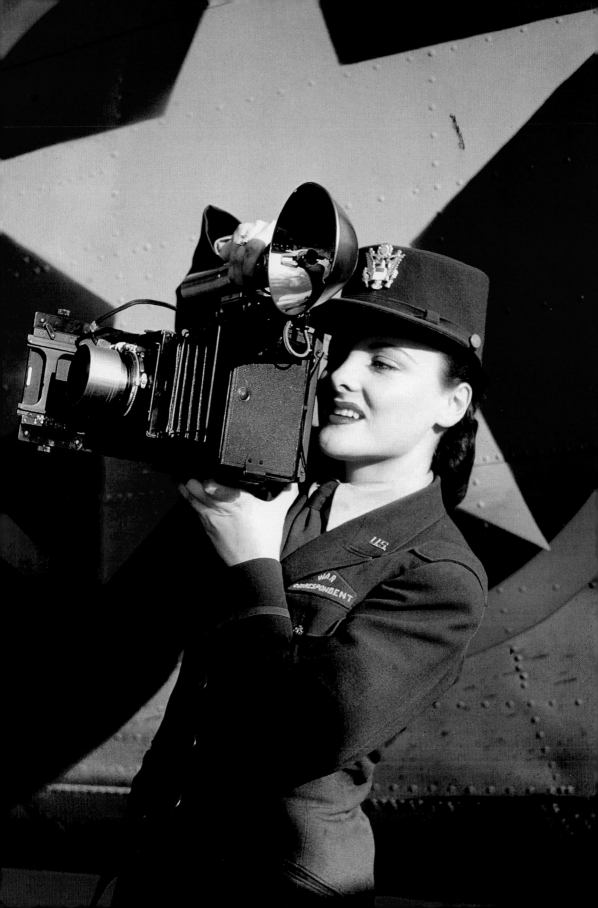

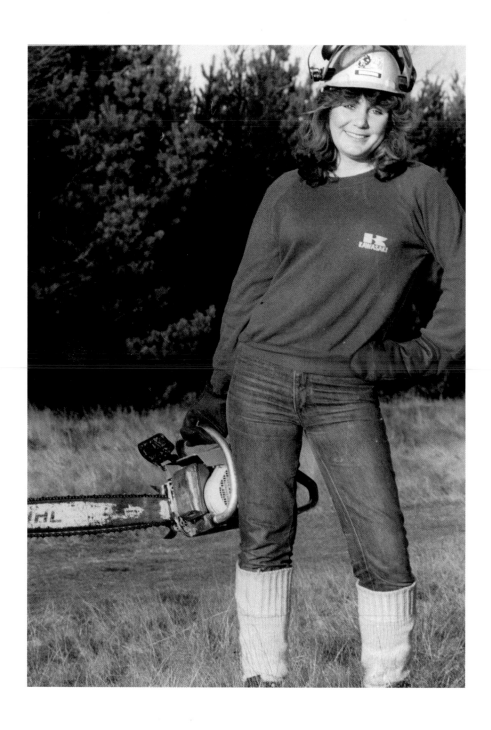

above A council worker and aspiring lumberjack learns to fell trees in her final year of a forestry and gardening certification course. England, 1980.

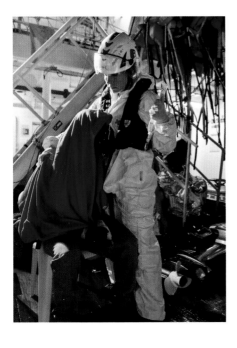

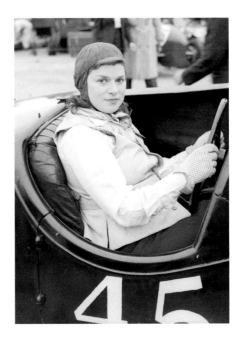

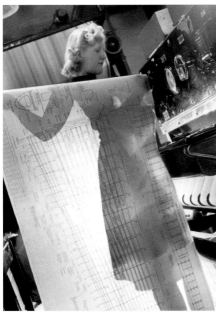

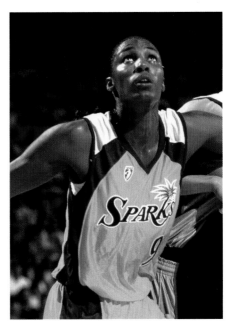

clockwise (from top left) A doctor from Red Cross International provides care to a rescued migrant. Mediterranean Sea, 2016; Dorothy Patten before the Junior Car Club race. West Sussex, England, 1948; Lisa Leslie of the Los Angeles Sparks during the inaugural WNBA game. Los Angeles, California, 1997; An Avro factory employee prepares to put a tracing through a blueprinting machine. Greater Manchester, England, 1942.

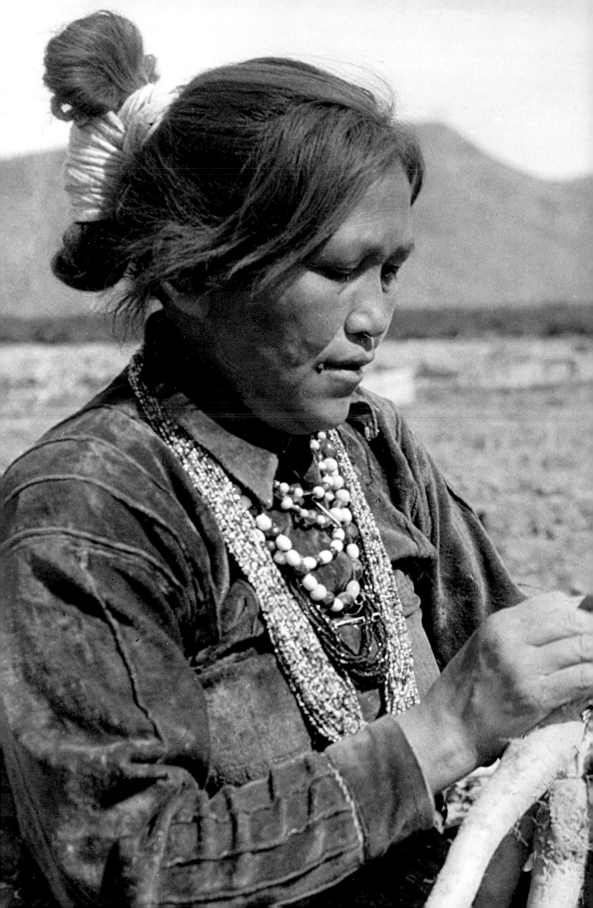

opposite A Navajo woman at the John Jacobs vegetable farm. Maricopa County, Arizona, 1944.

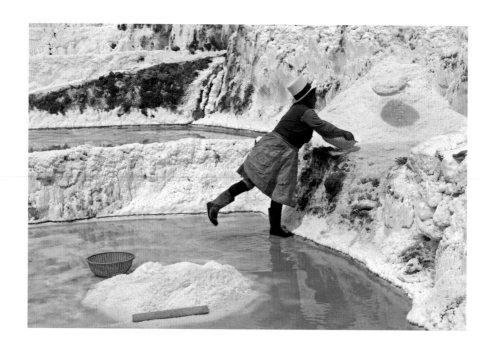

above A woman harvests salt from a plot in the salt pans. Maras, Peru, 2008. opposite Annie Easley at the NASA Glenn Research Center. In 1955, Easley began her career at the National Advisory Committee for Aeronautics as a human computer performing complex mathematical calculations. Cleveland, Ohio, 1955.

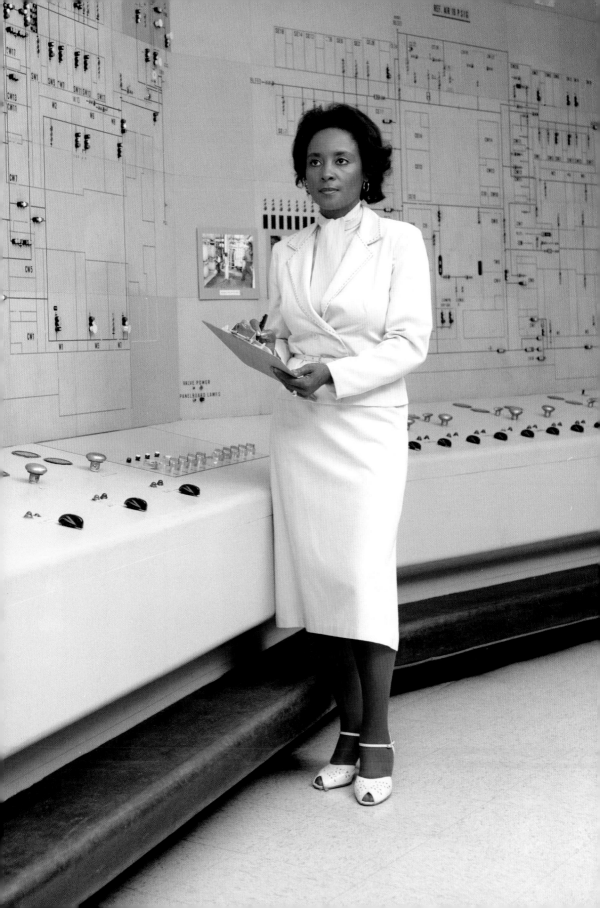

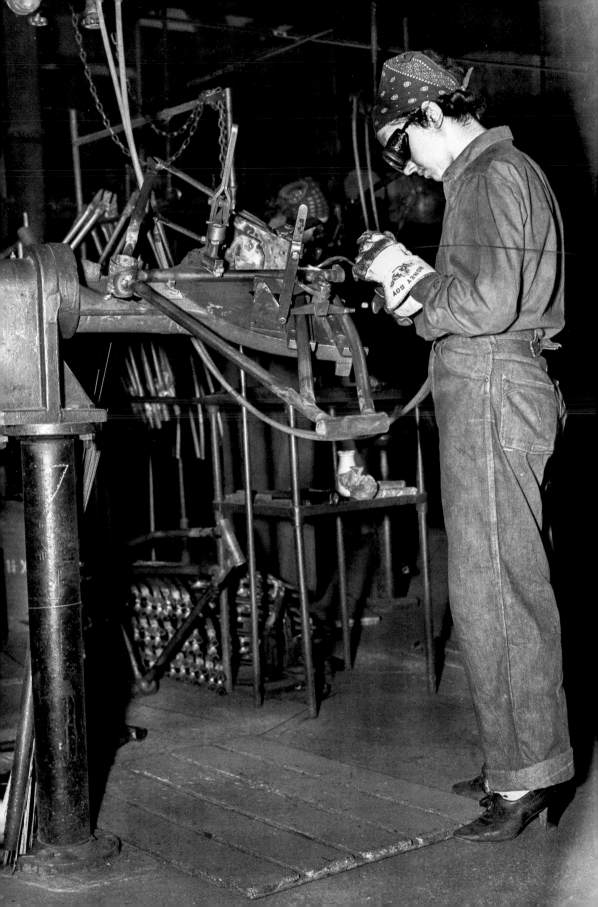

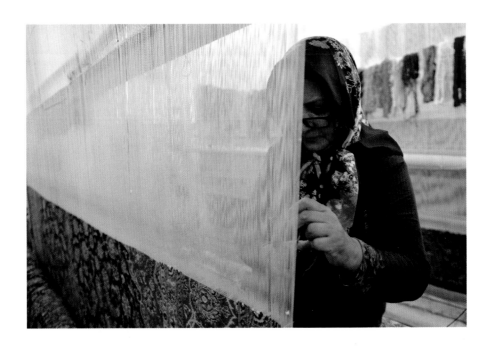

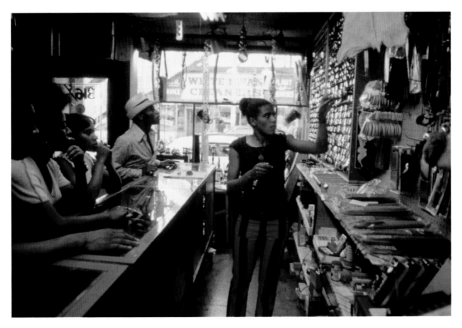

top A woman weaves a carpet at the Toranj o Mehrab handmade carpet factory. Kashan, Iran, 2016.
bottom A hardware store employee in Chicago's South Side. Chicago, Illinois, 1973. opposite A woman welds a bicycle frame at a manufacturing plant. Chicago, Illinois, 1937.

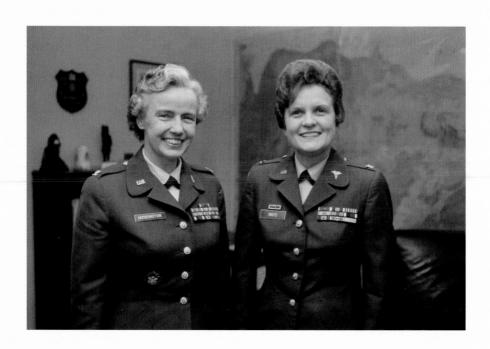

above Colonels Elizabeth P. Hoisington (left) and Anna Mae Hays (right) at the Pentagon shortly after President Nixon nominated them to the rank of brigadier general. They were the first two women to ascend to this level. Washington, D.C., 1970.

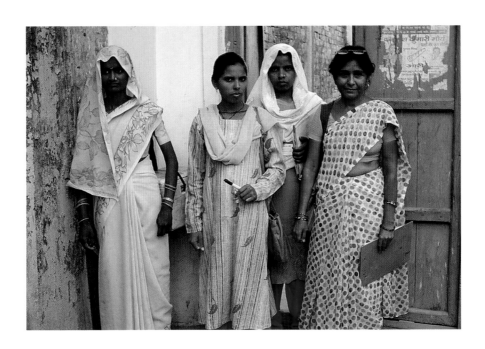

above Health workers take part in polio immunization efforts. India, 2006.

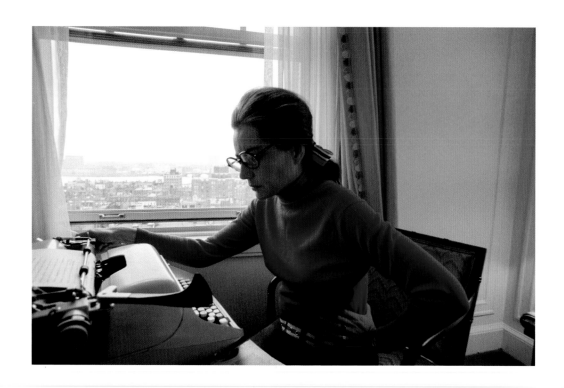

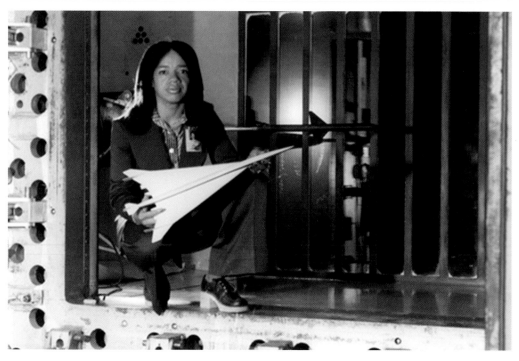

top American journalist Barbara Walters. United States, 1970. bottom Christine Darden, a mathematician, data analyst, and aeronautical engineer for NASA, at Langley Research Center. Over her forty-year career, Darden researched supersonic flight and sonic booms. Hampton, Virginia, 1973.

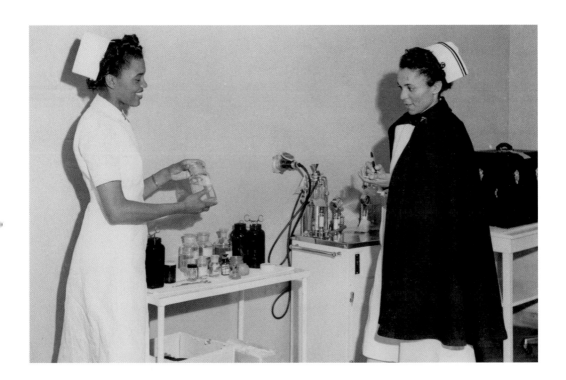

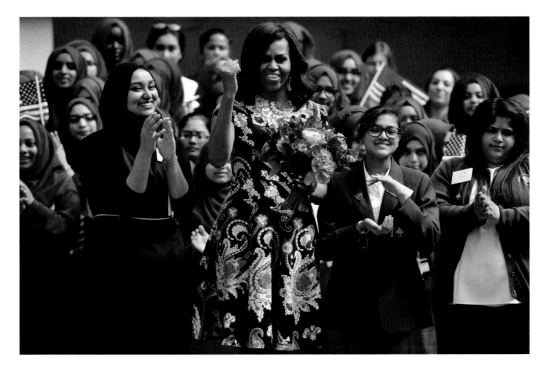

top Captain Mary L. Petty (left) and Second Lieutenant Olive Bishop (right) inspect an operating room at a camp hospital. Petty would go on to head the first contingent of African American nurses to arrive in Europe. Fort Huachuca, Arizona, c. 1944. bottom Former First Lady Michelle Obama visits London's Mulberry School for Girls as part of the global tour to promote her Let Girls Learn initiative. London, England, 2015.

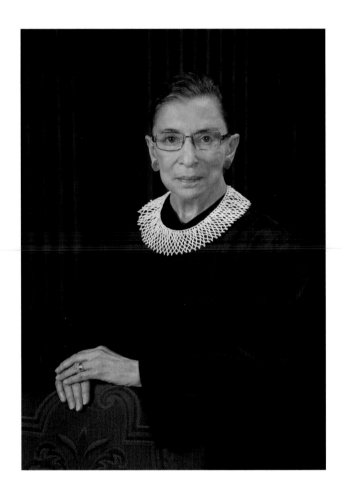

above Ruth Bader Ginsburg, associate justice of the Supreme Court. She was the second female justice in history to be confirmed, and is one of four female justices ever to serve on the court. Washington, D.C., 2010. opposite American political activist Angela Davis. Moscow, Russia, 1972.

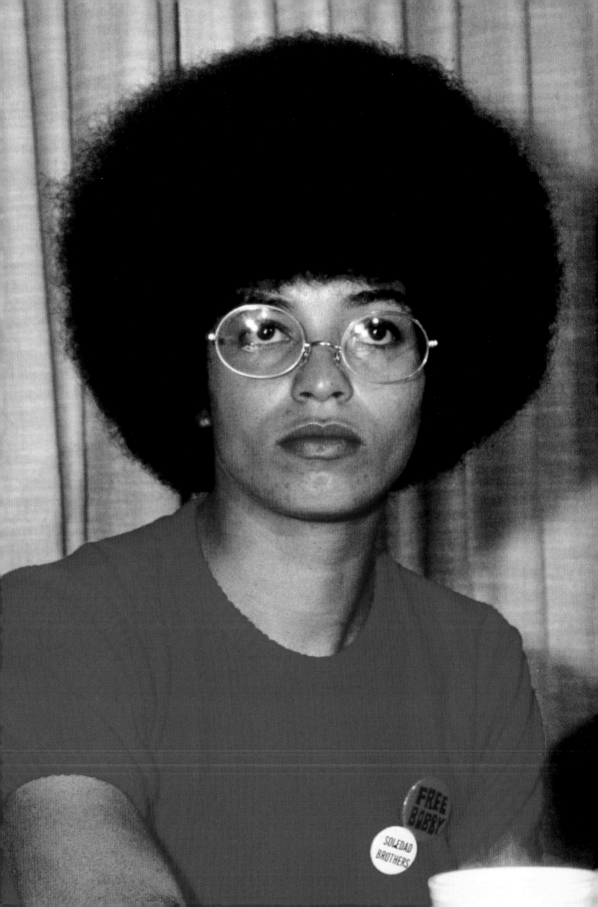

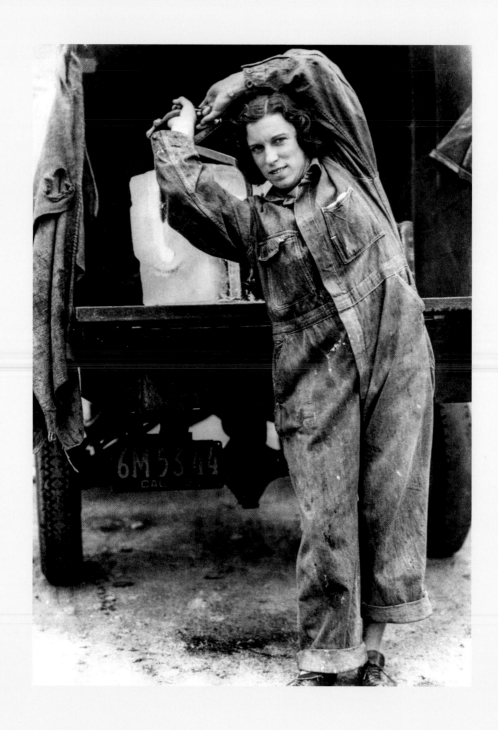

above A woman makes an ice delivery. California, 1931.

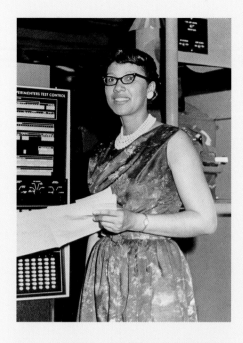

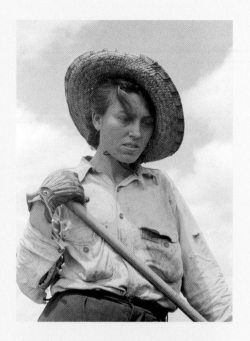

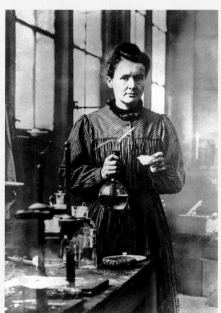

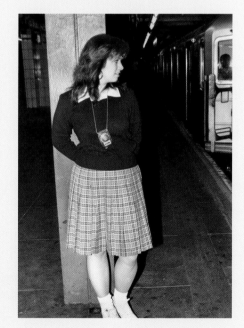

clockwise (from top left) Melba Roy Mouton, head mathematician for the Echo satellites at Goddard Space Center. She later was head computer programmer and assistant chief of research programs of NASA's Trajectory and Geodynamics Division. Washington, D.C., c. 1960; Sharecropper. Missouri, 1938; An undercover detective. New York City, New York, 1990; French chemist and physicist Marie Curie. Paris, France, 1906.

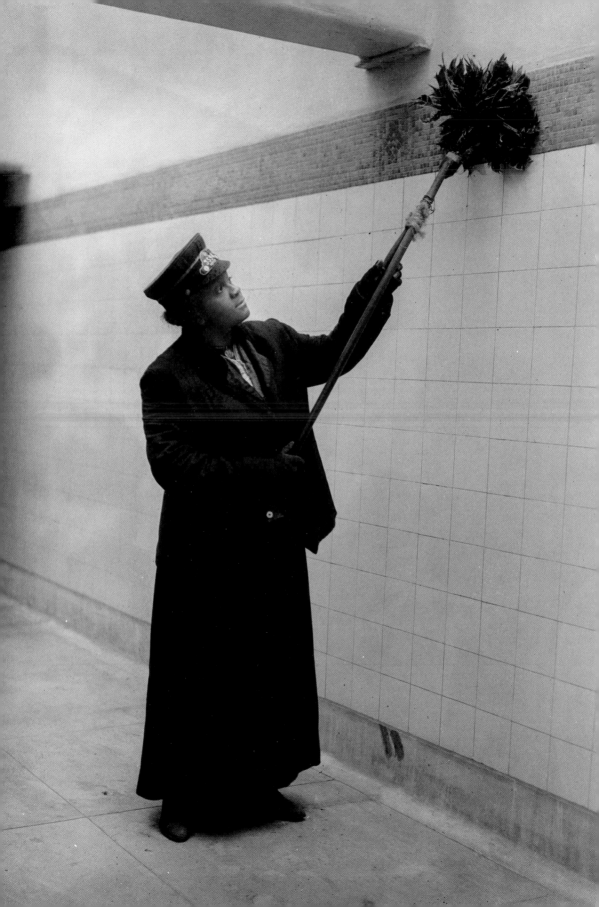

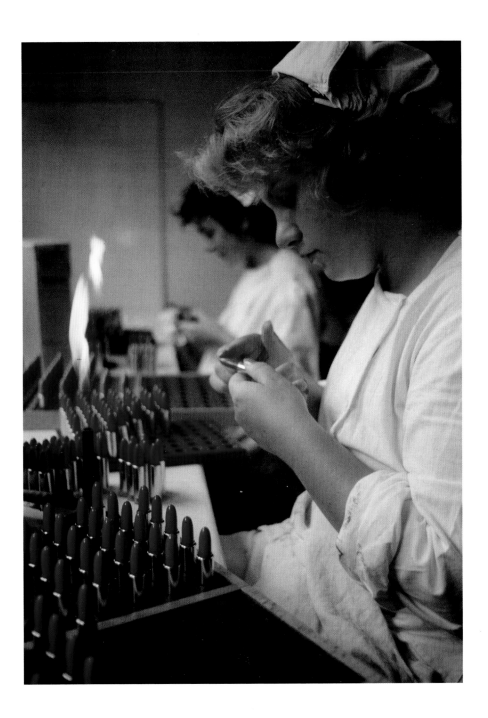

above A factory employee inspects lipsticks fresh from production. Monaco, 1963. opposite Subway porter.
New York City, New York, 1917. overleaf French fashion model Sophie Malgat is photographed by an
unidentified woman. Paris, France, 1950.

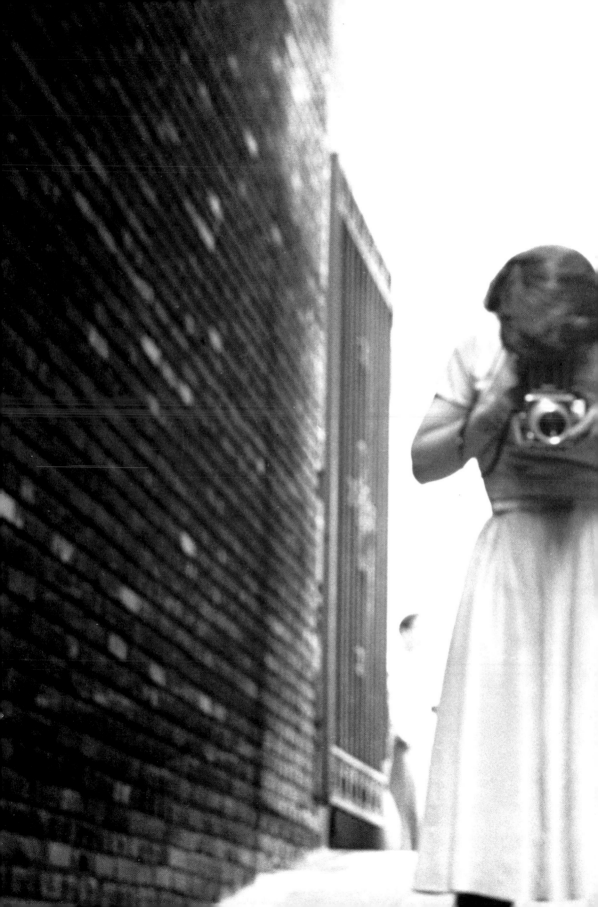

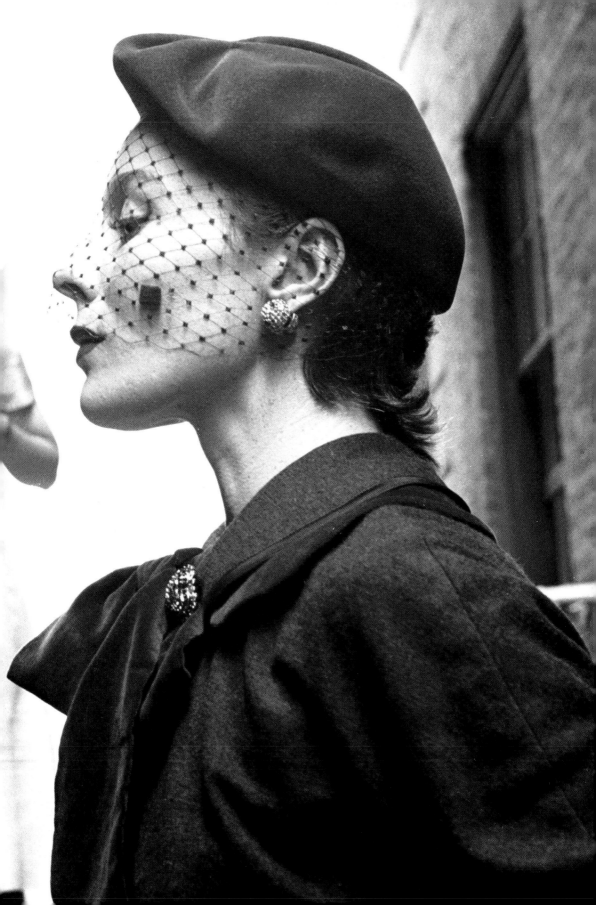

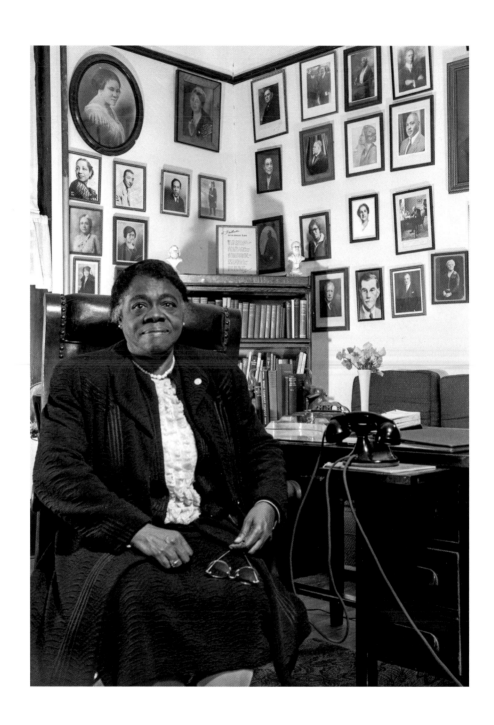

above Dr. Mary McLeod Bethune, seated in her office at Bethune-Cookman University, a private school she founded in 1904 for African American students. A prominent civil rights activist, Bethune was appointed the director of the National Youth Administration's Division of Negro Affairs—becoming the first African American female division head—by Franklin Delano Roosevelt. Daytona Beach, Florida, 1943.

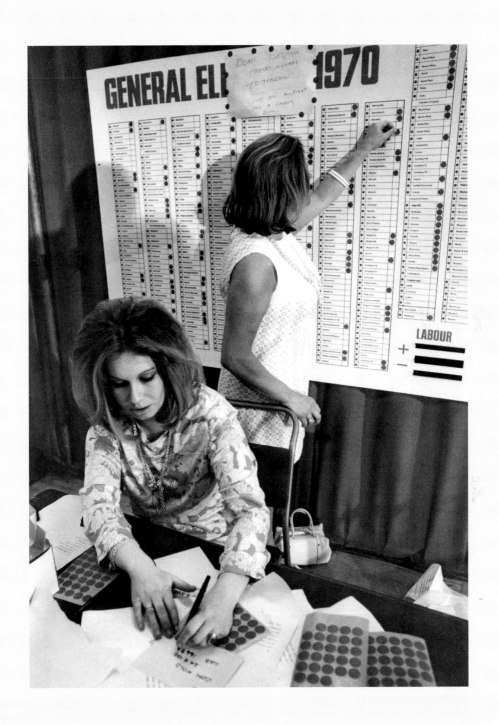

above Two women at the Labour Party headquarters during the 1970 general election. London, England, 1970.

opposite A migrant cotton picker and her baby, photographed by Dorothea Lange for the U.S. Farm Security Administration program, which sought to raise awareness of poverty during the Great Depression. Near Buckeye, Maricopa County, Arizona, 1940. overleaf Frances Clalin Clayton, a woman who disguised herself as a man to fight for the Union Army during the Civil War. Boston, Massachusetts, c. 1865.

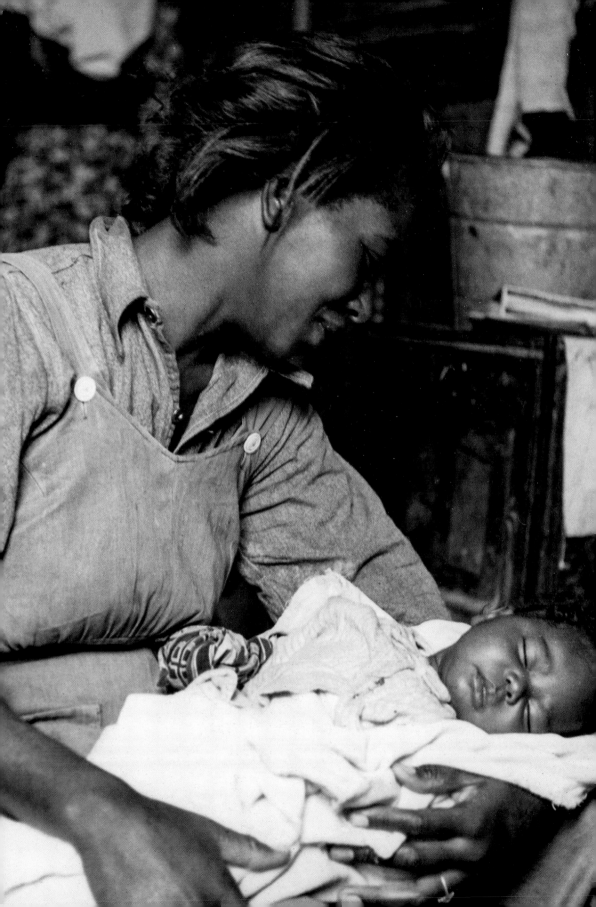

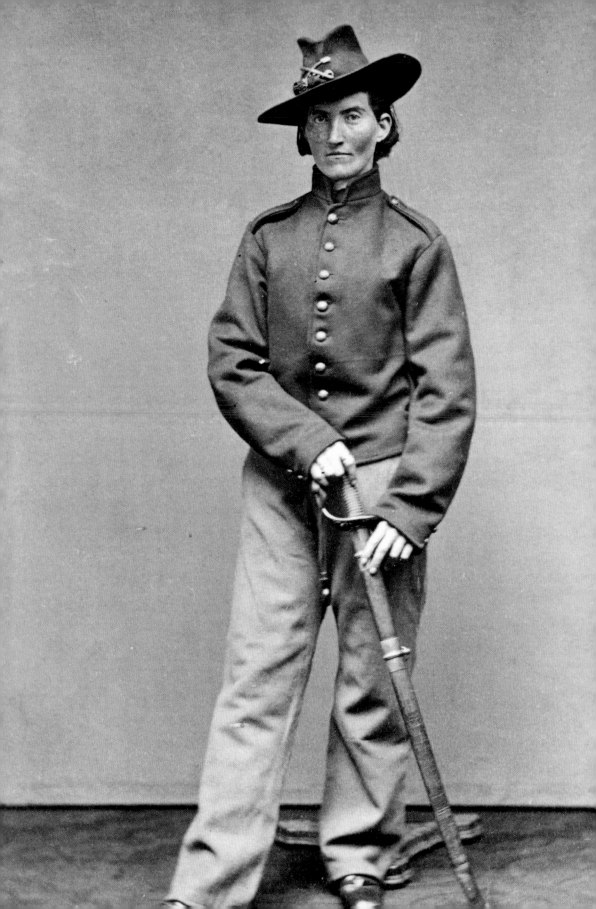

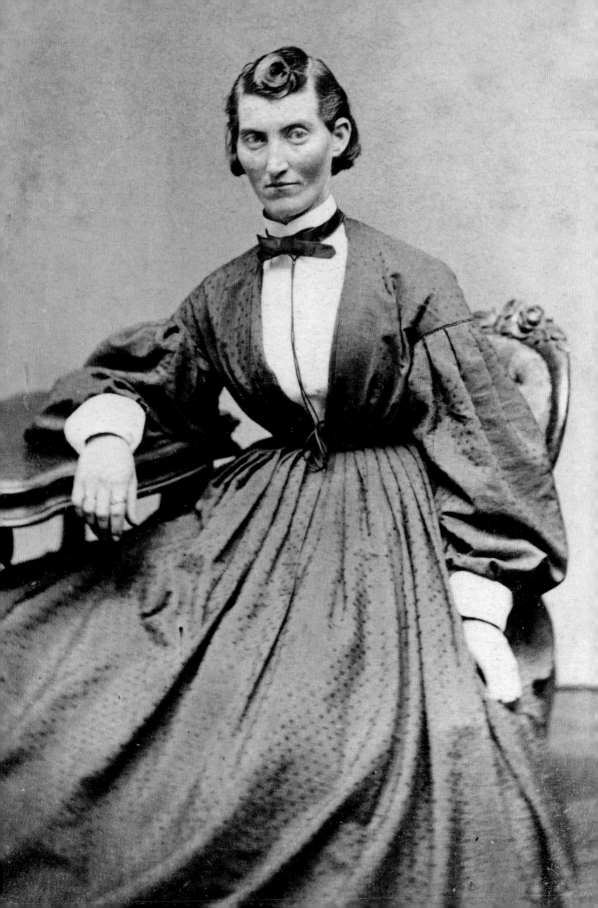

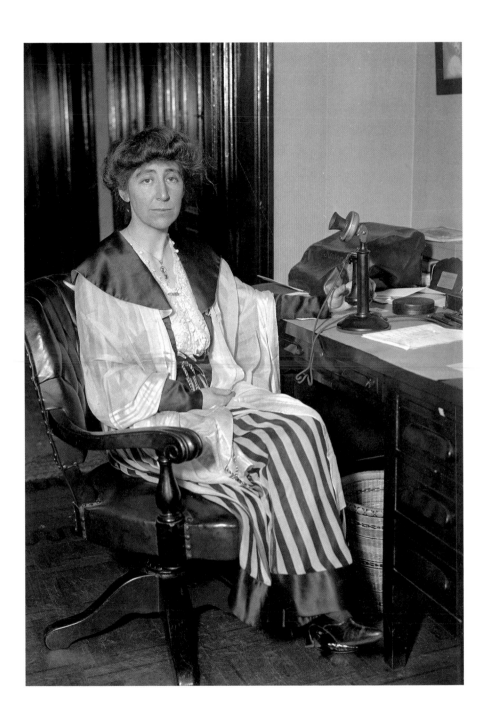

above American politician and women's rights advocate Jeannette Rankin at her desk. Rankin became the first woman to hold national office in the United States when she was elected to the U.S. House of Representatives by Montana in 1916. Washington D.C., c. 1918.

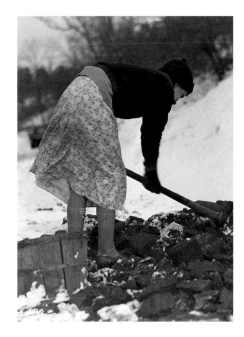
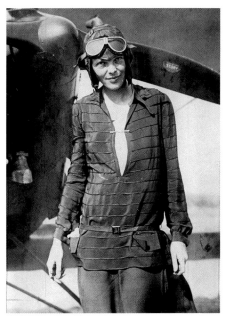
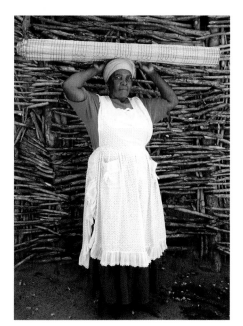

clockwise (from top left) Filipino women tend sugarcane, wearing bonnets customarily worn by Japanese laborers in the 1940s and 1950s. Maui, Hawaii, 1973; A woman gathers coal. Scotts Run, West Virginia, 1937; A woman sells traditional Zulu mats. KwaZulu-Natal, South Africa, 2012; American aviator Amelia Earhart, the first woman to make a solo flight across the Atlantic Ocean. Trepassey, Newfoundland, 1928.

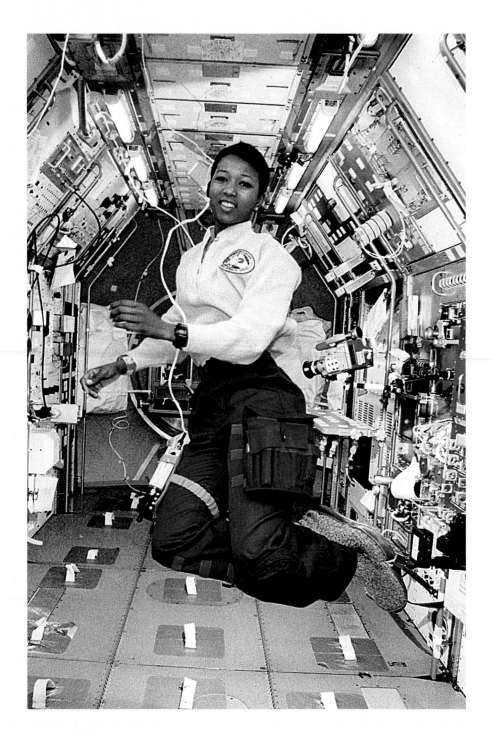

above Mae Jemison, the first African American woman to travel in space, works in Spacelab-J on board the space shuttle *Endeavour*, 1992.

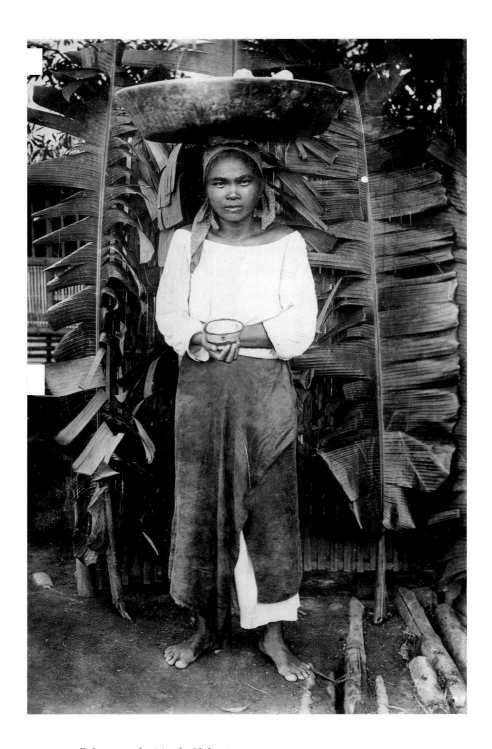

above A woman sells banana cake. Manila, Philippines, c. 1910.

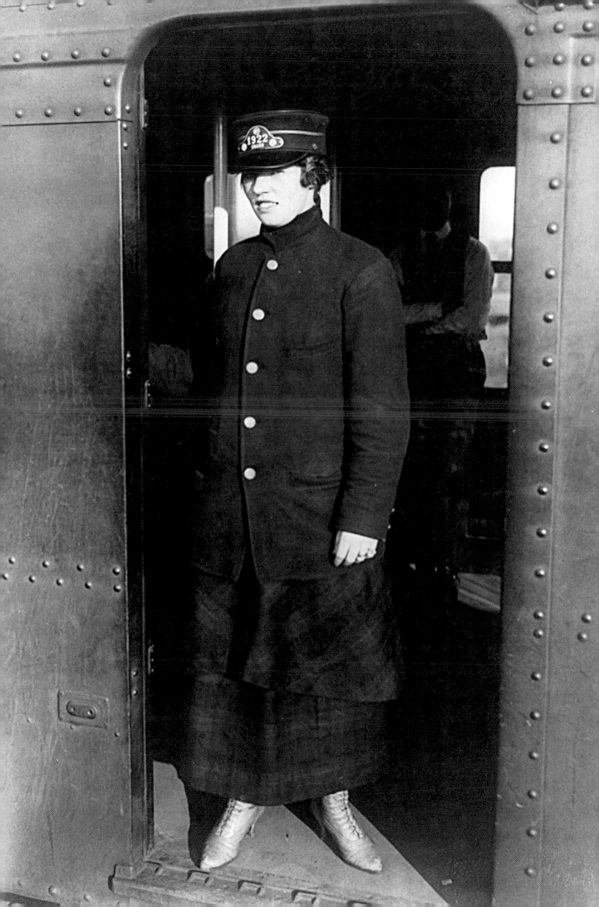

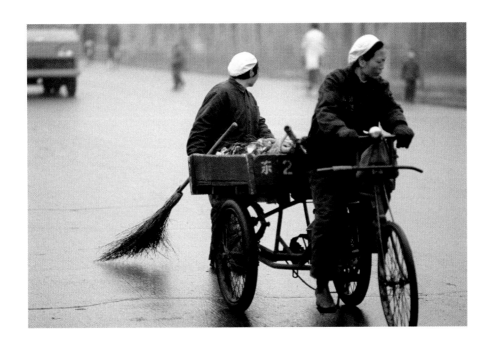

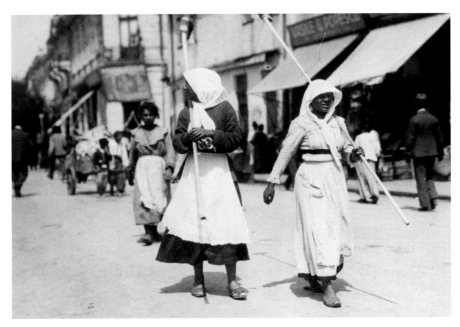

top Two street cleaners travel through the city in a bicycle cart. Beijing, China, 1973. bottom Members of the "White Wings," or street cleaners. Bucharest, Romania, 1920. opposite An attendant stands in a subway door. New York City, New York, 1917. overleaf Members of the 6888th Central Postal Directory—an all-female, all-African American battalion—arrive home from France. New York City, New York, 1946.

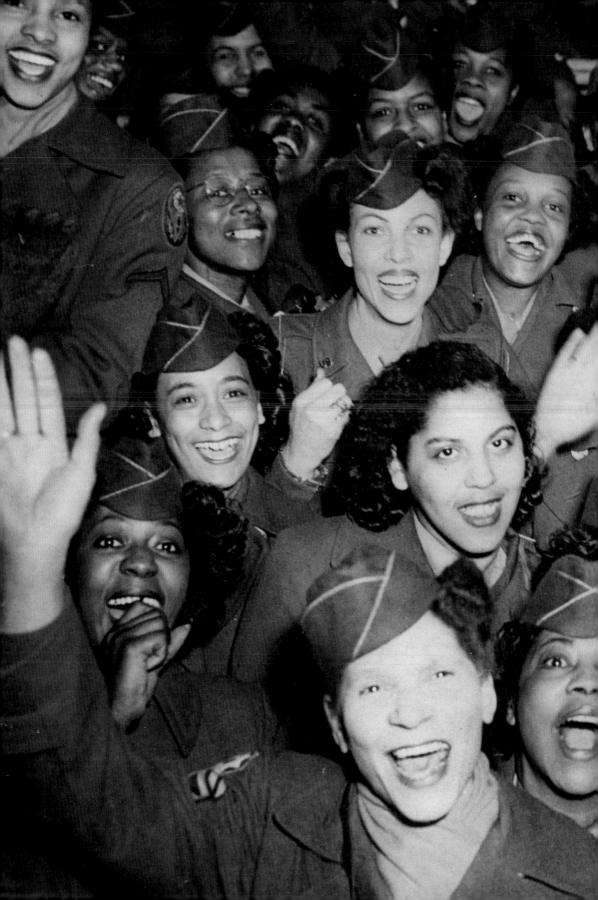

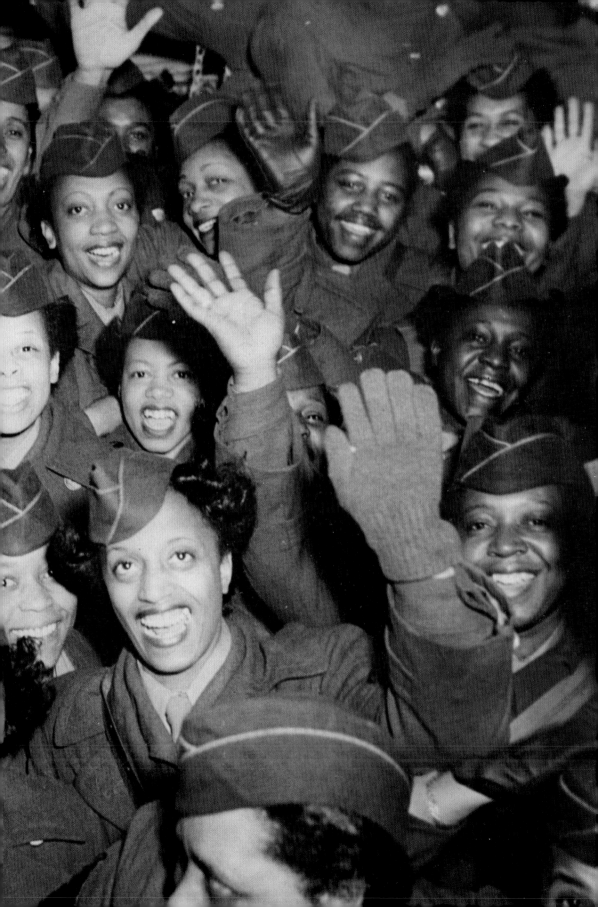

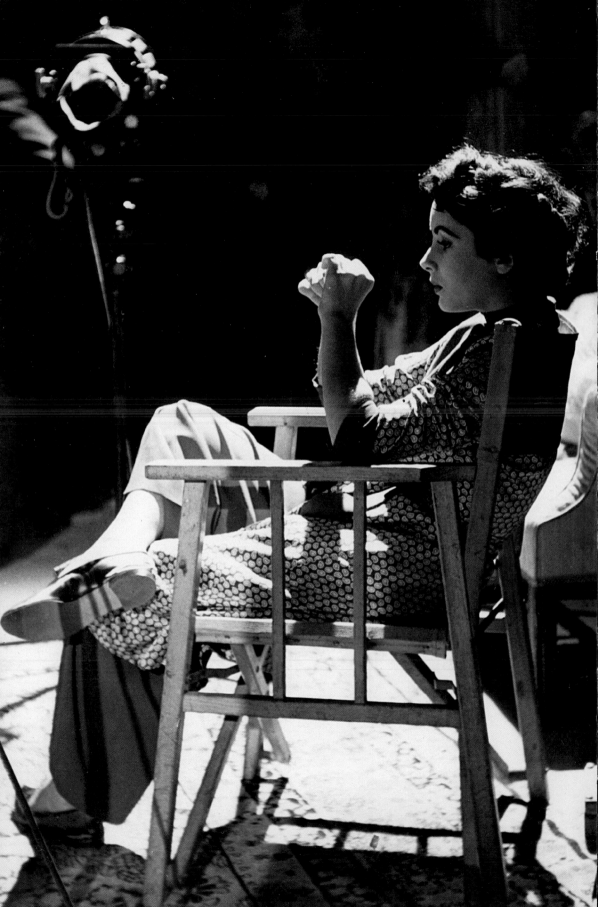

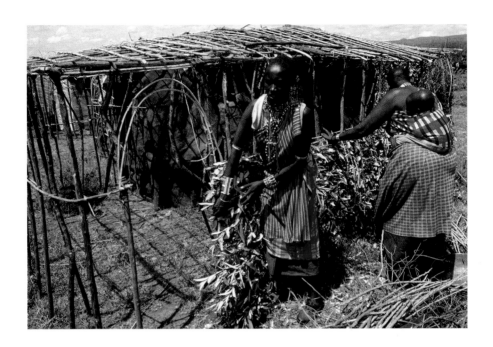

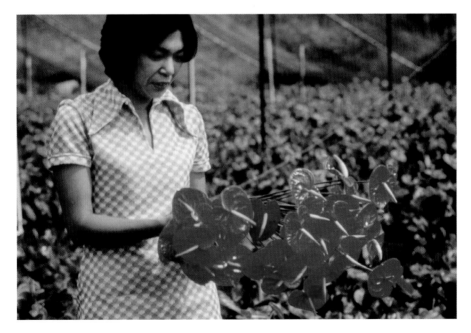

top Two Maasai women build a shelter while one carries a child on her back. The red of these women's clothing is customary in their culture, as are their shaved heads. Kenya or Tanzania, 1989. bottom A woman tends to anthuriums in a Hawaiian greenhouse. Hilo, Hawaii, 1973. opposite Actress Elizabeth Taylor on the set of the British thriller film *Conspirator*. London, England, 1948.

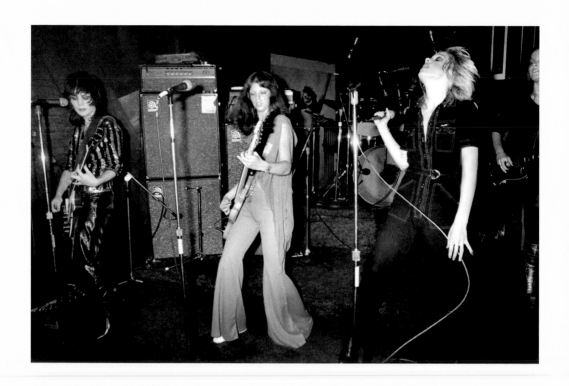

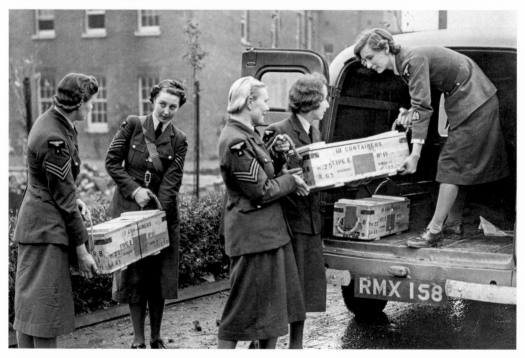

top The Runaways performing live at CBGB. New York City, New York, 1976. bottom Members of the Women's Auxiliary Air Force load military supplies into the back of a truck at a Royal Air Force station. England, 1939.

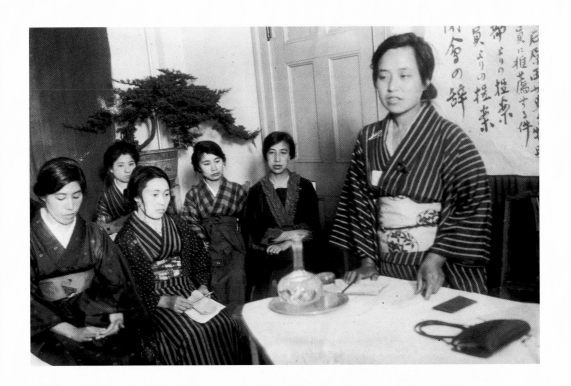

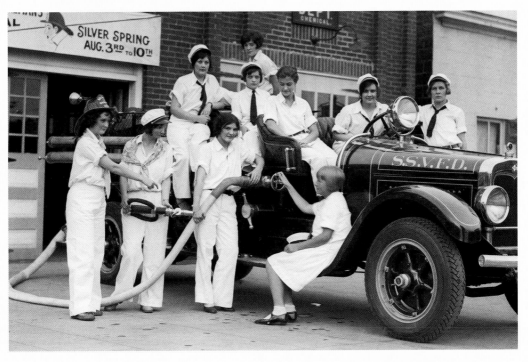

top A nineteenth-century geisha school. Trained to host and entertain, geishas are skilled in dance, conversation, and music. Japan, 1849. bottom A volunteer firefighter brigade. Silver Spring, Maryland, 1928.

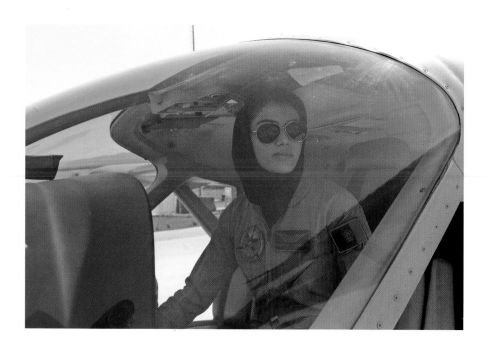

above Twenty-three-year-old Niloofar Rahmani sits in the cockpit of her fixed-wing Afghan Air Force aviator aircraft. She became the first female pilot in the Afghan military since the fall of the Taliban in 2001. Kabul, Afghanistan, 2015. opposite A woman sorts millet in her village. Near Banjul, Gambia, 1981.

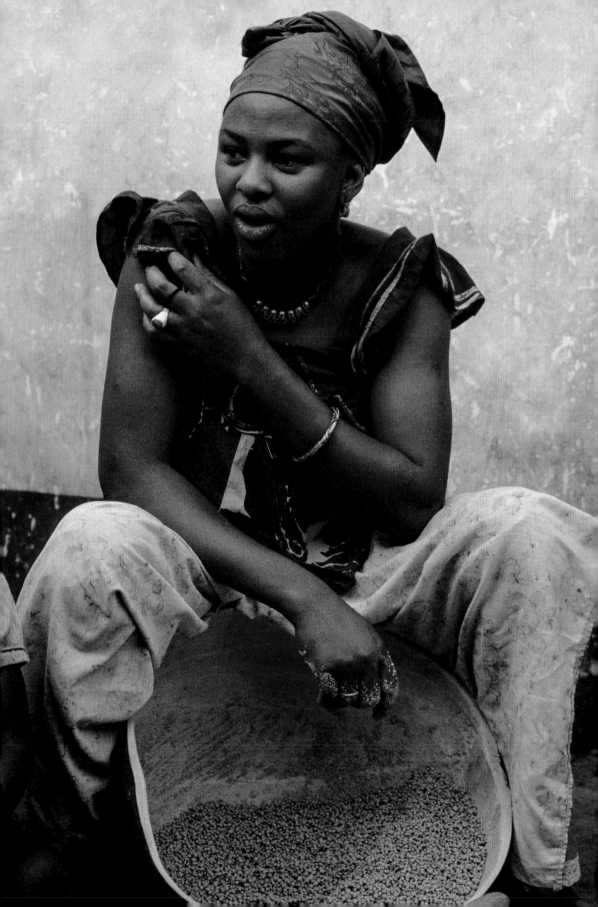

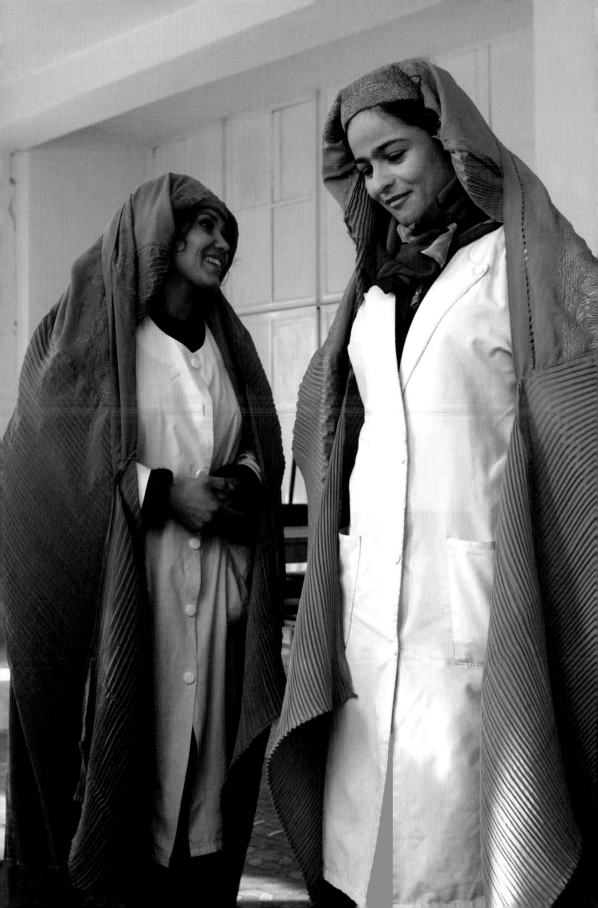

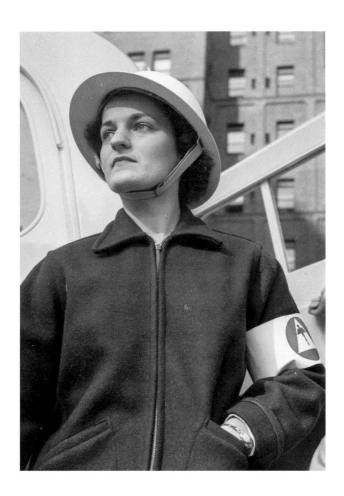

above Nurse in training. New York City, New York, 1942. opposite Nurses at Wazir Akbar Khan Hospital. After the Taliban abandoned Kabul, dress restrictions and rules barring male and female interaction were lifted. The medical staff could treat members of the opposite sex, women were once more permitted to wear makeup, and patients in the wards could receive visits from their spouses. Kabul, Afghanistan, 2001.

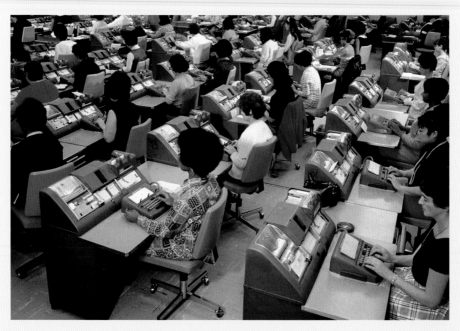

top An electoral agent examines the voters roll as Zambians line up outside to cast their ballots in the Zambian presidential election. Lusaka, Zambia, 2015. bottom Women work in the bookkeeping room at Bank of America. Los Angeles, California, c. 1970. opposite A factory worker balances a stack of cigarette packs ready for shipment. Ballymena, Northern Ireland, 1962.

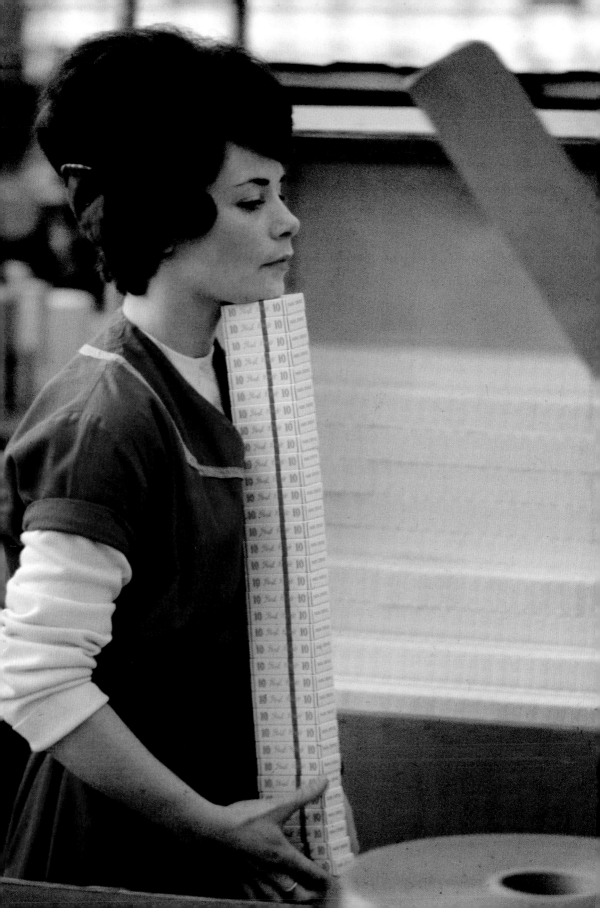

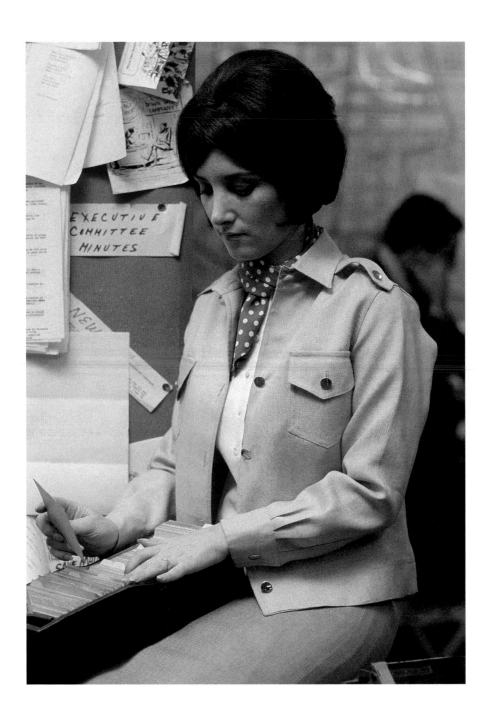

above An art teacher looks through a card catalog at Village Independent Democrats, a progressive political club based in New York City's Greenwich Village. New York City, New York, 1964.

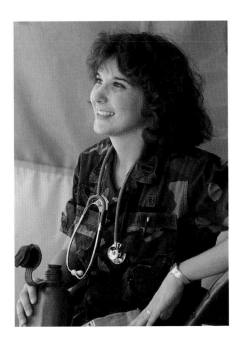

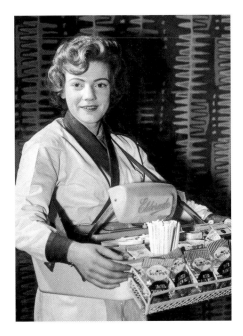

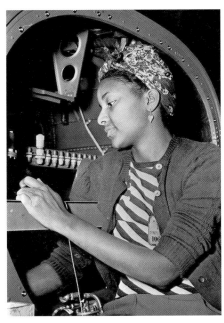

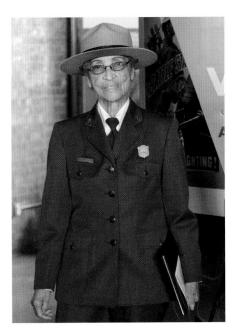

clockwise (from top left) A physician awaits patients at an American military hospital during the Persian Gulf War. Dhahran, Saudi Arabia, 1990; A movie usher sells ice cream and cigarettes. Glasgow, Scotland, 1957; Betty Reid Soskin, the oldest full-time National Park Service ranger. Richmond, California, 2013; A Douglas Aircraft Company employee manufactures plane parts. Long Beach, California, c. 1939–1945.

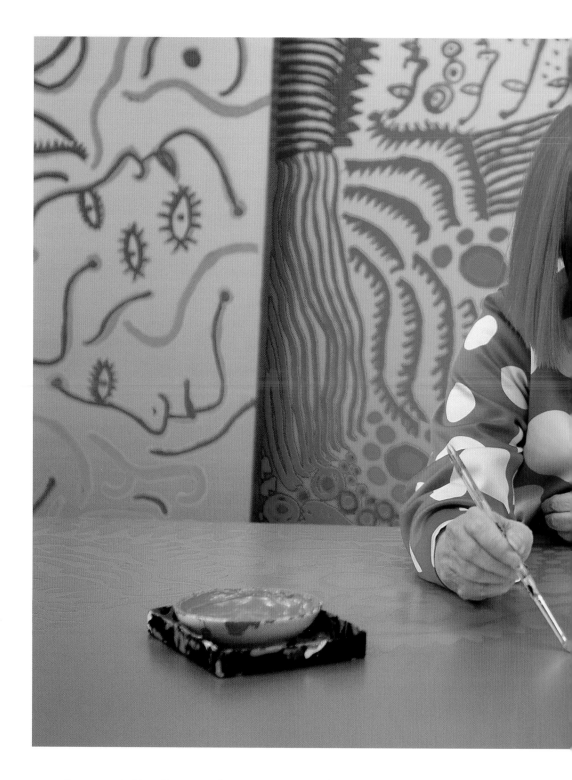

above Japanese artist Yayoi Kusama works on a new painting in her studio. Tokyo, Japan, 2012.

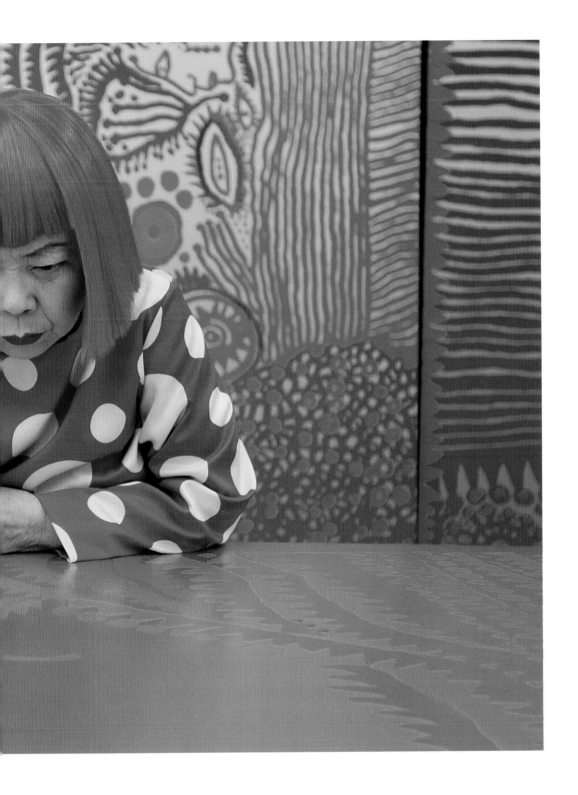

opposite A vendor rows on the Mekong Delta to the floating market, where she intends to sell her crop of chilies. Cần Thơ, Vietnam, 1993.

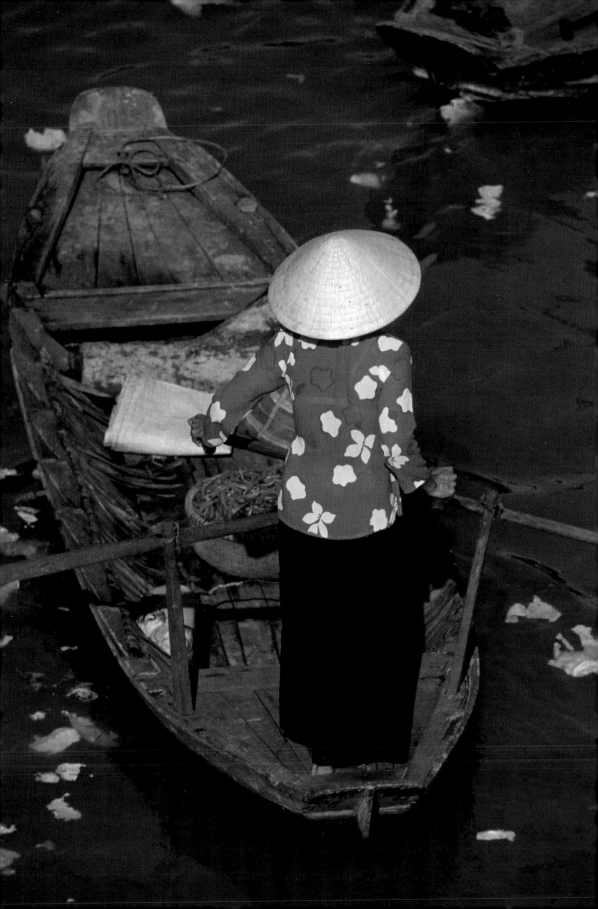

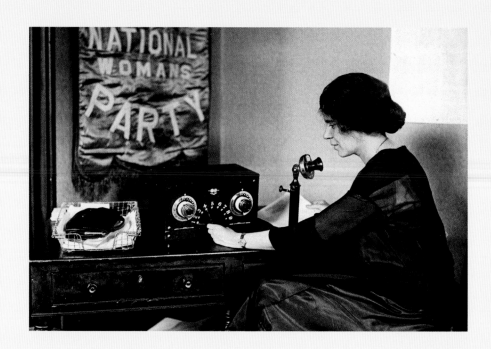

above Alice Paul, suffragette and vice president of the National Woman's Party, broadcasts plans for the dedication of the party's new national headquarters from her desk at the Capitol. Washington, D.C., 1922.

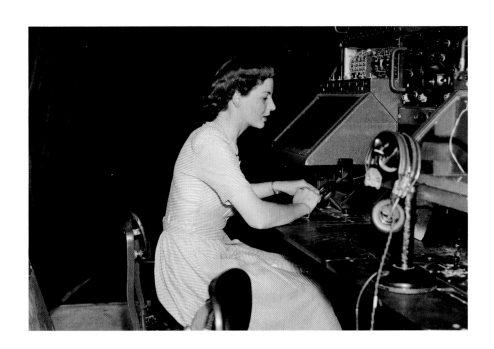

above A radar tracker at London Airport, after bringing the airport's one thousandth airliner to a safe landing. London, England, 1949.

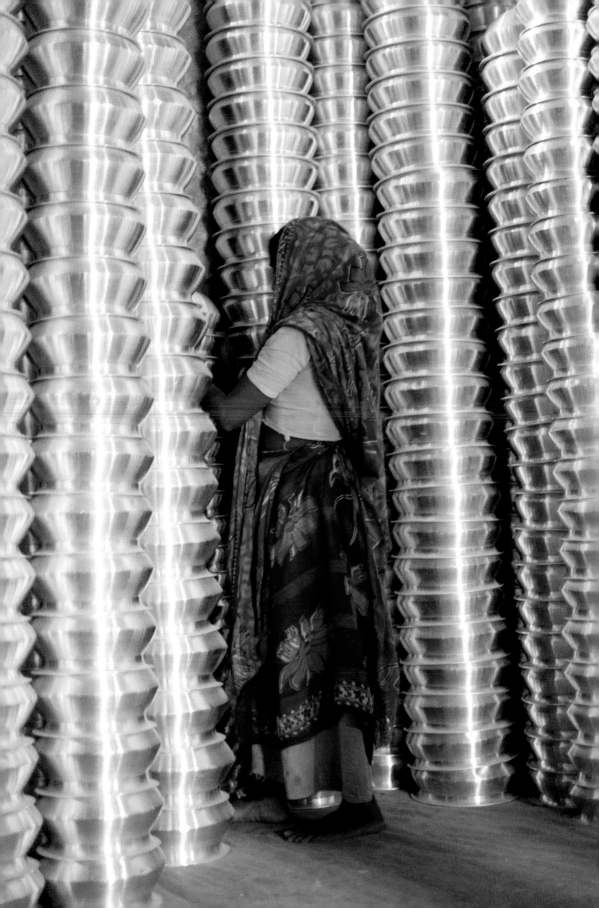

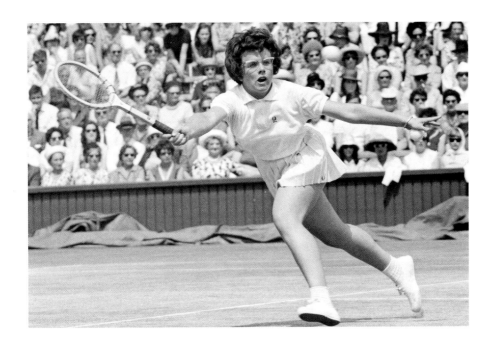

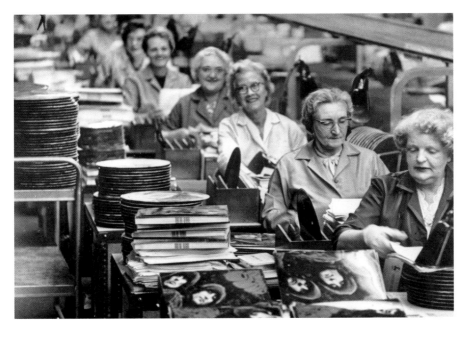

top American tennis player Billie Jean King during a Wimbledon semifinal. London, England, 1964.
bottom Workers on a vinyl record production line in an EMI factory package finished copies of *Rubber Soul* by The Beatles. Hayes, England, 1965. opposite A woman arranges aluminum cookware in a factory. Dhaka, Bangladesh, 2008.

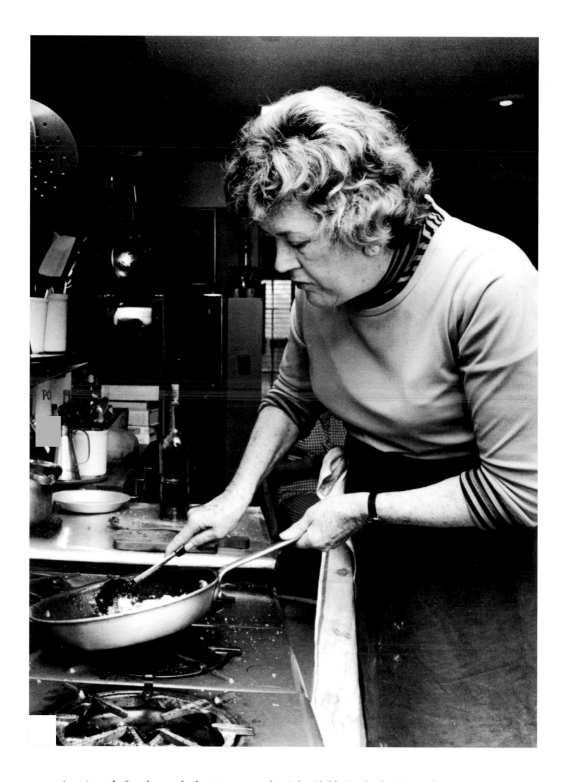

above American chef, author, and television personality Julia Child. Cambridge, Massachusetts, 1975.

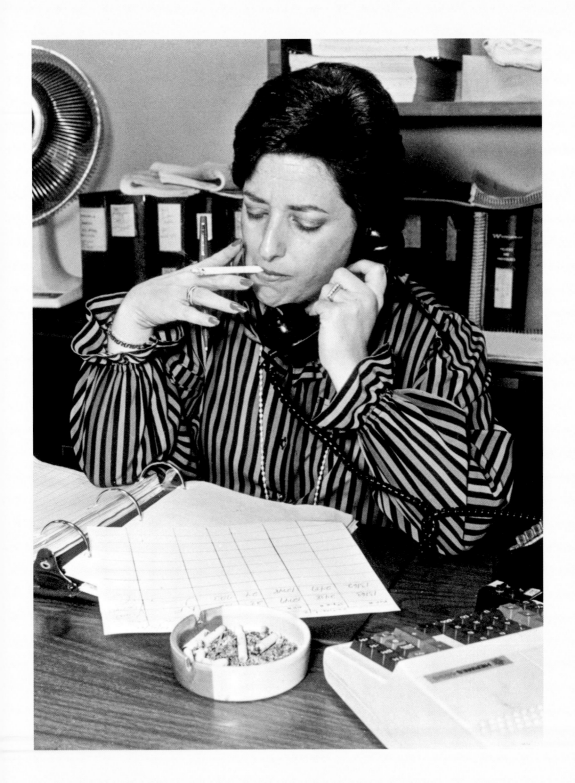

above A bookkeeper smokes a cigarette at her desk. New York City, New York, 1982.

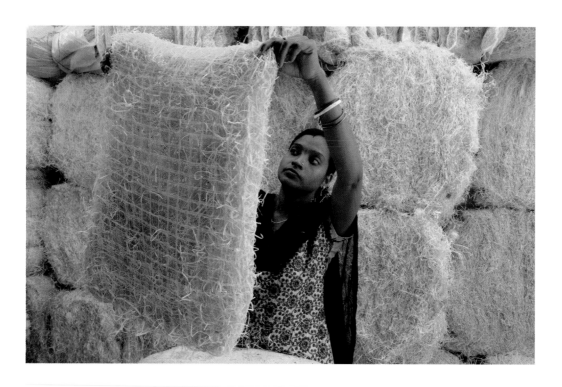

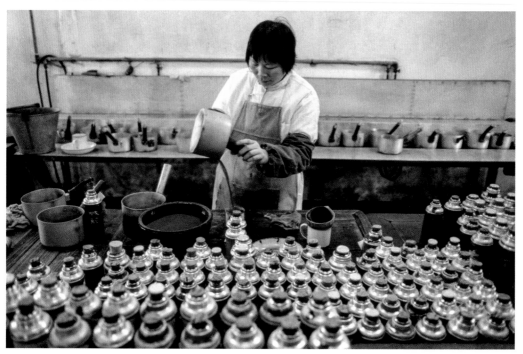

top A woman inspects a pad made of shredded wood fiber at an air-conditioning factory. Hyderabad, India, 2017.
bottom A pharmacist boils medicine. Shanghai, China, 1980.

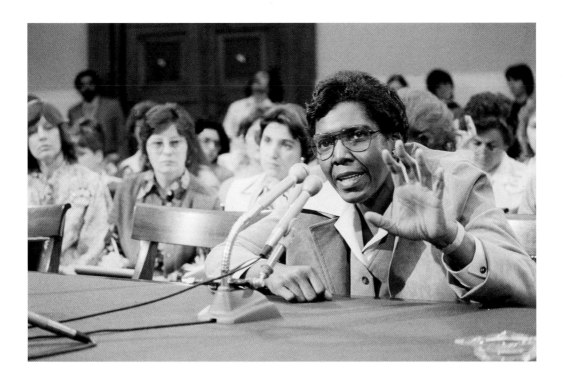

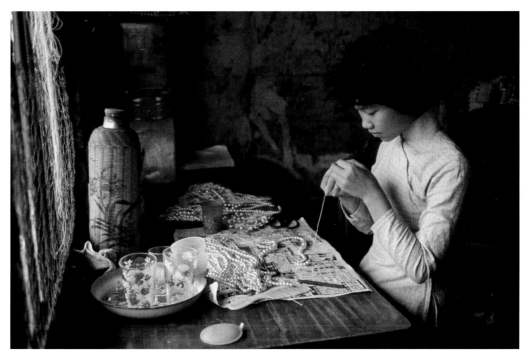

top Representative Barbara Jordan addresses a House Judiciary subcommittee at a hearing for the proposed Equal Rights Amendment. Washington, D.C., 1978. bottom A woman strings imitation pearls for costume jewelry at home. Hong Kong, China, 1962.

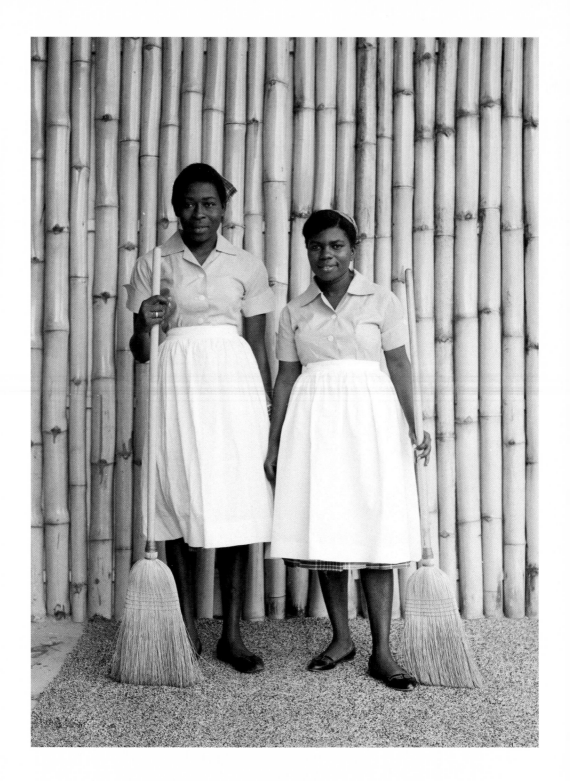

above Housekeepers at a resort pose in uniform with their brooms. St. Ann's Bay, Jamaica, c. 1950s.

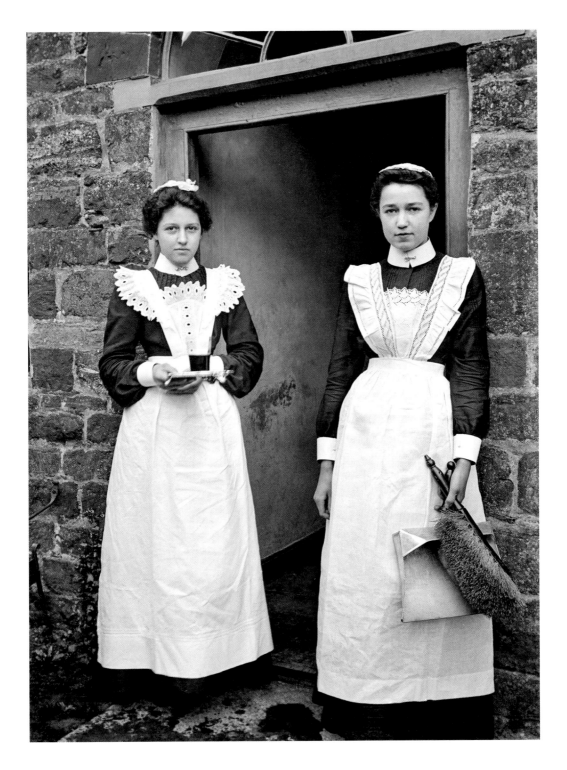

above Two maids in uniform stand outside their place of work. Byfield, Northamptonshire, England, c. 1896–1920.

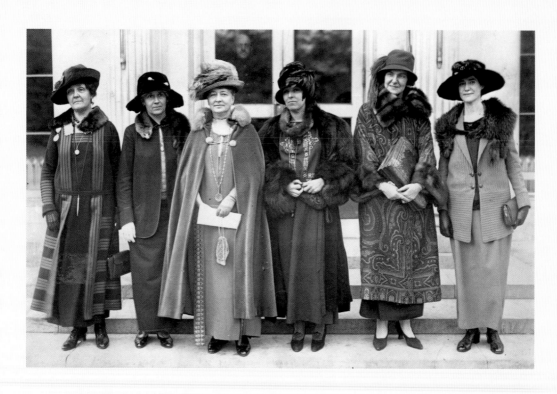

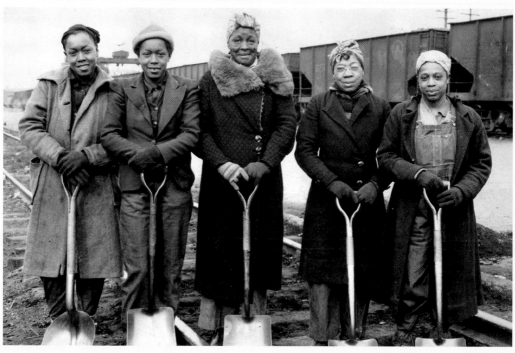

top Suffragists from the League of Women Voters outside the White House. The women were meeting with a commission on voting issues. Washington, D.C., 1920. bottom Track-women of the Baltimore and Ohio Railroad Company. They helped maintain railroad tracks during World War II. United States, 1943.

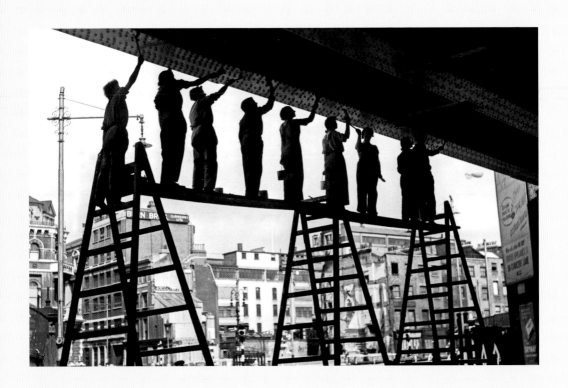

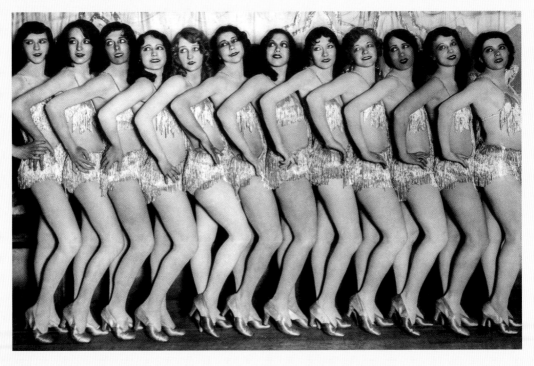

top A group of female war workers paint a railway bridge on the Southern Railway. London, England, 1942.
bottom Chorus girls. Los Angeles, California, 1925.

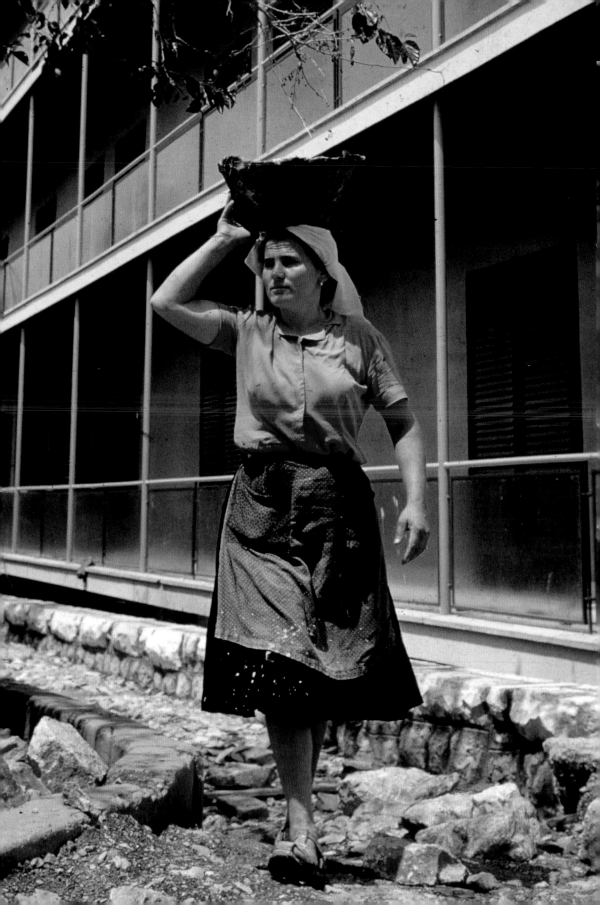

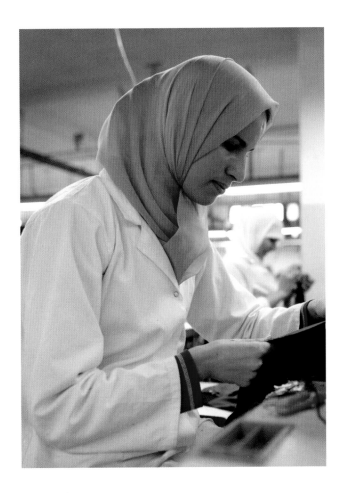

above An employee at her sewing machine on the factory floor of a textiles production company. Tangier, Morocco, 2011. opposite A woman carries plaster into a new apartment building. Sibenik, Yugoslavia (present-day Croatia), 1962.

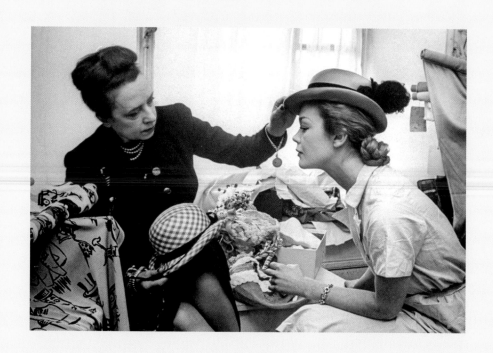

above Italian fashion designer Elsa Schiaparelli tries out different hats on a model's head. Paris, France, 1951.

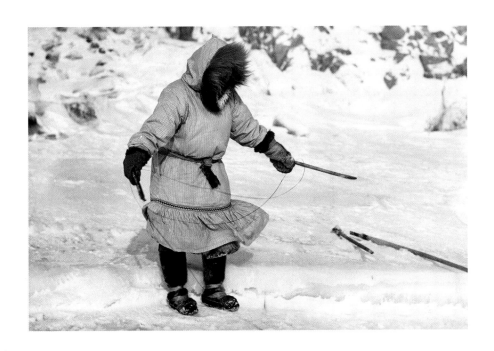

above An Inuit woman fishes with a hook that has no barbs. Location unknown, c. 1950s.

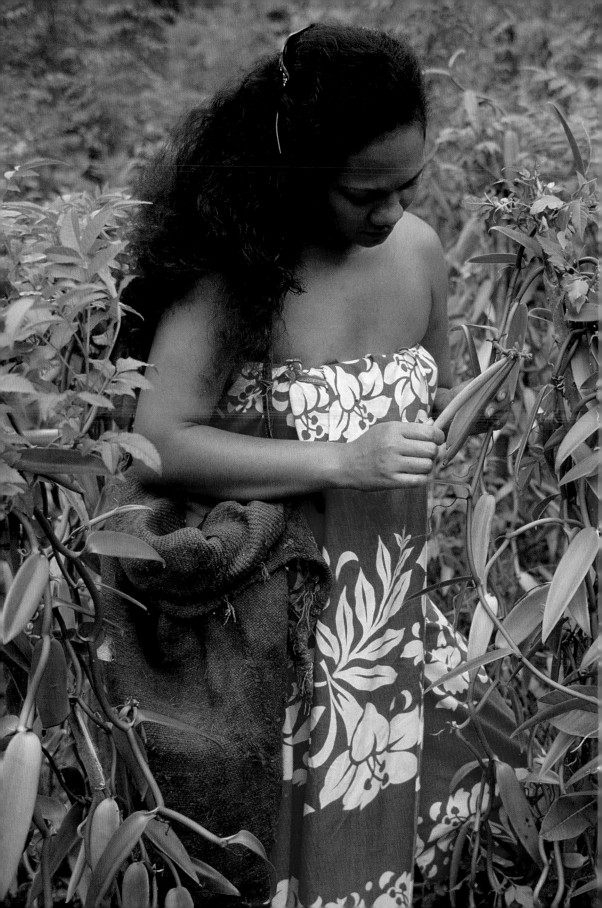

opposite A field worker pollinates vanilla flowers by hand. Tahiti Islands, Society Islands, French Polynesia, 1962. overleaf A splicer for Southwest Bell Telephone Company paints *WO* onto the standard "Men Working" sign. Dallas, Texas, 1977.

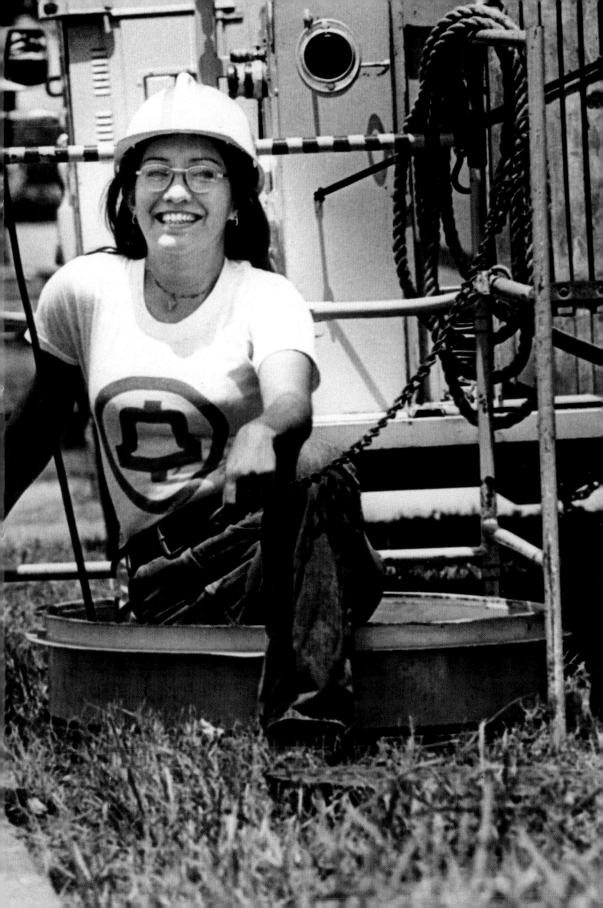

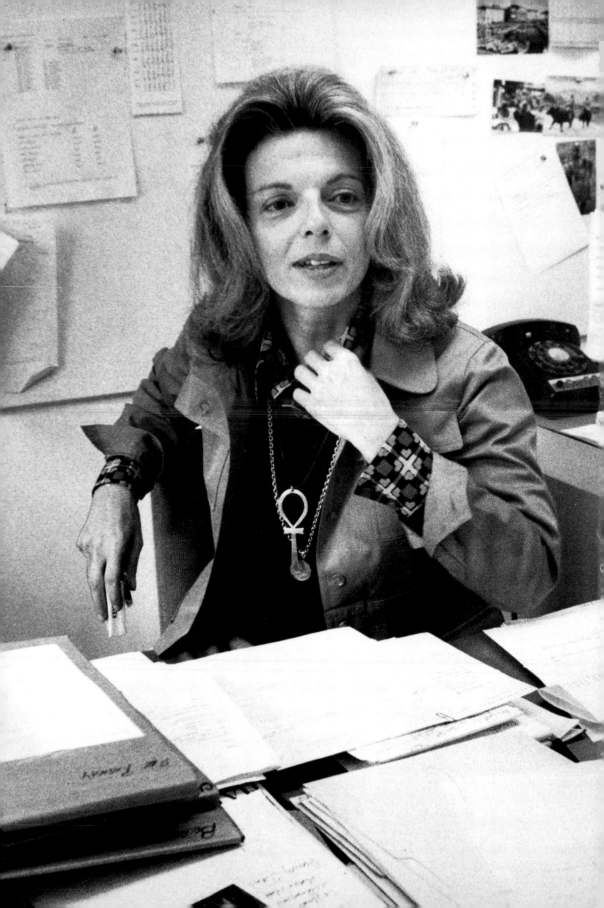

Credits

Pages 4–5: Library of Congress, Prints & Photographs Division, (LC-USZ62-51555). **6**: Julio Donoso/Sygma via Getty Images. **7**: Charles O'Rear/U.S. National Archives and Records Administration. **8**: Robert Nickelsberg/Getty Images. **12**: Department of Labor, Women's Bureau/U.S. National Archives and Records Administration. **16–17**: Edward S. Curtis/Library of Congress, Prints & Photographs Division, Edward S. Curtis Collection, (LC-DIG-ppmsca-05085). **19**: Russell Lee/Schomburg Center for Research in Black Culture, Photographs and Prints Division, The New York Public Library. "Pastor of the Pentecostal Church, Chicago, Illinois." *New York Public Library Digital Collections*. http://digitalcollections.nypl.org/items/510d47df-f993-a3d9-e040-e00a18064a99. **20**: Ernst Haas/Getty Images. **21**: Shafiqul Alam/Corbis via Getty Images. **22**: Bettmann/Getty Images. **23**: Gerhard Joren/LightRocket via Getty Images. **24**: Bettmann/Getty Images. **25**: Christopher Furlong/Getty Images. **26**, from top: Lam Yik Fei/Getty Images; General Photographic Agency/Getty Images. **27**: Pierre Vauthey/Sygma/Sygma via Getty Images. **28**: John Scofield/National Geographic/Getty Images. **29**, from top: Chip Somodevilla/Getty Images; FRED DUFOUR/AFP/Getty Images. **30**, from top: Serge Lemoine/Getty Images; Bettmann/Getty Images. **31**, from top: Leonard McCombe/Picture Post/Hulton Archive/Getty Images; Popperfoto/Getty Images. **32**: Paul Almasy/Corbis/VCG via Getty Images. **33**: Reg Speller/Fox Photos/Getty Images. **34**: Nina Leen/The LIFE Premium Collection/Getty Images. **35**: FPG/Archive Photos/Getty Images. **36–37**: Chicago History Museum/Getty Images. **38–39**: Gilbert M. Grosvenor/National Geographic/Getty Images. **40**: Winfield Parks/National Geographic/Getty Images. **41**, clockwise (from top left): ullstein bild/ullstein bild via Getty Images; Hulton Archive/Getty Images; W. Robert Moore/National Geographic/Getty Images. Charles "Teenie" Harris/Carnegie Museum of Art/Getty Images. **42**: Pinchos Horn/Schomburg Center for Research in Black Culture, Photographs and Prints Division, The New York Public Library. "Selma Burke with her portrait bust of Booker T. Washington," *New York Public Library Digital Collections*. 1935–1943. http://digitalcollections.nypl.org/items/0a7983d0-1156-0134-3aba-00505686a51c. **44**, from top: W. Robert Moore/National Geographic/Getty Images; Bain News Service/Library of Congress, Prints & Photographs Division (LC-DIG-ggbain-26024). **45**, from top: Jill Freedman/Getty Images; Alfred T. Palmer/Library of Congress, Prints & Photographs Division, FSA-OWI Collection (LC-USW361-295). **46**, from top: Lynn Johnson/National Geographic/Getty Images; John Scofield/National Geographic/Getty Images. **47**: Jodi Cobb/National Geographic/Getty Images. **48**: Haywood Magee/Picture Post/Getty Images. **49**: Keystone/Getty Images. **50–51**: Library of Congress, Prints & Photographs Division (LC-DIG-ds-10559). **52**: John White/U.S. National Archives and Records Administration. **53**: Terry Eiler/U.S. National Archives and Records Administration. **54**: Rob Verhorst/Redferns. **55**, from top: Harry Todd/Fox Photos/Getty Images; Keystone/Getty Images. **56**: Scott Olson/Getty Images. **57**: Jerry Redfern/LightRocket via Getty Images. **58–59**: Mark Kauffman/The LIFE Picture Collection/Getty Images. **61**: Three Lions/Getty Images. **62**: Tom Allen/The Washington Post/Getty Images. **63**: Alain Le Garsmeur/Corbis via Getty Images. **64**: Tom Hauck/Getty Images. **65**: A R Tanner/Getty Images. **66**: Hank Walker/The LIFE Picture Collection/Getty Images. **67**, from top: Robert Abbott Sengstacke/Getty Images; Kirill Kukhmar\TASS via Getty Images. **68**: PORTALI/

Gamma-Rapho via Getty Images. **69**: American Colony (Jerusalem) Photo Dept/Library of Congress, Prints & Photographs Division (LC-DIG-matpc-06017). **70**, from top: Robert Knudsen/White House Photographs/John F. Kennedy Presidential Library and Museum, Boston via U.S. National Archives and Records Administration; Barbara Alper/Getty Images. **71**, from top: Kaveh Kazemi/Getty Images; Ute Grabowsky/Photothek via Getty Images. **72**, from top: Alfred Eisenstaedt/The LIFE Picture Collection/Getty Images; MOHAMMED HUWAIS/AFP/Getty Images. **73**: Roberto Machado Noa/LightRocket via Getty Images. **74**: Department of Labor, Women's Bureau/U.S. National Archives and Records Administration. **75**, from top: Bettmann/Getty Images; Lewis Hine/U.S. National Archives and Records Administration. **76**: Planet News Archive/SSPL/Getty Images. **77**: Theo Wargo/Getty Images. **78–79**: Three Lions/Getty Images. **80–81**: M. McNeill/Fox Photos/Hulton Archive/Getty Images. **83**: Department of Agriculture/U.S. National Archives and Records Administration. **84**: Peter Still/Redferns. **85**: Library of Congress/Corbis/VCG via Getty Images. **86**, from top: CBS via Getty Images; NASA. **87**, from top: WATFORD/Mirrorpix/Mirrorpix via Getty Images; Universal Images Group via Getty Images. **88**: Published by Stillfried & Anderson/Library of Congress, Prints & Photographs Division (LC-USZC4-14308). **89**: Margaret Bourke-White/The LIFE Images Collection/Getty Images. **90**: Keystone/Getty Images. **91**: Michael Ochs Archives/Getty Images. **92**: Bernard Hoffman/The LIFE Picture Collection/Getty Images. **93**: NASA. **94**: Winfield Parks/National Geographic/Getty Images. **95**: Bain News Service/Library of Congress, Prints & Photographs Division (LC-DIG-ggbain-26023). **96**, from top: Evans/Three Lions/Getty Images; Douglas Miller/Keystone/Getty Images. **97**, from top: Barbara Alper/Getty Images; Bettmann/Getty Images. **98**, from top: Aaron P. Bernstein/Getty Images; Heather Wines/CBS via Getty Images. **99**: Gordon Parks/Library of Congress, Prints & Photographs Division, FSA/OWI Collection (LC-USZ62-80024). **100–101**: David Bransby/Library of Congress, Prints & Photographs Division, FSA-OWI Collection (LC-USW361-273). **102**: Independent Picture Service/UIG via Getty Images. **103**: Keystone/Hulton Archive/Getty Images. **105**: Bettmann/Getty Images. **106**, from top: Susan Wood/Getty Images; Kaveh Kazemi/Getty Images. **107**, from top: Robert Nickelsberg/Getty Images; ROSLAN RAHMAN/AFP/Getty Images. **108**: Young Women's Christian Association/U.S. National Archives and Records Administration. **109**: Winfield Parks/National Geographic/Getty Images. **110**: © Hulton-Deutsch Collection/CORBIS/Corbis via Getty Images. **111**: Mark Kauffman/The LIFE Picture Collection/Getty Images. **112**: Keystone View/FPG/Getty Images. **113**, clockwise (from top left): Bettmann/Getty Images; Barbara Freeman/Getty Images; Chicago History Museum/Getty Images; Education Images/UIG via Getty Images. **114**: NACA/NASA/Langley Research Center. **115**: Schomburg Center for Research in Black Culture, Photographs and Prints Division, The New York Public Library. "Members of the Women's Army Corps identifying incorrectly addressed mail for soldiers, Post Locator Department, Camp Breckinridge," *New York Public Library Digital Collections*. 1943. http://digitalcollections.nypl.org/items/510d47df-fa14-a3d9-e040-e00a18064a99. **116**, from top: Bettmann/Getty Images; Ratib Al Safadi/Anadolu Agency/Getty Images. **117**: Robert Daemmrich Photography Inc/Corbis via Getty Images. **118–119**: Department of Labor, Women's Bureau/U.S. National Archives and

opposite **Grace Mirabella**, *Vogue* editor in chief from 1971 to 1988, at her desk. New York City, New York, 1971.

Records Administration. **120**: Lane Montgomery/Hulton Archive/ Getty Images. **121**: Alfred Eisenstaedt/The LIFE Picture Collection/ Getty Images. **122**: Haywood Magee/Picture Post/Getty Images. **123**: Alan Band/Fox Photos/Getty Images. **124**: U.S. Navy/U.S. National Archives and Records Administration. **125**, from top: Jie Zhao/Corbis via Getty Images; Lintao Zhang/Getty Images. **126**: War Industries Board/U.S. National Archives and Records Administration. **127**, from top: Evening Standard/Getty Images; E. F. Joseph/Anthony Potter Collection/Getty Images. **128**: © Hulton-Deutsch Collection/ CORBIS/Corbis via Getty Images. **129**: John Phillips/The LIFE Picture Collection/Getty Images. **130–131**: Buyenlarge/Getty Images. **133**: The Metropolitan Museum of Art, New York. Gift of Georgia O'Keeffe, through the generosity of The Georgia O'Keeffe Foundation and Jennifer and Joseph Duke, 1997. www.metmuseum.org. **134**: A J O'Brien/Getty Images. **135**, from top: Janos Kalmar/Keystone Features/ Getty Images; Fred Ramage/Keystone/Getty Images. **136–137**: Chris Hondros/Getty Images. **138**, from top: Brent Stirton/Getty Images Reportage; Dmitri Kessel/The LIFE Picture Collection/Getty Images. **139**: Tony Russell/Redferns. **140**: Winfield Parks/National Geographic/ Getty Images. **141**, from top: Three Lions/Getty Images; Bob Peterson/ The LIFE Images Collection/Getty Images. **142**: H. B. Lindsley/ Library of Congress, Prints & Photographs Division (LC-USZ62-7816). **143**: Three Lions/Hulton Archive/Getty Images. **144**: William Vanderson/Fox Photos/Getty Images. **145**, from top: Helen H. Richardson/The Denver Post via Getty Images; Underwood Archives/ Getty Images. **146**: U.S. National Library of Medicine. **147**: Michael Melford/National Geographic/Getty Images. **148–149**: Frank Leonardo/New York Post Archives/© NYP Holdings, Inc. via Getty Images. **150**, from top: Alex Wong/Getty Images; Tim Clayton/Corbis via Getty Images. **151**: Popperfoto/Getty Images. **152**: Ian Tyas/Keystone Features/Getty Images. **153**, clockwise (from top left): ANDREAS SOLARO/AFP/Getty Images; Jimmy Sime/Central Press/Getty Images; © Copyright WNBAE 2002/Photograph by Andrew D. Bernstein/WNBAE/Getty Images; Saidman/CPL/Paul Popper/ Popperfoto/Getty Images. **154**: U.S. Department of Agriculture/U.S. National Archives and Records Administration. **156**: Arne Hodalic/ Corbis via Getty Images. **157**: NASA. **158**: Bettmann/Getty Images. **159**, from top: Fatemeh Bahrami/Anadolu Agency/Getty Images; John White/U.S. National Archives and Records Administration. **160**: Bettmann/Getty Images. **161**: AJ Williams/CDC. **162**, from top: Douglas Kirkland/Corbis via Getty Images; NASA. **163**, from top: Schomburg Center for Research in Black Culture, Photographs and Prints Division, The New York Public Library. "Captain Mary L. Petty, Chief Nurse, holding a glass bottle and showing it to 2nd Lieutenant Olive Bishop, who is writing on a small pad of paper," *New York Public Library Digital Collections*. 1939–1945. http://digitalcollections. nypl.org/items/92cd3290-c645-012f-0f9b-58d385a7bc34; Jeff J Mitchell/ Getty Images. **164**: Steve Petteway/The Collection of the Supreme Court of the United States. **165**: AFP/Getty Images. **166**: Bettmann/ Getty Images. **167**, clockwise (from top left): NASA; Russell Lee/ Library of Congress, Prints & Photographs Division, FSA/OWI Collection (LC-DIG-fsa-8a23266); Neil Schneider/New York Post Archives/© NYP Holdings, Inc. via Getty Images; Hulton Archive/ Getty Images. **168**: Bain News Service/Library of Congress, Prints & Photographs Division (LC-DIG-ggbain-24739). **169**: Gilbert M. Grosvenor/National Geographic/The LIFE Picture Collection/Getty Images. **170–171**: Gordon Parks/The LIFE Picture Collection/Getty Images. **172**: Gordon Parks/ Library of Congress, Prints & Photographs Division, FSA/OWI Collection (LC-DIG-fsa-8d12510). **173**: Ian Showell/Keystone/Hulton Archive/Getty Images. **175**: Dorothea Lange/U.S. National Archives

and Records Administration. **176**: Samuel Masbury/Library of Congress, Prints & Photographs Division, (LC-DIG-ppmsca-30978). **177**: Samuel Masbury/Library of Congress, Prints & Photographs Division, (LC-DIG-ppmsca-30980). **178**: Bettmann/Getty Images. **179**, clockwise (from top left): Charles O'Rear/U.S. National Archives and Records Administration; Lewis Hine/U.S. National Archives and Records Administration; Lauren Barkume/Moment Mobile; New York Daily News Archive via Getty Images. **180**: NASA. **181**: Haeckel Collection/ullstein bild via Getty Images. **182**: George Grantham Bain Collection/Library of Congress, Prints & Photographs Division (LC-USZ62-46396). **183**, from top: John Bulmer/Getty Images; Library of Congress, Prints & Photographs Division, American National Red Cross Collection (LC-DIG-anrc-10684). **184–185**: Schomburg Center for Research in Black Culture, Photographs and Prints Division, The New York Public Library. "A crowd of African American Women's Army Corps members waving at the camera, Staten Island Terminal, New York Port of Embarkation," *New York Public Library Digital Collections*. 1946. http://digital.gallery.nypl.org/items/510d47df-f9fb- a3d9-e040-e00a18064a99. **186**: George Konig/Keystone Features/Getty Images. **187**, from top: David Turnley/Corbis/VCG via Getty Images; Charles O'Rear/U.S. National Archives and Records Administration. **188**, from top: Richard E. Aaron/Redferns; Central Press/Getty Images. **189**, from top: Photo12/UIG via Getty Images; Bettmann/Getty Images. **190**: SHAH MARAI/AFP/Getty Images. **191**: Wolfgang Kaehler/LightRocket via Getty Images. **192**: Robert Nickelsberg/Getty Images. **193**: Fritz Henle/Library of Congress/FSA/OWI Collection. **194**, from top: GIANLUIGI GUERCIA/AFP/Getty Images; Hulton Archive/Getty Images. **195**: Robert B. Goodman/National Geographic/ Getty Images. **196**: George Barkentin/Condé Nast via Getty Images. **197**, clockwise (from top left): Jacques Langevin/Sygma/Sygma via Getty Images; Daily Record/Mirrorpix/Mirrorpix via Getty Images; National Park Service/U.S. National Archives and Records Administration; Schomburg Center for Research in Black Culture, Photographs and Prints Division, The New York Public Library. "Workers of many races push plane output" *New York Public Library Digital Collections*. 1939–1945. http://digitalcollections.nypl.org/ items/510d47df-fa4b-a3d9-e040-e00a18064a99. **198–199**: Jeremy Sutton-Hibbert/Getty Images. **201**: Peter Charlesworth/LightRocket via Getty Images. **202**: Bettmann/Getty Images. **203**: WATFORD/ Mirrorpix/Mirrorpix via Getty Images. **204**: K M Asad/LightRocket via Getty Images. **205**, from top: Dennis Oulds/Central Press/Getty Images; Keystone/Getty Images. **206**: Ulrike Welsch/The Boston Globe via Getty Images. **207**: Barbara Alper/Getty Images. **208**, from top: NOAH SEELAM/AFP/Getty Images; Bruce Dale/National Geographic/Getty Images. **209**, from top: Bettmann/Getty Images; John Scofield/National Geographic/Getty Images. **210**: Bradley Smith/ CORBIS/Corbis via Getty Images. **211**: S W A Newton/English Heritage/Arcaid/Corbis via Getty Images. **212**, from top: Library of Congress/Corbis/VCG via Getty Images; Department of Labor, Women's Bureau/U.S. National Archives and Records Administration. **213**, from top: Harry Shepherd/Fox Photos/Hulton Archive/Getty Images; Harry Wenger/FPG/Hulton Archive/Getty Images. **214**: Gilbert M. Grosvenor/National Geographic/Getty Images. **215**: Thomas Koehler/Photothek via Getty Images. **216**: Nina Leen/The LIFE Picture Collection/Getty Images. **217**: © Hulton-Deutsch Collection/CORBIS/Corbis via Getty Images. **218**: Luis Marden/ National Geographic/Getty Images. **220–221**: Bettmann/Getty Images. **222**: Richard Gummere/© NYP Holdings, Inc. via Getty Images.

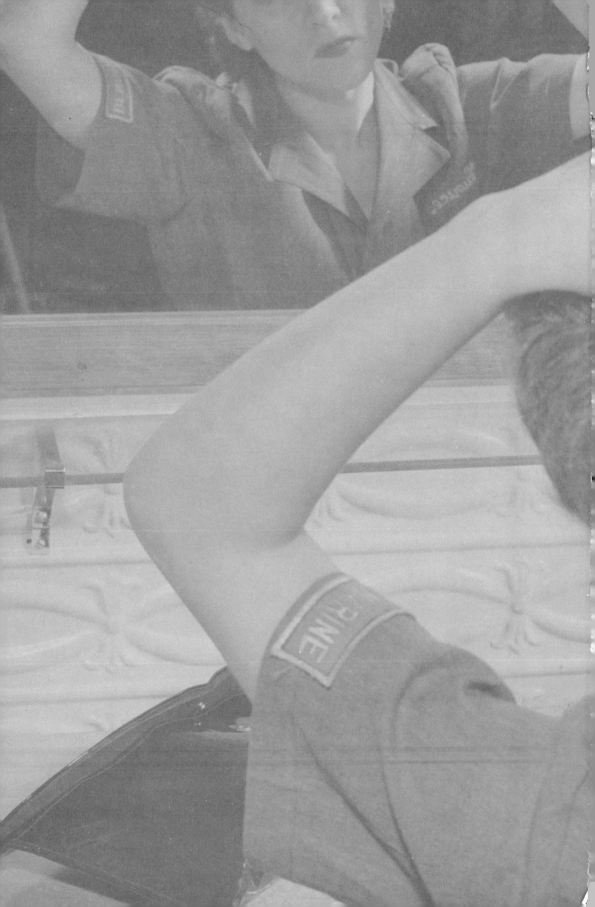